Drawn West

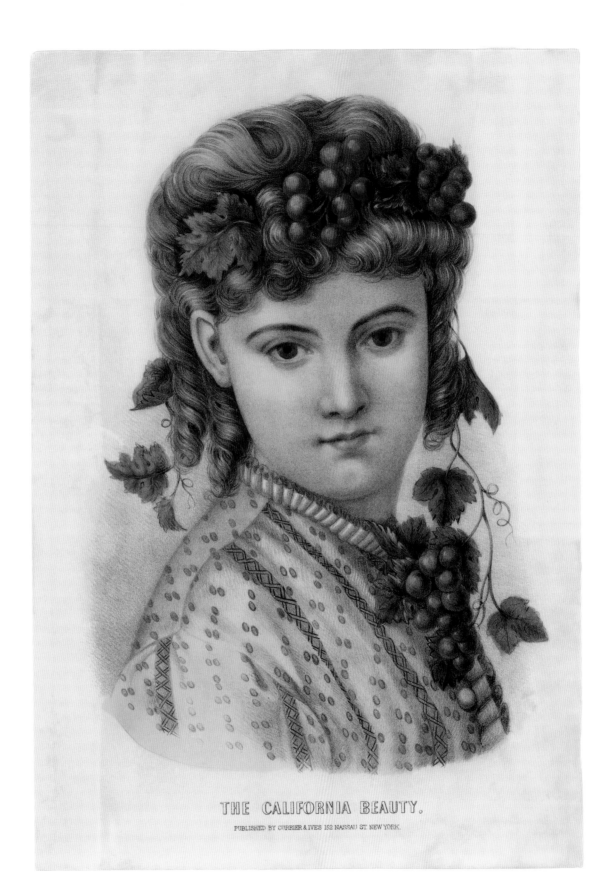

THE CALIFORNIA BEAUTY.

PUBLISHED BY CURRIER & IVES 152 NASSAU ST NEW YORK.

Drawn West

SELECTIONS FROM THE ROBERT B. HONEYMAN JR. COLLECTION

OF EARLY CALIFORNIAN AND WESTERN ART AND AMERICANA

JACK VON EUW AND GENOA SHEPLEY

The Bancroft Library, University of California, Berkeley

Heyday Books, Berkeley, California

Library of Congress Cataloging-in-Publication Data
Von Euw, Jack.
Drawn West : selections from the Robert B. Honeyman Jr. collection of early
Californian and Western art and Americana / Jack von Euw, Genoa Shepley.
p. cm.
The Honeyman collection is housed at the University of California at
Berkeley's Bancroft Library.
Includes bibliographical references and index.
ISBN 1-890771-92-9 (hardback : alk. paper)
1. Art, American — California — 19th century. 2. Art, American — West (U.S.) —
19th century. 3. West (U.S.) — In art. 4. Honeyman, Robert B. — Art collections.
5. Art — California — Berkeley. 6. Bancroft Library — Art collections.
I. Shepley, Genoa. II. Honeyman, Robert B. III. Bancroft Library. IV. Title.
N6530.C2V66 2004
760'.0443678'07479467 — dc22 2004007650

Frontispiece: Currier & Ives, publisher, *The California Beauty*, 1800s;
print on paper: lithograph, hand colored; 14 x 10. See also Plate 1-22.
Book Design: David Bullen Design
Printed in Singapore by Imago

Orders, inquiries, and correspondence should be addressed to:
Heyday Books
P.O. Box 9145, Berkeley, CA 94709
(510) 549-3564, fax (510) 549-1889
www. heydaybooks.com

10 9 8 7 6 5 4 3 2 1

To my partner, Judy, my sons, Max and Erik, and to Wesley Chamberlin, a fine teacher who insisted that his students look.

Jack von Euw

To my family—you know who you are.

Genoa Shepley

Contents

The Bancroft Library

The Bancroft Library is the primary special collections library at the University of California, Berkeley. One of the most heavily used libraries of manuscripts, rare books, and unique materials in the United States, Bancroft supports major research and instructional activities. The library's largest resource is the Bancroft Collection of Western Americana, which was begun by Hubert Howe Bancroft in the 1860s and which documents through primary and secondary resources in a variety of formats the social, political, economic, and cultural history of the region from the western plains states to the Pacific coast and from Panama to Alaska, with greatest emphasis on California and Mexico from the late eighteenth century to the present. The Bancroft Library is also home to the Rare Book and Literary Manuscript Collections, the Regional Oral History Office, the History of Science and Technology Collections, the Mark Twain Papers and Project, the University Archives, the Pictorial Collections, and the Center for the Tebtunis Papyri. For more information, see the library's website at http://bancroft.berkeley.edu.

For information on the Friends of The Bancroft Library,
to make a gift or donation, or if you have other questions, please contact:
Friends of The Bancroft Library
University of California, Berkeley
Berkeley, California 94720-6000
(510) 642-3782
bancroftfriends@library.berkeley.edu

Acknowledgments

The Bancroft Library, the author, and the publisher wish to acknowledge our deep gratitude to the Barkley Fund, whose generosity made this book possible.

Author Acknowledgments
The Bancroft Library is able to present the outstanding works in the Robert B. Honeyman Jr. Collection to the public thanks to the vision and hard work of the late Susanna Bryant Dakin and the Friends of The Bancroft Library, who, with the support of the University Regents, brought the collection to the library in 1963. In 1968, Joseph Armstrong Baird Sr. compiled the *Catalogue of Original Paintings, Drawings and Watercolors in the Robert B. Honeyman Jr. Collection*, which is an invaluable guide to these works and the artists who created them. Mary Elings and Eva Garcelon broke new ground in creating an online catalog of the collection, while Dan Johnston went bravely and boldly into the digital universe where few had gone before. Kevin Starr and Gary Kurutz of the California State Library helped bring the Honeyman digital project to fruition through their magnanimous support. And finally, Charles Faulhaber gave us the opportunity and believed that we were up to the task at hand.

Drawn West: Selections from the Robert B. Honeyman Jr. Collection of Early Californian and Western Art and Americana was made possible by all of the aforementioned individuals and by the gracious contributions of the following: Alfred Harrison and Oscar Lemer, who shared their knowledge, appreciation, and passion for nineteenth- and early twentieth-century California painting; Nancy Crowley, who provided crucial research assistance; the staff of Heyday Books, especially Malcolm Margolin, whose enthusiasm spurred on the development and completion of this book, and whose guidance, along with the excellent editorial work of Jeannine Gendar, helped to shape and refine it; Rebecca LeGates, for shepherding the book through production; designer David Bullen, who gave *Drawn West* its handsome form; Gray Brechin, Douglas R. Nickel, and Donna Stein, who were perceptive readers of the manuscript; Bancroft staffers and student assistants who helped with this project in various ways—Tony Bliss, who shared his knowledge of French, Franz Enciso, who took on extra duties, Marc Engberg, who made numerous trips to the Doe Library and completed a great variety of other tasks, Erica Nordmeier, who cheerfully provided hundreds of color prints, and the circulation desk workers who fetched countless volumes in the research phase of the book; and perhaps most importantly, an anonymous donor who recognized the potential of the collection as a book and so generously supported it.

Jack von Euw and Genoa Shepley

Introduction

Jack von Euw

GROWING up in the suburbs of London, England, in the 1950s, I fueled my outsize fantasies of the Wild West with the help of a small-screened, black-and-white television set. My favorite program on the "telly" was about Rin Tin Tin, the courageous and clever German shepherd who always saved his master, Rusty, and led the cavalry in the closing moments of the broadcast to the inevitable and rousing rescue of a wagon train under attack from a fearsome horde of Indians. Living a stone's throw from Epping Forest, I might have more fittingly identified with Robin Hood or perhaps William Tell, the apple-splitting hero of my Swiss heritage. My heroes, however, were Hopalong Cassidy, Roy Rogers, Wyatt Earp, Brett Maverick, the Lone Ranger, and a very young Clint Eastwood as Rowdy Yates in *Rawhide*; my weapon of choice a six-shooter and caps.

When I was twelve, my family moved to Rio de Janeiro. Television was no longer an entertainment option, but the Wild West was not finished with me. My mother decided to enroll my sister and me in the Swiss Brazilian School, where we would learn to speak and write in German and Portuguese. There, my favorite teacher, having somehow intuited my earlier

I don't think that Bob Honeyman ever would have accepted an invitation to membership, because he is not what they call "clubbable": he doesn't care for that sort of thing, although he is by far the greatest collector this part of the world has ever known, if you except William Andrews Clark.

What is known is that Mr. Honeyman dedicated part of Rancho Los Cerritos, his home near San Juan Capistrano, as a museum for his collection. As part of the purchase agreement with the University of California, he exhibited the collection at the Santa Barbara Museum of Art and at the Oakland Museum of California before the final transfer to Bancroft. And after the collection came to Bancroft, Honeyman continued to express an interest in it, adding several important paintings in the 1970s. A brief obituary notice in the *New York Times* states that Robert Honeyman died on June 30, 1987, in Orange County, California, at the age of eighty-nine.

Unlike better-known collectors such as the Karoliks in Boston or Paul Mellon in Washington, D.C., Honeyman did not work with any particular museum or institution until he had essentially completed his collection. Nor did he appear to express any particular goal or grand design; at least none that he chose to make known in writing. Not knowing the details or precise circumstances under which he acquired and assembled his pictorial collection of Western Americana, we can only speculate as to his motivations and try to find some clues in the works he acquired.

An analysis of the collection reveals Honeyman's belief in its value and importance as a visual history of California and the western states, as is made impressively clear by the presence of works from the early European voyages of exploration, which epitomize Honeyman's passion for the unique and original record.

The era represented and the era in which Mr. Honeyman collected may also reveal something about him and certainly something of the social agendas and aesthetics that characterize the collection as a whole. It appears that Honeyman started his pictorial collection in the late 1930s and had completed much of it by the end of the 1950s. This was contemporaneous with the success of the New Deal, America's entry into World War II, and subsequent victories on the Pacific and European fronts, the period when America shed the last vestiges of the Depression to attain the status of military and economic superpower. Characterized by tremendous growth, the immediate postwar period was an era of optimism and confidence in progress, the future, and the "American way." It was in some ways similar to the era of the pioneers settling the American West, an era also characterized by a belief in progress and the special destiny of Americans, in this case to all the seemingly endless riches, ripe for the taking, that the West had to offer.

True to the collection itself, *Drawn West* is not meant to be a chronological narrative of the history of the western states. Instead it provides the reader with a visual cross section of the West, dating from the late eighteenth century through the end of the nineteenth. The images within each chapter are arranged more or less chronologically following a specific theme over time. Out of this montage, certain patterns emerge in the artistic treatment of the West — its inhabitants and

visitors, its landscape — that deepen our understanding of the perceptions, as well as the needs and desires, of people encountering this new land for the first time.

It is a testimony to the depth of the Honeyman Collection that this book could probably contain a completely alternative selection of images. Because this selection confined itself primarily to the continental United States, we could not include many splendid images, such as the two drawings that Georg Heinrich von Langsdorff made, on the same voyages that brought him to the coast of California, of two inhabitants of the Marquesas Islands. Nor did we select any of the nearly two hundred prints, drawings, and paintings of the California missions: works by Henry Chapman Ford, William Birch McMurtrie, Harry Fenn, Seth C. Jones, John Edward Borein, Edwin Deakin, Edward Lehman, Lemuel Maynard Wiles, and many others. These alone could be the basis of a book.

It is our hope that as the reader pages through this book, he or she will recognize and take pleasure in the many ways in which the artist's hand asserts itself in the collection, from sketchbooks and journals to large studio canvases, from personal and intimate visual recollections to lithographs, engravings, and other types of prints designed to promote the wonders of the California landscape. Perhaps Honeyman's emphasis on the original, unique, or rare item explains the absence of photographs in his collection. Unlike nearly all photographic prints, whose creation begins with light fixed on a light-sensitive emulsion, lithographs and most other means of reproducing paintings or drawings can be traced back to the hand of the artist.

In the end we might conclude that Honeyman's love for his adopted state accounts for the voraciousness and determination that he brought to compiling this unrivalled pictorial collection of California and the West. The wonder of this collection lies in the omnivorous selection of material, where letter sheets, clipper ship cards, and magazine illustrations have a place at the table alongside landscape oils, shipboard sketchbooks, and topographical watercolors. To survey the collection is to journey back and forth between works by such acknowledged artists as Bierstadt, Keith, and Hill, popular illustrations published by Currier & Ives, and images by anonymous or little-known artists such as Richard Brydges Beechey, Victor Seamon, and J. Boot. In fact, many of these images are reproduced for the first time in this book. It is a visual adventure fraught with fanciful and often dangerous encounters such as that between William Tylee Ranney's rugged trapper and a party of Indian warriors (Plate 1-9), or Nahl's gold hunters on the treacherous Chagres River (Plate 3-8). It is also a journey of exploration made with the help of Thomas Ayres, the first artist to record an encounter with the awe-inspiring Yosemite Valley. It is the quiet thrill of intimate disclosure found in the sketches of Louis Jules Rupalley, who came from France to seek his fortune in the gold country and returned home having discovered a treasure trove of California flora and fauna. Our debt to Honeyman is as great as his inclusive embrace. ᏸᎦ

Chapter One

Inhabitants
and Travelers

With regard to the people you may visit, you will observe their
disposition and different corporeal qualifications . . .

Catherine the Great, "Admonitions to Naturalists"

JUST AS the moon existed in fact and fiction long before NASA beamed fuzzy pictures of Armstrong and Aldrin planting the Stars and Stripes on the lunar surface in 1969, so too did the western portion of the North American continent and its inhabitants occupy their place on the globe long before Europeans and Americans claimed it for themselves. But the idea of the "undiscovered country" exerted an irresistible gravitational pull on explorers and settlers who flocked to the West in droves. Many brought with them dreams of conquest, as well as preconceived notions of this terra incognita, and especially of the people who inhabited it. As illustrated in the Honeyman Collection, the record left by artists of the travelers who made this journey and of the inhabitants they encountered is far less black and white than that of the Apollo missions.

The story of the settlement of the West, including the "discovery" of California, is one that still grips the imagination as it is told and retold on page, screen, sketchbook, and canvas. The cast of characters includes Native Americans, early explorers hailing from several countries, Californios, Canadian trappers, and the melting pot engendered by the California gold rush. The tale involves a succession of claimants, fatal collisions between cultures, brutal confrontations, and vast assimilation. The Honeyman Collection offers a kaleidoscopic view of the encounters, clashes, integration, and disintegration of the peoples of the American West.

In these pages, we sail with the early European explorers and experience their encounters and observations of California's native people through the sketches, drawings, and paintings of their shipboard artists. We encounter the vaquero and discover the range of people who toiled in the California mines. We come face to face with a French swashbuckler fighting to protect his claim. We share a moment with a lone trapper and ride with the Plains Indians. Lastly, we have the opportunity to meet the original California Girl.

Several of these artists were separated from their subjects not only by place of origin, but by time—like us, contemplating their subjects retrospectively. And in some cases, the term "artist" is applied anachronistically here, for they were first and foremost sailors, miners, and naturalists, none of whom would have thought of themselves as artists. To fully appreciate the implications and significance of these works, we must consider the ways in which the backgrounds and

in history. These likenesses are not penetrating or intimate portraits; they are more in the nature of advertisements—designed to promote agendas. In Frémont's case, the images uphold and perpetuate the myth that he single-handedly wrested California from Mexico; in Sutter's, that the West was won by trailblazers and god-fearing settlers and merchants who sought freedom and prosperity for those who had the courage to follow the trail west. Without a doubt, there is more than a grain of truth in this myth. And yet when one knows who made these images, and for whom, when one is aware of how these personalities were portrayed and perceived in their time, the distance between fact and fiction becomes obvious.

The Honeyman Collection boasts a particularly rich collection of images of the infamous argonauts, and they too run the gamut of fantasy, fact, and myth. These fortune seekers who left home and hearth or abandoned ship to strike it rich in the goldfields are depicted with humor, satire, racism, and an array of other treatments worthy of a modern-day image

consultant. In these pages we are privy to everything from Charles Christian Nahl and Frederick August Wenderoth's solitary prospector (Plate 1-17) and José Baturone's fruit-loving miners (Plate 1-18) to a carefully wrought portrait by Ernest Narjot (Plate 1-20), whose brush was thickly laden with the warm and glowing tones of nostalgia.

Immigrants who came for gold but could not countenance the work or the life of a miner soon realized that California offered other treasures, such as a rich agricultural bounty. Promoters developed a new set of myths touting the potential of California's fertile soil and temperate weather to produce oversized fruits and vegetables, and if one believed them, beautiful women. A Currier & Ives lithograph in this collection, *The California Beauty*, combines these conceits (Plate 1-22). Here we see the idealization of woman in the best European art tradition, and to make the unsubtle point that she is ripe for the plucking, she sports large, full grapes in her hair. If this image did not drive men to California, what would? ❧

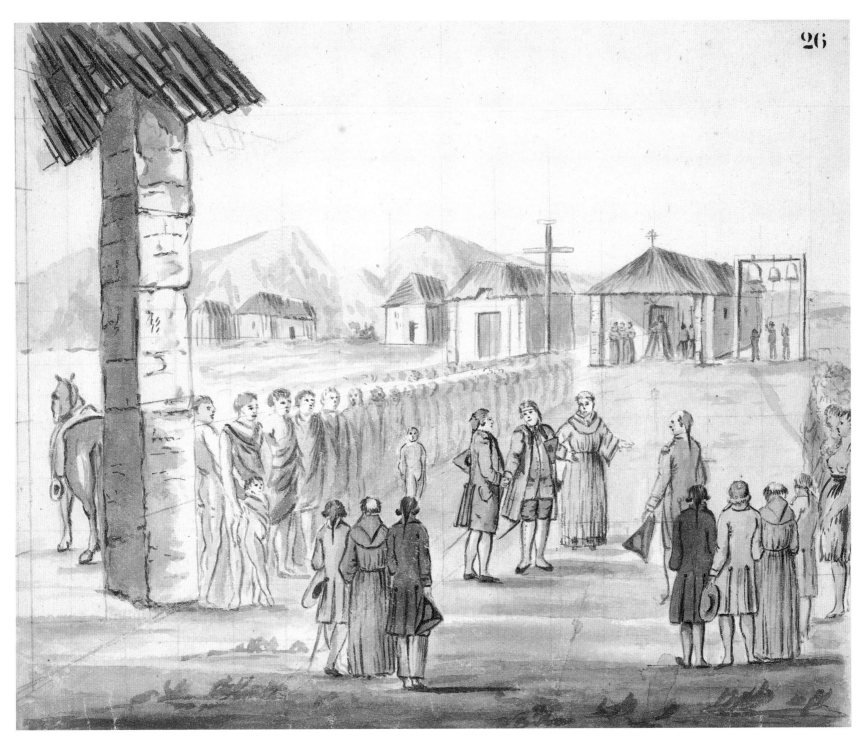

PLATE 1-1. José Cardero, *Copia de un dibujo que deja el Pintor del Conde dela Perouse a los Padres de la Mision del Carmelo en Monterey* (Reception of Jean-François de La Pérouse at Mission Carmel in 1786, [after Gaspard Duché de Vancy]), c. 1791–92; drawing on paper: ink, wash, and pencil; 8⅜ x 10⅛ in

José Cardero's copy of a 1786 sketch by Gaspard Duché de Vancy (Plate 1-1) is an example of not just one, but possibly three different lenses applied to the same scene. The original work of de Vancy, the shipboard artist to the French explorer La Pérouse pictured here, was lost. Two copies by Alexander Malaspina's shipboard artists Tomás de Suria and José Cardero reveal the interpretive license employed in the renderings. Whereas de Suria shows the natives barely clad in loincloths, Cardero chooses to clothe them in togalike costumes. Cardero's Indians appear more "civilized" and less impoverished. In both cases, however, the artists de-emphasized the importance of the natives by reserving the details for the visiting dignitaries.

Sailing with the Russian expedition led by Otto von Kotzebue, twenty-one-year-old Louis Choris wrote of his encounter at San Francisco de Assis Mission:

After Sunday mass the Indians gather in the cemetery opposite the missionary's house and begin to dance. . . . Usually six or eight men dance together, all making the same movements. They are all armed with spears. Their music consists of hand-clapping, singing, and shaking lengths of wood to produce a din that has charms for their ears alone.

Perhaps containment of the "din that has charms for their ears alone" was one of the themes of Choris's watercolor (Plate 1-2). Choris captured the dancers, their body decorations, and their dance steps vividly and colorfully. And yet the mission buildings that dwarf this group of Native Americans and, moreover, the giant cross that towers above them emphasize their subjugation by the church.

Georg Heinrich von Langsdorff, in his "Indians Dancing" (Plate 1-3), portrayed Native Americans in their environment. He did not dramatize the scene as Choris did. In his capacity as a naturalist he was equally as interested in the leaves of the trees and blades of grass around the dancers as he was in their body paint and headdresses.

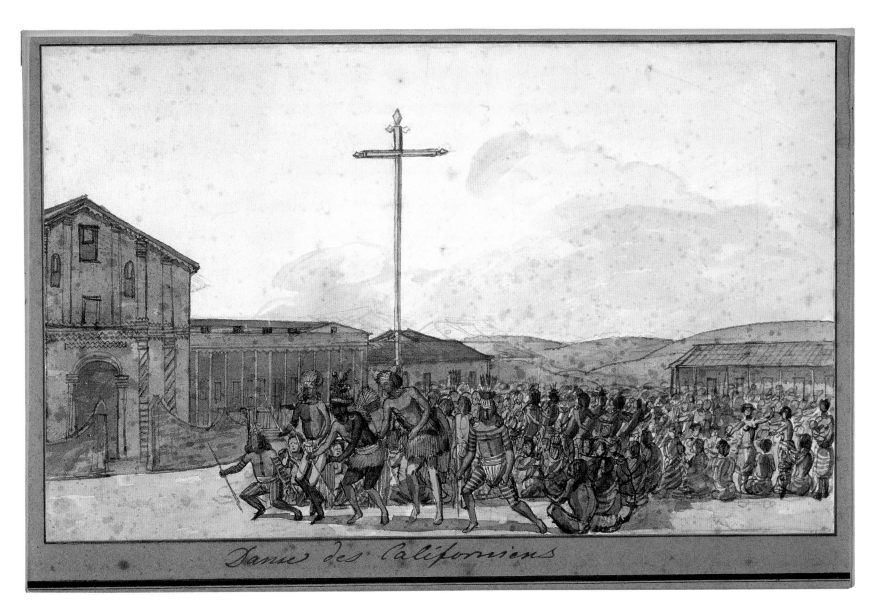

Danse des Californiens

PLATE 1-2. Louis Choris, *Danse des Californiens* (Dance of the Californians), c. 1816; painting on paper: watercolor and pencil; 7 x 11 in

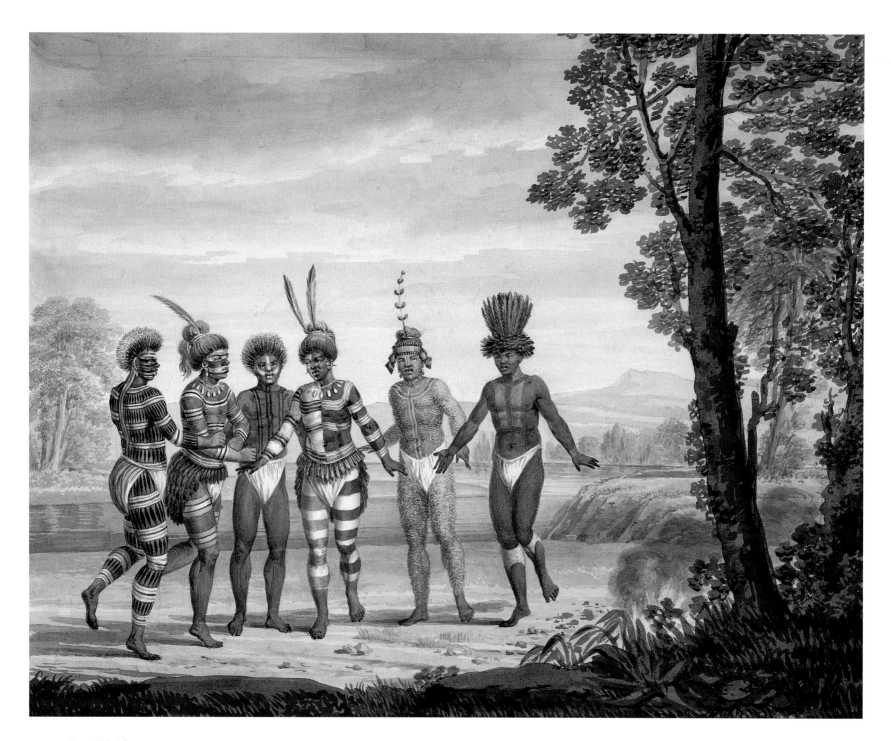

PLATE 1-3. Georg Heinrich
von Langsdorff, *Ein Tanz der
Indianer in der Mission in St. Jose
in Neu-Californien* (Indians
Dancing in Mission San Jose,
New California), c. 1806;
drawing on paper: ink wash
highlighted with gouache;
8⅜ x 11 in

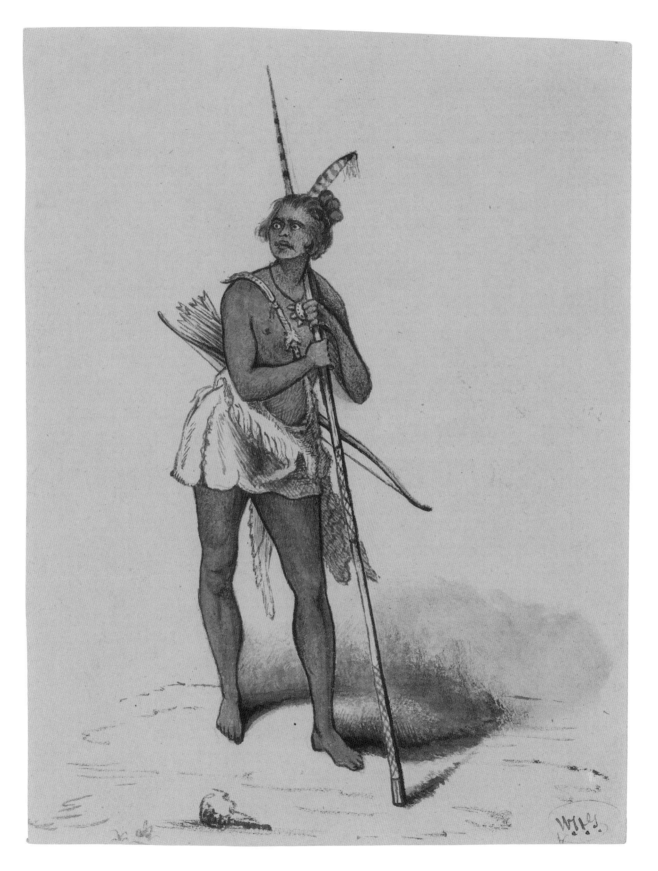

PLATE 1-4. Attributed
to William H. O'Grady,
*Corlappich, Klamath
River Indian Chief, 1851,*
1851; drawing on
tinted paper: ink
and wash; 6 x 4 7/8 in

Unlike some of the works of early explorers, the sketch by William O'Grady (Plate 1-4) is not a generalized depiction of a Native American but a portrait and a character study of an individual, Corlappich, a Klamath River chief. According to A. J. Bledsoe, in his 1885 book *Indian Wars of the Northwest: A California Sketch*, a Klamath Indian by the name of Kaw-tap-ish was one of four influential leaders who helped prevent the Klamath from engaging in hostilities in the early 1850s. Is it possible that O'Grady's Corlappich and Bledsoe's Kaw-tap-ish are one and the same?

Little is known about William H. O'Grady, but he may well have joined the crowds of gold seekers who invaded the area around the Klamath River. Perhaps he sketched Corlappich, leaning on his spear with his bow and arrows on his back, getting ready to fish and hunt in the Klamath, when the river was still teeming with fish and the surrounding mountains alive with game. By 1851, the date of this portrait and two years into the gold rush, the indigenous population of California had been cut to less than half of what it was at the time of their first contact with white explorers, missionaries, and settlers. The argonauts and those who followed in their wake continued this devastating decline through land grabs, including the reappropriation of reservations, the spread of disease, and casual massacres. Small wonder, then, that there is something sorrowful about this sketch, as this young Indian chief looks with apprehension in his eyes toward a future in which he most likely will not grow old, and his way of life is doomed to extinction.

Assimilation and idealization are illustrated, to the point of absurdity, in the hand-colored engraving *Habitans de la Californie* (Plate 1-5). These "California natives" are attired in fanciful costumes, their features appear to be of European origin, and their poses resemble those of classical antiquity, leaving one with the dubious impression that the only difference between them and their French counterparts lies in their fashion sense. The woman's woven basket filled with food and the game hanging from the princely figure's spear imply a life of abundance in a Garden of Eden where feather skirts have replaced fig leaves. Similar images became stock figures in the publishing trade and as such they tell us more about the society for which they were created than about the indigenous people they were meant to depict.

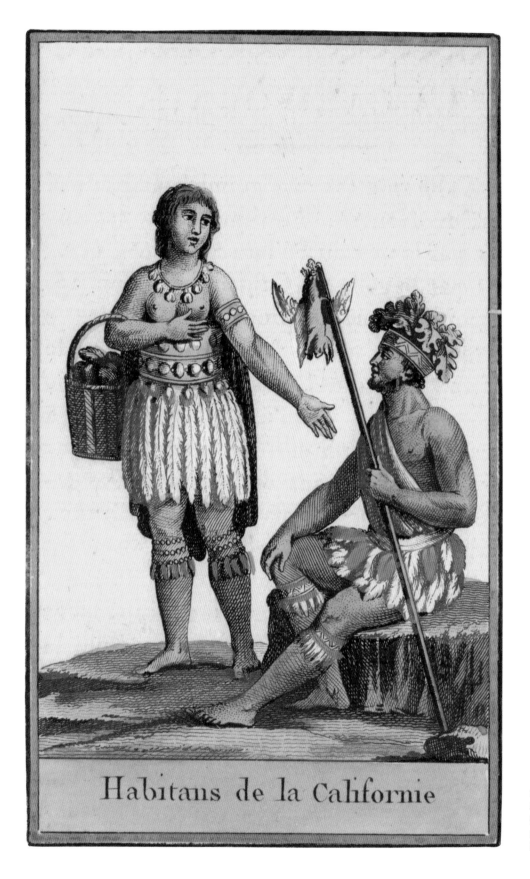

Habitans de la Californie

PLATE 1-5. Unknown artist, *Habitans de la Californie* (Natives of California), 1800s; print on paper: engraving, hand colored; 6½ x 3⅞ in

Although Ferrán, Walker, and Nahl, from Spain, England, and Germany respectively, came from very different backgrounds, their portraits of Californios have much in common. These works represent the general rather than the particular: they stand for the way of life of the Californios—the vast ranchos and cattle herds that flourished before the American annexation of California.

In *Vaqueros Lassoing a Steer* (Plate 1-6), Ferrán pits three vaqueros against an escaping bull along a strong diagonal, pulling the viewer into a dynamic scene of courage and impressive equestrian prowess. The central figure facing the errant bull like a matador appears at the apex of this triangular composition, heightening the tension of the scene and reinforcing the idea of the vaquero's bravery and skill.

Walker's "Patrón" rides in sartorial splendor, seated in his finely tooled saddle like a king on a throne (Plate 1-7). Straight-backed and handsome, he gazes down upon the viewer from above the horizon line. His clothes are royally hued in contrasting reds and greens; his hat is rakishly cocked. No less impressive and imperial, his magnificent horse, resplendent in an ornamented bridle and a red sash tied across its powerful chest, has stopped, dressage-like, in mid-step, its noble profile inclined toward the viewer. One wonders what their destination is as they pause momentarily against a sky of blue with a billowing white cloud rising from behind the mountains in the distance and the lush green grass underfoot. Walker's painting reflects his subject's powerful and privileged station in the Californio way of life. The patrón's back is unbowed by the responsibility for thousands of acres of land, heads of cattle, his vaqueros, and his family obligations.

Many of Nahl's best-known works were large-scale commissions that he executed late in his career. One of them, an 1873 painting called *Fandango*, is a six-by-nine-foot depiction of life in Spanish California with a large cast of characters and a multitude of synoptic stories. Painted subsequently, "The Elopement" (Plate 1-8) takes an intimate look at a single element of the elaborately staged *Fandango*. Here, the couple on horseback take center stage against a loosely rendered and distant landscape dominated by a pale sky. Nahl's interest lies, particularly in his large paintings, in action and drama, detailed flourishes, and props. In this painting, which again involves an equestrian feat of derring-do, we encounter two lovers speeding toward marital bliss. The horse in full gallop and the dark-haired beauty who sits sidesaddle upon the lap of her windswept vaquero all contribute to the romantic and sentimental image of the Californio. Nahl, a master of nostalgia, was not above making a joke; in the foreground he has included an aroused drake taking off after the duck at the other end of the pond as a parallel to the human lovers' courting.

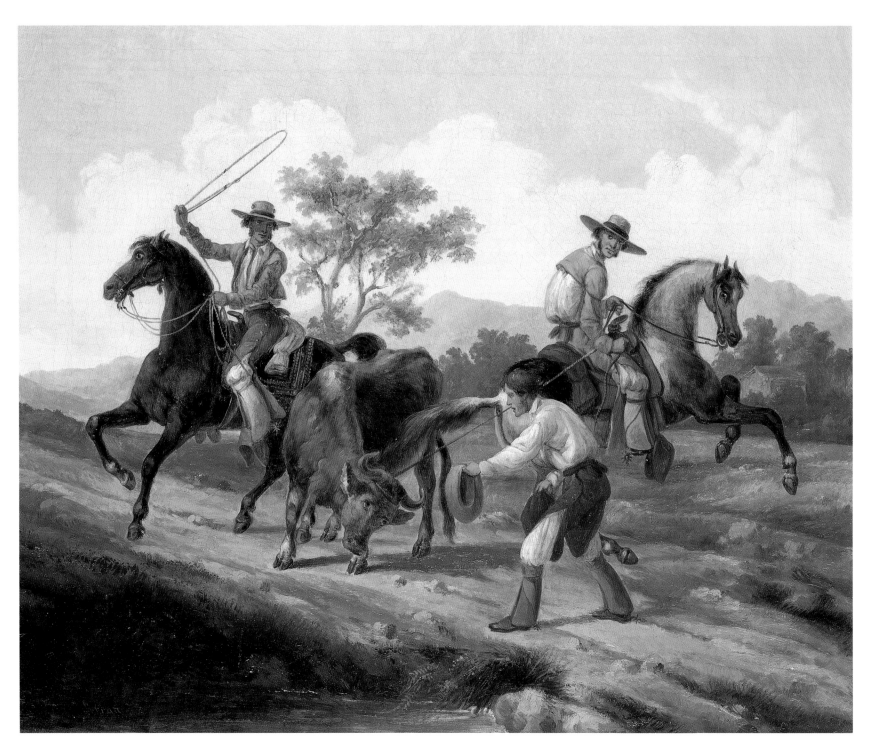

PLATE 1-6. Augusto Ferrán,
Vaqueros Lassoing a Steer,
c. 1849; painting on canvas
mounted on board: oil;
15 ³/₈ x 18 ³/₈ in

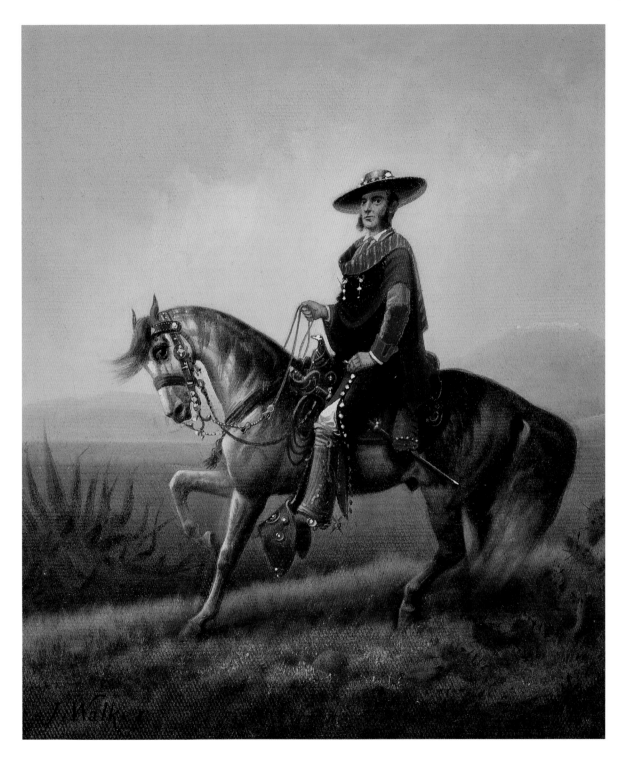

PLATE 1-7. James Walker,
Untitled (Patrón [Boss]),
c. 1849; painting on canvas:
oil; visible image: 11⅞ x 9⅝ in

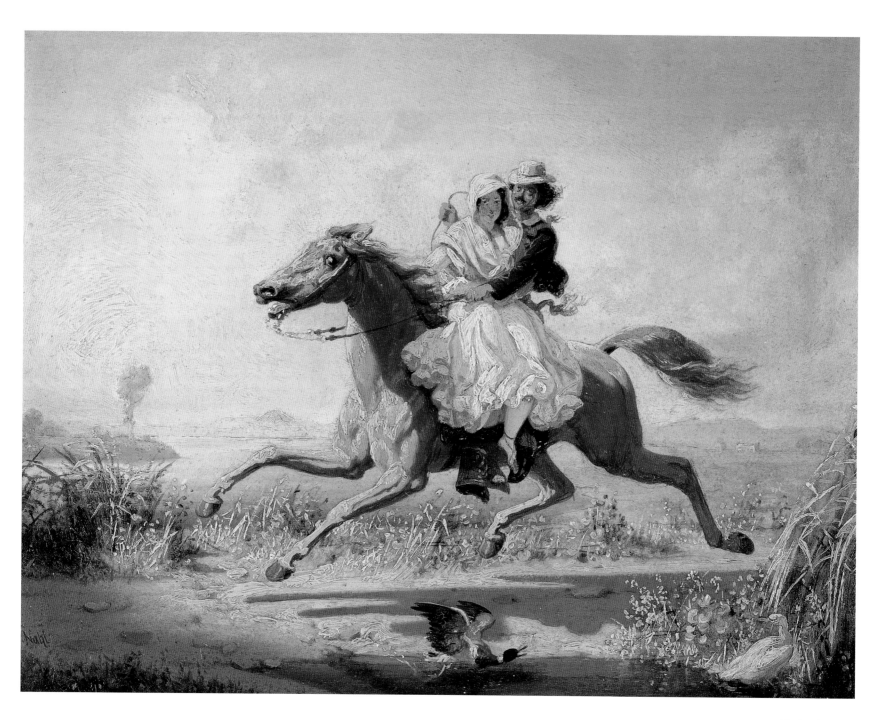

PLATE 1-8. Charles Christian
Nahl, Untitled (The Elope-
ment), c. 1875; painting on
board: oil; 9⅝ x 12⅝ in

Rugged individualism, pioneering spirit, and civilizing progress contrast and combine in Ranney's and Palmer's portraits of frontier life. Paintings such as Ranney's (Plate 1-9) dramatized not the mundane activities of trapping (in the same way that other artists would later depict mining), but the critical incident—that pivotal moment requiring decision, impelling action, when only cunning and raw courage would carry the day. In part, through the dissemination of works such as Ranney's, the westerner began to assume a respectable and increasingly formidable presence in the minds of the public, eventually superseding all other types as the true American icon.

Ranney's trapper rides a strong and handsome horse, and although he has twisted himself 180 degrees over the back of the horse, his long-barreled rifle in hand, he keeps a still and steady mount without handling the reins. Both horse and rider are alert and poised for a confrontation. The sky, an ominous shade of blue black, hangs heavily above. Behind the rider, the viewer imagines the enemy and the vulnerability of the open plain. Ahead we see tall grass and the potential for safe cover, but the trapper halts defiantly to face his enemy with this final, single shot. And just in case that's not obvious in the composition, Ranney has titled it *The Trapper's Last Shot*. The painting leaves the viewer on an uneasy dramatic precipice—will the trapper survive another day or be felled by his enemy?—but leaves no doubt as to how to interpret the subject's demeanor. His steadfast expression; his clothes, worn but strangely elegant in their soft folds; and his sturdy steed, all combine to give him the noble, heroic aspect that captured the hearts and minds of mid-nineteenth-century Americans.

"Fanny" Palmer's lithograph for Currier & Ives (Plate 1-10) is as colorful and fictitious a re-creation of frontier life as the anonymous engraving of *Habitans de la Californie* (Plate 1-5).

Educated in London, Palmer and her husband arrived in the early 1840s in New York City, where she collaborated on numerous lithographs for Currier & Ives. Her idealized depiction, produced for popular consumption, incorporates the trappings of Ranney's rugged frontiersman with the civilizing influences of home and hearth. The perfect log cabin stands in a forest clearing, a phalanx of sheaves guarding against the encroaching forest, as mother and children eagerly await the return of the buckskin-clad hunters, elegant and balletically posed in the late afternoon sun. The game is plentiful, the children happy, and the home fires are burning in this patch of paradise. This charmingly rendered fantasy assumes a certain poignancy in the light of Fanny's far-from-perfect home life—her husband was notorious for drunkenness. Even though she was successful enough for her name to appear on the prints she designed and drew on stone for Currier & Ives, she died in obscurity.

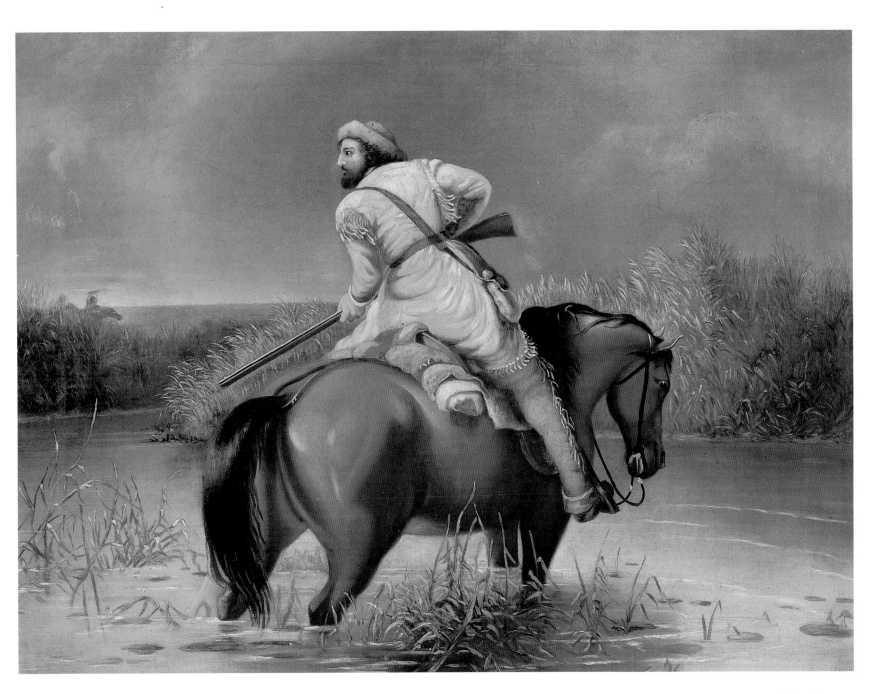

PLATE 1-9. William Tylee Ranney, *The Trapper's Last Shot*, c. 1850; painting on canvas: oil; 18⅝ x 24⅜ in

THE PLAINS INDIANS captured the imagination of the American public, alternately inspiring curiosity, admiration, and fear. Particularly after the Plains Indian population had dwindled and their way of life was verging on extinction, artists became enamored of the rich, dramatic subject matter Native Americans represented.

Carl Ferdinand Wimar and his mother emigrated to St. Louis from Cologne in 1844. Only fifteen years old, Wimar brought with him his innate talent for drawing and his fascination with American Indians, which had been fueled by the *Wildwestgeschichten* that he had read in Germany. He returned to Germany to study in Düsseldorf, and there he focused almost exclusively on Indian themes—although he'd had little direct experience with Native Americans. On his return to America, however, Wimar traveled up the Missouri River on fur company steamboats, taking his sketchbooks and a camera. He was among the last to document the Plains Indians before their forced exile onto the reservations.

In *Fleeing a Prairie Fire* (Plate 1-11), Wimar eschews a detailed rendering of the Indians, choosing instead to create a dramatic moment. Here they are silhouetted against a great blood-red arc of sky that stretches across the canvas; its glow backlights and obscures their faces. Having captured them at the very moment when the lead rider has just wheeled his terrified mount around to face the flames, Wimar creates an intense sense of immediacy.

A native of Baltimore, Maryland, Alfred Jacob Miller often worked from on-the-spot sketches, finishing them in his studio. His later paintings, of which *Sho-shoni Indians* (Plate 1-12) is one, are highly polished and carefully drawn. In this jewel-like work, Miller uses a light, delicate palette to render two Indians on horseback rushing toward a river. Less theatrical than Wimar, Miller nevertheless lends his painting a sense of drama by having the lead figure look over his shoulder, leaving us to imagine that these two are being pursued by an enemy who is just beyond our vision. Miller studied in Paris at the height of the French romantic movement; his use of color and motion recalls Eugène Delacroix.

Henry Farny's work takes a more realistic stance than either Wimar's or Miller's. In this serene work, Farny's Native Americans carry rifles and wear clothes that show the influence of their contact with the white man (Plate 1-13). Farny's regard for Native Americans stemmed from his childhood contact with a visiting Indian and his mother's concern for the Onandaigua tribe.

After having established a career as an illustrator for *Harper's Weekly*, Farny pursued a varied artistic education that led him to Rome, Venice, Munich, and Düsseldorf. There, he was mentored by the eminent landscape painter Herman Herzog (Plates 2-15 and 2-16). As is clear in this luminous rendering of a winter landscape, Herzog's lessons were not lost on Farny.

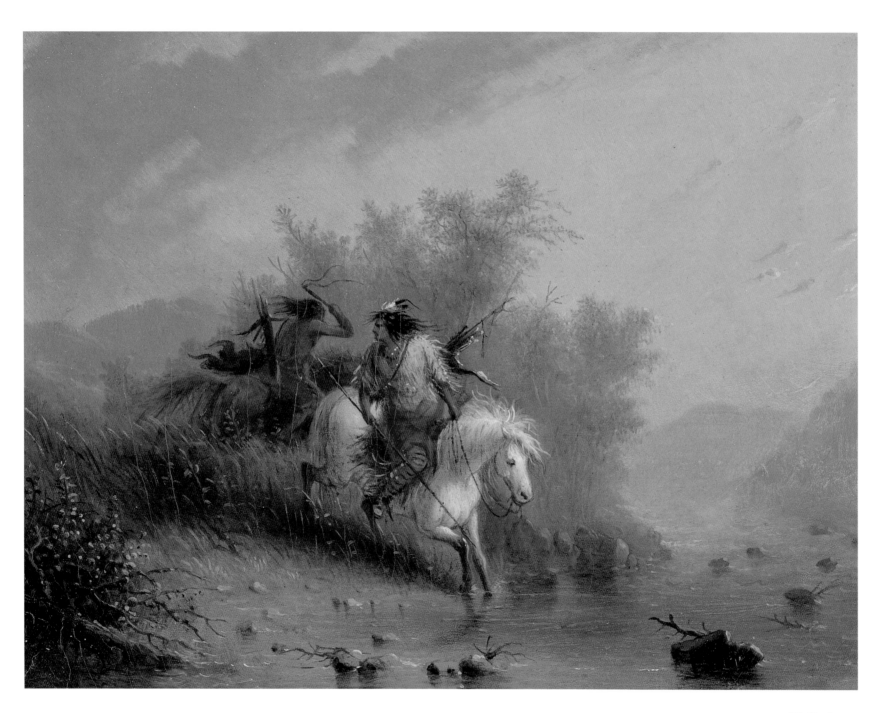

PLATE 1-12. Alfred Jacob Miller, *Sho-shoni Indians*, c. 1860s; painting on board: oil; 6⅜ x 8⅜ in

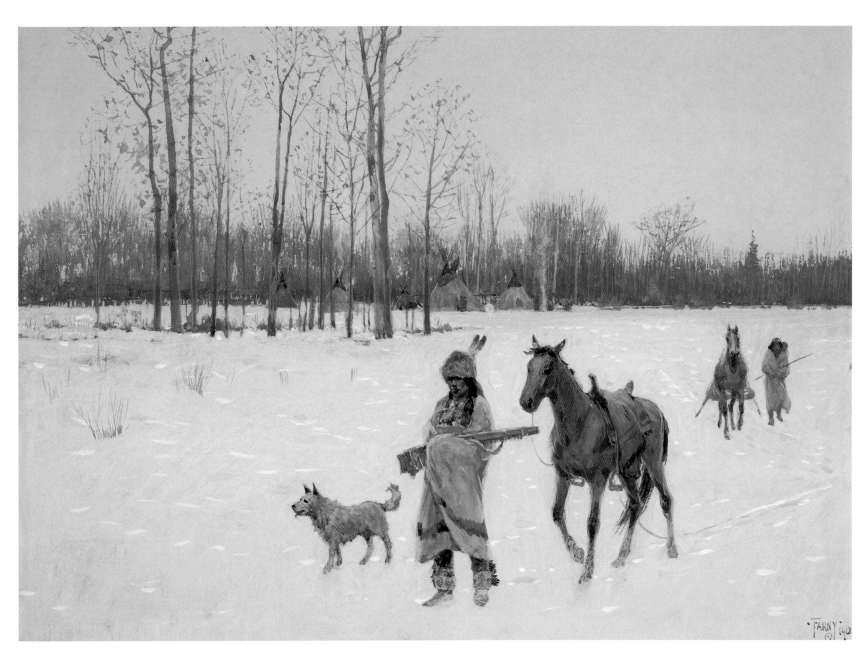

PLATE 1-13. Henry Farny,
Untitled, 1901; painting
on tinted paper: gouache;
7 x 10⅝ in

WHETHER DARLEY ACTUALLY
painted this particular canvas or not
(Plate 1-14), it remains an unusual and
sensual exposition of a popular, if
sensationalistic, genre — the abduc-
tion scene. The evidence that the dark-
haired beauty is indeed a captive is
as slender as the thin black ribbon so
decorously tied in a bow around her
delicate wrists. Three strands of her
jet-black hair blowing in the wind and
a fourth snaking down alongside her
throat, following the curve of her dress
against her breasts, emphasize the
sensuality of the painting. Her closed
eyes and the way she rests her head
against the broad bare chest of the
Indian warrior convey a dreamlike,
wistful quality. The contrast between
her dress, decidedly western, its plung-
ing neckline, decidedly suggestive, and
her decorative moccasins further
heightens the compelling ambiguity of
the painting. How did she come by
those moccasins? Had she been cap-
tured by other Indians before? Do the
shoes and dress imply she has mixed
origins? The flowing sinuous lines and
shapes accentuate the elemental
nature of this scene.

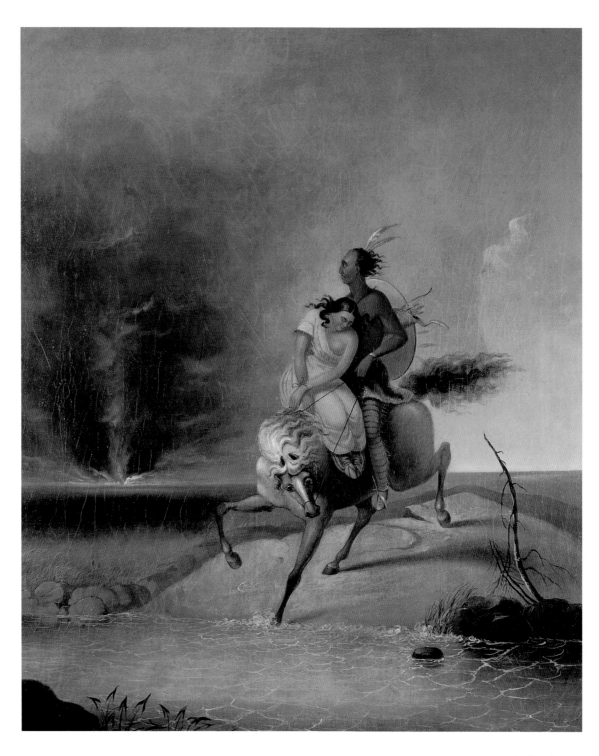

PLATE 1-14. Attributed to
Felix Octavius Carr Darley,
Untitled (Indian Captive),
c. 1880; painting on canvas:
oil; 29 x 24 in

THERE IS HARDLY ANOTHER figure in California history who has engendered as much controversy and fierce loyalty as John C. Frémont. Frémont was considered a hero for his exploration of the West: in 1842 he mapped most of the Oregon Trail, climbing the second highest peak in the Wind River Mountains, afterward known as Fremont Peak. In 1843, with Kit Carson as its guide, Frémont's party made a midwinter crossing of the Sierra Nevada. But perhaps most of all, Americans considered him the hero in the conquest of California.

On the cover of a music sheet "respectfully dedicated" to him, this handsomely groomed portrait of Colonel John C. Frémont gives the impression of trustworthiness and distinction (Plate 1-15). It was no coincidence that this music sheet appeared in 1856, the year in which Frémont was nominated as the first Republican Party candidate for the presidency. Despite Mr. Sherwin's presidential-appearing portrait and Mr. de Buena's polka, march, and schottish, Frémont lost the election to Democrat James Buchanan.

In this unusual print honoring John Sutter (Plate 1-16), four letter sheets — an illustrated type of stationery that was very popular during the 1850s and 1860s — and one likeness of Sutter are shown pinned haphazardly to a board in much the same way that postcards and notes are attached to the refrigerator door in modern kitchens. Cleverly self-referential — the publisher's name, Thompson & West, is clearly visible beside the legend, "Sutter's Mill from Painting by Chas. Nahl by permission of Julius Jacobs the present owner" — this collage-like lithograph summarizes John Sutter's early years in California. And it was a remarkable success story until the gold rush ruined him and New Helvetia, his agricultural empire, which he had named for his homeland, Switzerland. Fleeing his creditors, he had arrived in North America in 1834. About ten years later, he was the owner of some forty-eight thousand acres of land and was the "general" of his own Sutter's Fort, a formidable structure and trading post that occupied one of the most strategic positions in Northern California on the overland trails.

The lithograph traces Sutter's success and hints at the decline of his fortunes. Beneath his portrait is an image of "Sacramento City in Early Days" that coincides with Sutter's sailing up the Sacramento River. We are also shown Sutter's Fort and Sutter's Mill — now under different ownership — where Marshall discovered the gold that proved to be Sutter's undoing. An image of the flood of 1853 appears; by this time Sutter had abandoned his fort and lost his empire. From the upper right corner, Sutter gazes back in time, thoughtfully and perhaps with a trace of melancholy.

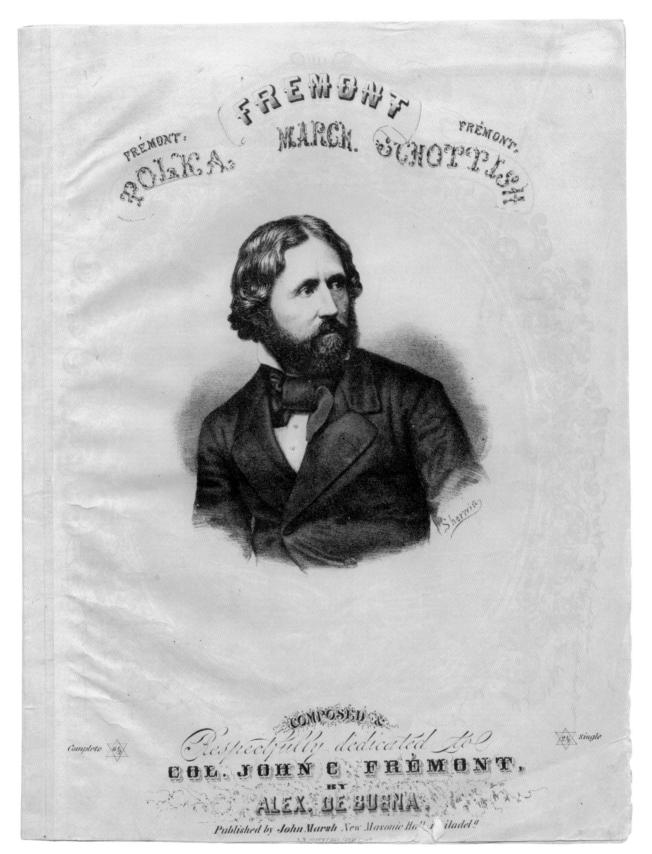

PLATE I-15. Sherwin,
artist; L. N. Rosenthal,
lithographer; published
by John Marsh, *Fremont
Polka, Fremont March,
Fremont Schottish*,
c. 1856; print on paper:
lithograph, color;
12 x 9⅞ in

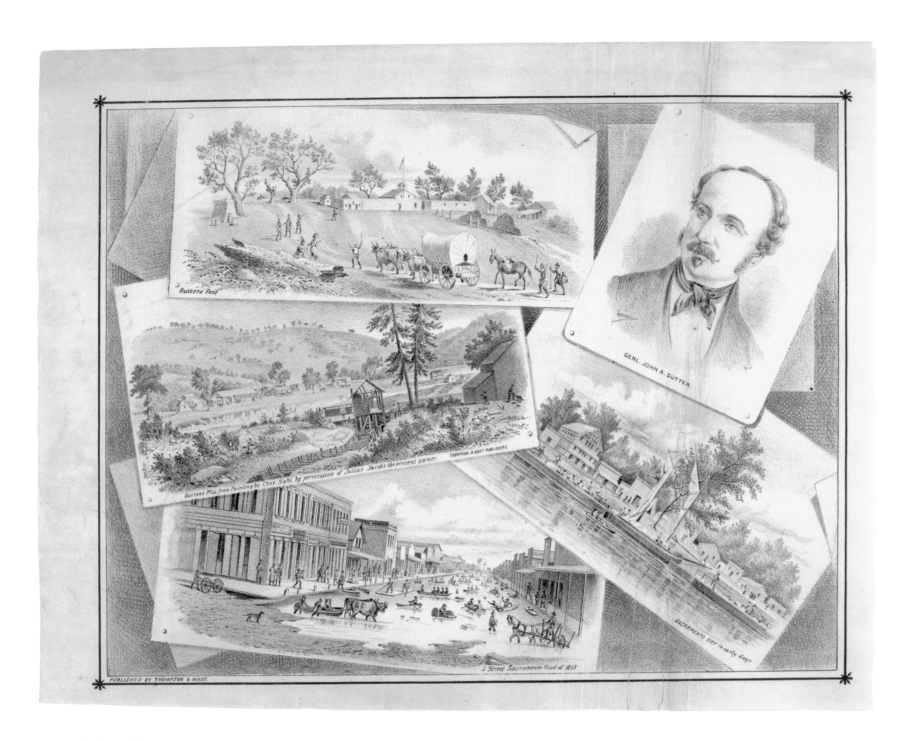

PLATE 1-16. Thompson &
West, Untitled, c. 1879;
print on paper: lithograph;
10 3/8 x 13 in

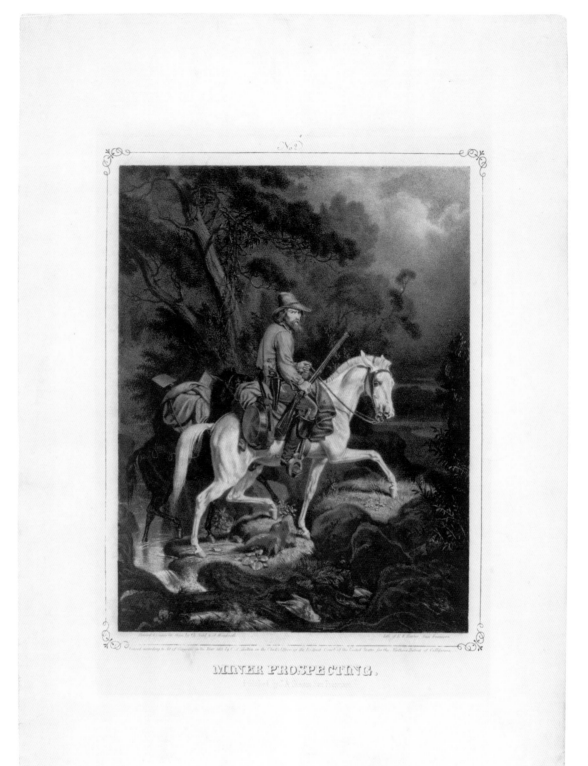

MINER PROSPECTING.

PLATE 1-17. Charles Christian Nahl and Frederick August Wenderoth, artists; B. F. Butler, lithographer; published by C. A. Shelton, *Miner Prospecting*, c. 1852; print on paper: lithograph, hand colored; 17⅞ x 12⅜ in

DEPICTIONS OF THE CALIFORNIA gold rush ran the gamut from serious oil paintings to satirical lithographs. This solitary miner, depicted here in a lithograph by Charles Nahl and Frederick August Wenderoth (Plate 1-17), was perhaps the most ubiquitous icon of his day. A horse his only companion, this miner is well-supplied and armed—ready to confront any danger. Although the details of the print are realistically and precisely rendered, the image has a stylized linearity. Nahl and Wenderoth's interpretation of the subject recalls German romanticism, with its emphasis on folk and fairy tales. The scene, with a glowering sky on the horizon, evokes the idea of a knight on a quest riding a white charger through a foreboding forest.

The result of a collaboration between José Baturone and Augusto Ferrán, *Album Californiano Colección de Tipos Observados y Dibujados por los Tres* is a series of twelve satirical views drawn in part from their experiences when the artists visited San Francisco between 1849 and 1850. Baturone's *Partidarios del sistema antiphlogistico* (Plate 1-18) refers to the scurvy prevalent among miners who were unable to secure fresh produce. Meaning anti-inflammatory, the term antiphlogistic may also reference the sometimes disparaged American Botanical Movement, which between 1830 and 1850 rebelled against bloodletting and other medical practices. It is possible that this particular scene actually takes place in Havana, where miners who had made their "pile" sometimes stopped on the way home after crossing the Isthmus. The fruit vendor's dress and appearance, and her variety of fruit, seem improbable for San Francisco.

Striking a very different note, a Hollier print (Plate 1-19) celebrates the adventures of a French character named Derville in the gold mines of California. The text below describes the action in an episodic comic-book fashion. With pistols tucked into his crimson sash, the tall, dark-haired protagonist brandishes his cutlass, an elegant boot firmly planted on the body of one of the enemies he has vanquished. The improbable attire— pirate blouse and striped pantaloons— and setting elements—palm trees, mountains, and bears all within the same landscape—place Derville firmly in the realm of the imaginary. But geographic exoticism and thrilling action surely appealed to the mid-nineteenth-century French audience for whom Derville seems tailor-made.

By the time Ernest Narjot completed his 1884 painting "Days of Gold" (Plate 1-20), mining had long since become industrialized. As the era of the forty-niner receded, he became sanitized, glorified, and romanticized in the collective memory.

Narjot, like many artists, had experience as a miner. Trained as a painter in Paris, he set out for the Mother Lode when he could not find adequate patronage for his work in San Francisco. Eventually he was able to set up a studio in that city, and he became well known for his portraiture and mining scenes.

Here, the pick and shovel strewn in the shadow beside the water bucket and the torn and faded red shirtsleeve tell a tale of toil and sweat. The wisps of tobacco smoke and the red glow of a lit pipe are part of this nostalgic vignette of three hardworking miners at ease, the two older men taking time out to perhaps share their experiences with a young lad whose cherubic, upturned profile and open-handed gesture imply a question or wish for some friendly counsel.

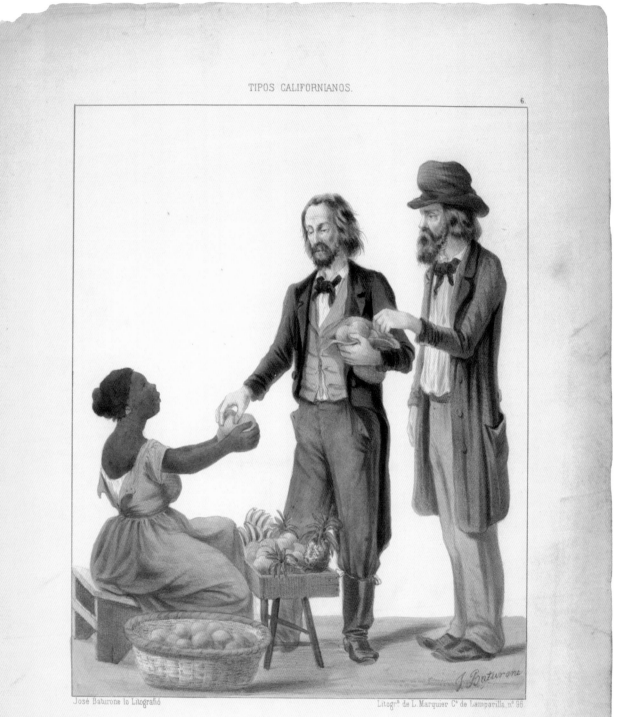

José Baturone lo Litografió

Litogrª de L. Marquier Cª de Lamparilla, nº 96

Partidarios del sistema antiflogistico. | Partisans of the antiphlogistic system.

PLATE 1-18. José Baturone, artist and lithographer; published by Luis Marquier, *Tipos Californianos: Partidarios del sistema antiphlogistico* (California Guys: Partisans of the Antiphlogistic System), 1849; print on paper: lithograph, hand colored; 14 x 10 in

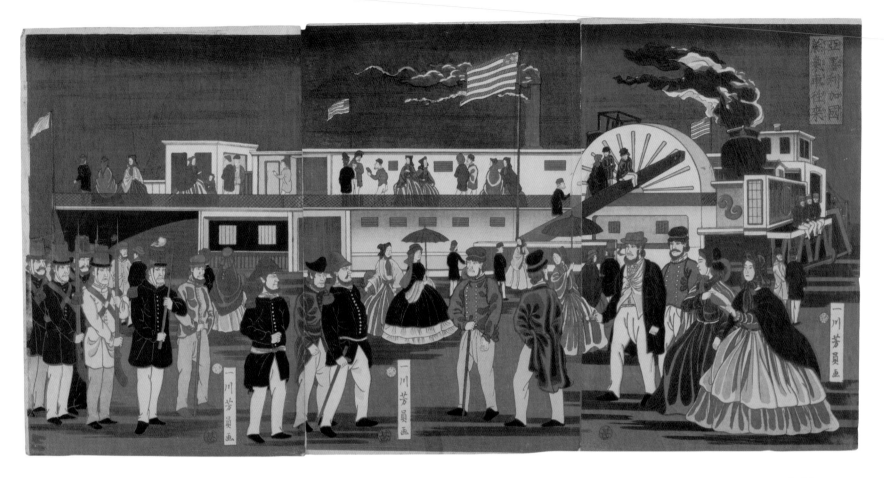

PLATE 1-21. Yoshikazu Utagawa, *Amerikakoku jokisha orai* (Steamship in an American Port), 1861; print on hosho paper: woodcut; composed of 3 sheets; 14 x 28⅞ in

Arguably one of the most interesting prints in the Honeyman Collection, this stunning triptych (Plate 1-21) is a reflection of an unparalleled period in history when, after two hundred and fifty years of isolation from western nations, Japan set upon a course of modernization. Previously unaware of the scientific and technological revolutions in the West, the Japanese were impressed and intimidated by the smoke-belching, ironclad vessels that followed in the wake of Commodore Matthew C. Perry's arrival in 1853.

Yoshikazu Utagawa's woodblock of an American ship at a dock prominently features American flags, smoking stacks, and Japanese inscriptions, with apparently Japanese people in western dress crowding the wharf and the ship. Did the artist intend to depict an actual western American scene—possibly the side-wheel steamer *California*, the first Pacific Mail steamship to arrive in San Francisco after gold was discovered? Was he simply not familiar with western physiognomy? Or perhaps Utagawa wanted to imply to his Japanese audience that this scene of western modernity and fashion was something all Japanese should aspire to.

Sex to be sure, was not for them, for, while it is said upon the best authority to have been existent in their day, it was not recognised. On one occasion they did print a picture of the "Three Graces," as represented by nude, and rather plump, ladies, but the storm of protest that arose closed that field forever.

Russell Crouse, *Mr. Currier and Mr. Ives: A Note on Their Lives and Times*

This *California Beauty* (Plate 1-22) is as pure as the driven Sierra snow, her heart as bright as the California sunshine, and her disposition as sweet as those luscious California grapes entwined in her curls. Currier & Ives conjured up the perfect embodiment of nineteenth-century youthful pulchritude to represent California's agricultural bounty. It is a charming picture, fecundity without sex, an invitation to the viewer to "come hither" — to California of course.

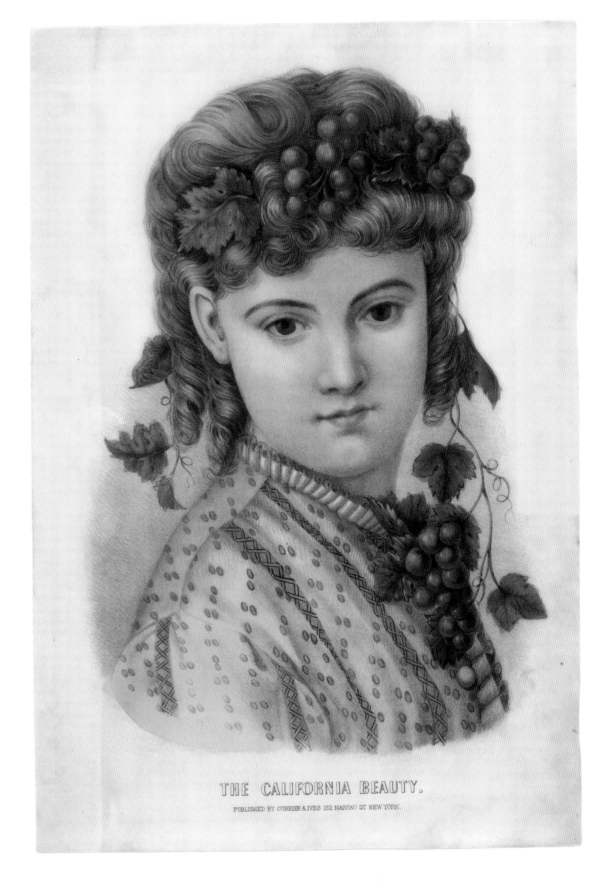

THE CALIFORNIA BEAUTY.

PUBLISHED BY CURRIER & IVES 152 NASSAU ST. NEW YORK.

PLATE 1-22. Currier & Ives, publisher, *The California Beauty*, 1800s; print on paper: lithograph, hand colored; 14 x 10 in

Chapter Two

The Land Beheld

The true owners of this continent are those who know
how to take advantage of its riches.

Alexis de Tocqueville, Journey to America

IMAGINE that, after a year or more at sea through storms and treacherous waters, you have arrived on the shores of the land named after the legendary Calafia, queen of an Amazon paradise. Rising out of the turbulent Pacific are rugged, majestic cliffs like nothing you have seen before, and beyond these shores a boundless forest. Or you are the first American artist to trek into Yosemite, where towering rock formations and dizzying waterfalls overwhelm your senses. Or perhaps you have rocked on a wagon or trudged on foot across the brutally hot, dry expanse of the Great Plains, and suddenly a snowcapped mirage of a mountain seems to have burst through the parched earth in your path. In these pages, a collective gasp is heard as artists encounter the scenery of the American West. Responses to this land are at first primal, visceral, but soon they run a predictable human course: awe is gradually displaced by understanding and familiarity, the acculturated eye tempers the primitive reaction, and the feeling of diminution is replaced by one of domination.

Beginning with the voyages of exploration and continuing into the early twentieth century, landscape images in the Honeyman Collection trace an arc from topographic to romantic, from sublime to picturesque, and from wilderness to civilization. They attest to the remarkably complicated relationship between nineteenth-century Americans and the land they inhabited, venerated, and exploited—often simultaneously—and suggest the influences at work on both artist and audience.

The Pacific coast of the American continent aroused the interests of European and American governments in the late eighteenth and nineteenth centuries, and artists would participate—unwittingly or not—in its appropriation. When George Vancouver led an English expedition to the Spanish-controlled Alta California from 1792 to 1793, it was with an eye toward British colonization. His artists, including midshipman John Sykes, carefully rendered the contours and vegetation of the "new" land, providing useful data to expedition sponsors. In his topographical sketch of the Monterey shoreline in this chapter (Plate 2-2), Sykes gave little attention to the signs of the land's inhabitants.

Midshipman Richard Brydges Beechey's stylized view of Monterey, done some thirty-five years later, contrasts with Sykes's more straightforward rendering. The country is rich, the maidens are fair, and the

cows are tame (Plate 2-3). This landscape corresponds with the report of his older brother, English expedition leader Captain Frederick William Beechey, on nearby San Francisco: "a country diversified with hill and dale, partly wooded and partly disposed in pasture lands of the richest kind, abounding in herds of cattle." In his published account Captain Beechey goes on to despair that the land has been so poorly employed:

> *In short, the only objects wanting to complete the interest of the scene are some useful establishments and comfortable residences on the grassy borders of the harbor, the absence of which creates an involuntary regret that so fine a country, abounding in all that is essential to man, should be allowed to remain in such a state of neglect.*

In keeping with his brother's message, the younger Beechey's work may have telegraphed a welcoming message to British administrators, providing an ideal tableau onto which they could project their own desires and schemes.

Developers and entrepreneurs would not neglect this land for long, although not all areas were as hospitable as Beechey's Monterey. Areas that defied settlement, however, lent themselves to other opportunities, such as tourism—both actual and armchair. Ruggedness often went hand in hand with drama, as Thomas Ayres's hauntingly beautiful image of Yosemite illustrates (Plate 2-5). With the idea of publishing an illustrated magazine of California that would build the tourist trade, entrepreneur James Hutchings hired Ayres in 1855 to accompany him into the valley and depict the sights of this newly discovered natural phenomenon. The Hutchings-Ayres expedition resulted in the first published pictorial record of Yosemite. In the example appearing in this chapter (Plate 2-6), the severe contrast in scale between human and rock formation would certainly have captivated potential readers. We note that the figures, as tiny as they are, are drawn in detail—one can make out the hooves on the horses—whereas Ayres has barely limned the cliffs above. Chimeric against the foreground of human spectators, they seem almost too grand, too impossible for the artist's hand. Here we are witness to the sublime, as defined by eighteenth-century philosophers Immanuel Kant and Edmund Burke: that which inspires awe and fear.

In the decades after Ayres, the "big guns" took on Yosemite—artists such as Albert Bierstadt, Thomas Hill, and William Keith. Having studied in the European art capitals of Düsseldorf and Paris, they show a sophisticated mastery of technique and composition. These men were no doubt conversant with the prevailing philosophical currents of the day, including the central nineteenth-century question of the relationship between nature and God. The influential Hudson River School artists Thomas Cole and Asher B. Durand, among others, had consecrated the landscape as a place for meditating on (and ultimately representing) God's truths. In Cole's 1835 essay "American Scenery," he wrote, "in gazing on the pure creations of the Almighty, [a man] feels a calm religious tone steal through his mind." In this vein, the "sublime" transmuted into a more serene, divine state, and it began to combine with the "beautiful," a word

applied to sights that gave pleasure rather than pause. Cole describes one mountainous landscape as the "sublime melting into the beautiful." A gentler version of sublimity, what was termed the "picturesque," blended the drama of the sublime with the softer lines of the beautiful. In works by Keith (Plate 2-8) and John Ross Key (Plate 2-14), we see jagged edges of cliffs blurred and smoothed over, or rougher, asymmetrical trees juxtaposed with curving forms.

The proper way to convey the "truth" of the American landscape was a matter of some controversy. While Durand had urged artists "not to transcribe . . . [nature] 'verbatim ad literature'" but to use their interpretive skills, and a European critic praised Albert Bierstadt for not being a "mere copyist of nature," American writers attacked Bierstadt for his "inaccuracies." Speaking of *Storm in the Rocky Mountains—Mt. Rosalie, 1866* (Plate 2-10), one critic opined that the artist had not preserved "or even sought to retain, those individual details which make up the truth of nature . . . the whole science of geology cries out against him." Hotly contested, Bierstadt's manipulations must have unnerved some Americans. In a country with little cultural past, many equated American history with natural history: the extraordinary living resources and geological possibilities of the New World were central to the American identity. In this light, accuracy or, more importantly, the illusion of accuracy, trumped artistic aspirations. Imaginative alterations, however, did not seem to bother many of the patrons at the time. Bierstadt enjoyed great popularity in the 1860s; *Lander's Peak*, the precursor to

Storm in the Rocky Mountains, sold for the unheard-of sum of $25,000.

Cole suggested that a "love of scenery" was a cure to the "asperities" of the American way of life: "toiling to produce more toil — accumulating in order to aggrandize." But it was just such accumulators who were the primary patrons of western landscape painters. The often-oversized compositions helped fill the grand walls of the mansions of businessmen, who were not above putting in their two cents and meddling with art as well as reality. Hill suffered at the hands of railroad baron Leland Stanford, for instance, who commissioned him to record the joining of the rails of the transcontinental railway at Promontory Point. Stanford added and subtracted people from the painting, depending on whom he favored at the moment, and he put himself in the center of the composition when it was actually Charles Crocker who had stood there. These patrons also influenced the imagery of the West in more insidious ways. Interested in promoting investment and settlement, they encouraged the creation of works advertising the grandeur and limitless resources of this land, as well as images that reconciled natural beauty with development and technology.

Given the biases of the people buying these paintings, artists avoided portraying the ugly effects of development such as mining, lumbering, agribusiness, or railroading. Thus we observe with interest the signs of deforestation attendant to the gold rush in Alburtus Del Orient Browere's 1857 masterwork depicting Mokelumne Hill (Plate 2-18). Although this painting indicates that the wilderness is disappearing, we sense

in its tone neither alarm nor melancholy. Numerous published testimonials indicate that the picture of western expansion and development was not always unwelcome. As if to answer Beechey's regret about the "neglected" land, one emigrant guide, published the same year as Browere's painting, takes emphatic pride in the improvements made by settlers:

> The former wild prairie, now a cultivated farm; the float-ing palaces upon the bosom of the river which but a little while ago rolled on undisturbed in its lonely beauty; the churches and school-houses that now stand where stood a few summers since the Indian's wigwam . . . are these not proofs enough that we are justified in boasting of what we have accomplished?

Numerous painters admitted the signs of civiliza-tion—churches and schoolhouses—into their land-scapes, and the results usually signaled harmony between nature and humans. A fine example is Her-man Herzog's view of a Southern California valley (Plate 2-16), in which a handful of buildings are nestled between mountain and stream beyond a screen of dense foliage. Given the rapid pace of settlement at the time, one can easily imagine a reversal in perspective—the hamlet in the middle ground will undoubtedly spread toward and overtake the vegetation of the fore-ground. Two works attributed to Augusto Ferrán (Plates 2-20 and 2-21) show an even more marked transition from rural to urban perspective. Both of these works are views of San Francisco in 1850, although one offers a tranquil, pastoral vision on one side of the harbor and the other shows the numerous buildings and ships of a busy port.

The intense campaign of development and its concomitant natural devastation coincided with a flurry of landscape painting in America. Already in 1835, Cole despaired over the disappearance of the wilderness, the very wilderness that made America unique, in his estimation:

> I cannot but express my sorrow that the beauty of such landscapes [is] quickly passing away—the ravages of the axe are daily increasing—the most notable scenes are made desolate, and oftentimes with a wantonness and barbarism scarcely credible in a civilized nation.

But Cole was fatalistic about the course of progress, as he continued, "This is a regret rather than a com-plaint; such is the road society has to travel." In the early 1830s, Alexis de Tocqueville put a more positive spin on the paradox of the concurrent pursuits of beauty and advancement:

> It is this consciousness of destruction, this arrière-pensée of quick and inevitable change that gives, we feel, so peculiar a character and such a touching beauty to the solitudes of America. One sees them with a melancholy pleasure; one is in some sort of a hurry to admire them. Thoughts of the savage, natural grandeur that is going to come to an end become mingled with splendid anticipations of the tri-umphant march of civilization.

Tocqueville describes a kind of aesthetic of loss—an anticipatory nostalgia. Many artists were, like Cole, aware that civilization was quickly casting shadows on their canvases, which may explain in part why so many images were made of Yosemite, for example, in a des-perate attempt to capture this artistic Brigadoon.

Ironically, artists may have abetted the demise of the very thing they sought to immortalize. Although they did not wield the ravaging axe, they did help to mold

the western landscape in the public mind. This was a public still suffering from an inferiority complex about Europe, hungering for affirmation of America's greatness. With the arrival of European-trained artists, the western wilderness took on the veneer of centuries of artistic and cultural traditions. These renderings presented the West's natural riches as both grand and familiar; they visually civilized the land, making it safe for human incursion. Thus the primary responses of Ayres—his stark, slightly fearsome views of nature's formidable sculptures—inevitably gave way to a more refined, benign view of the American West.

Nonetheless, the artists represented here all seem to share an appreciation of the land and a sincere desire to do it justice. In their contours and details, contrasts and hues, these works evince an abiding faith in nature's ability to redeem the human soul, and an acknowledgment of the privilege of standing witness to its beauty and magnitude. ❧

Langsdorff's small, delicate drawing (Plate 2-1) is possibly the earliest known view of San Francisco and the Presidio. It formed part of a sketchbook of thirty-seven original drawings that were refined for Langsdorff's book *Voyages and Travels in Various Parts of the World During the Years 1803, 1804, 1805, 1806, and 1807*. This view was sketched from the ship *Juno*, an American trading ship that Russian expedition leader Nikolai Petrovich Rezanov purchased in Sitka, Alaska, and sailed to Northern California in an effort to find food and other supplies for the starving Alaskan colony. When the Russians arrived in "new" California, the ranking Spanish official, Governor José Joaquín de Arrillaga, was willing to feed them but not to supply their colonies. Rezanov hatched a scheme to ingratiate himself to his hosts: he proposed marriage to the fifteen-year-old daughter of José Argüello, commandant of the Presidio. The wedding never took place — Rezanov died before he could return to claim his bride, and legend has it that she waited for him for thirty-five years until the news of his death finally reached her.

Langsdorff's landscape is particularly intriguing in our retrospective context. He gives prominence through detail and definition to the Native Americans paddling a small boat in the foreground, while a mere smattering of softly outlined buildings foreshadows the great city that will consume this land and decimate its indigenous population. Two small, indistinct figures stand close to each other on the shore, face to face, like lovers. The romantic turn of Rezanov's pilgrimage to California inflects this odd detail with intriguing speculative potential.

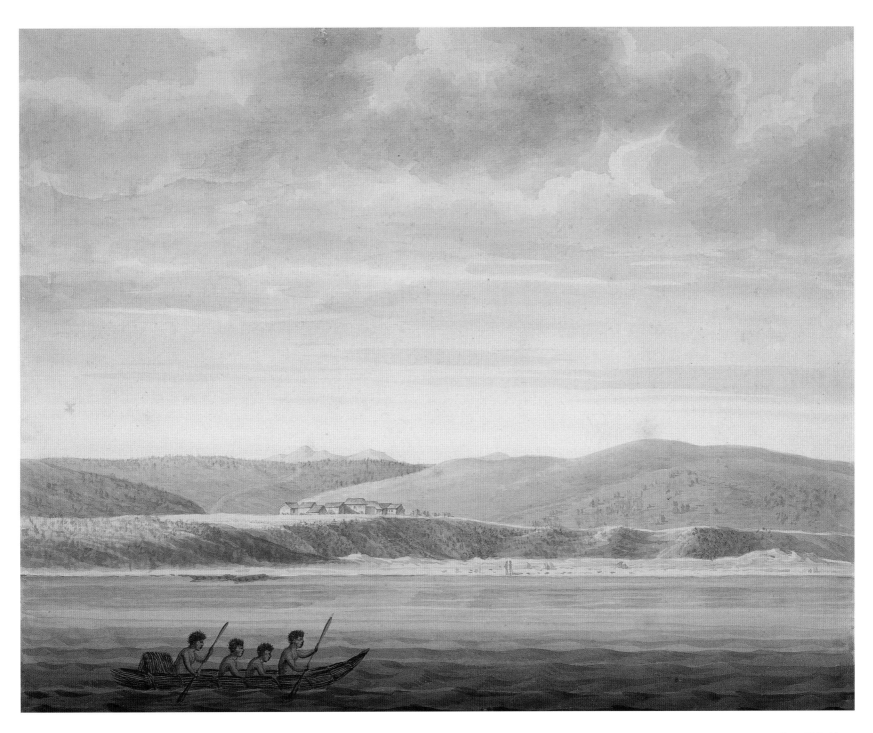

PLATE 2-1. Georg Heinrich von Langsdorff, *Ansicht des Spanischen Etablissements von St. Francisco in Neu-Californien* (View of the Spanish Establishment of St. Francisco in New California), c. 1806; drawing on paper: ink and wash; 8 x 10¹³/₁₆ in

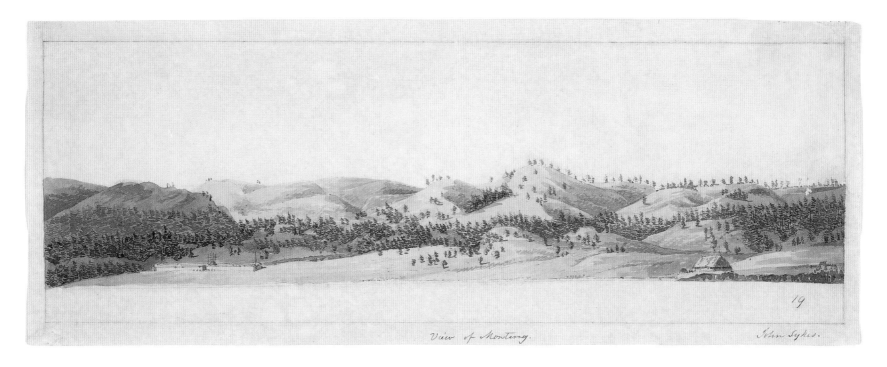

View of Monterey.　　John Sykes.

PLATE 2-2. John Sykes, *View of Monterrey* [sic], c. 1791–95; drawing on paper: watercolor; 5 5/16 x 14 in

Two views of Monterey give us delightfully different perspectives of this early and significant California port. There is something supremely elegant about John Sykes's tinted, elongated drawing (Plate 2-2). It conveys the type of information—the lay of the land, vegetation—that one would expect of a topographical artist. Yet it evokes a feeling of serenity and timelessness—as though the gentle contours of this landscape are immutable. This drawing is part of a group of sixty-five in the Honeyman Collection, most of which are attributed to Sykes, all from the Vancouver Expedition.

The designation "artist" was something of a misnomer as far as John Sykes was concerned; he was first and foremost a navy lifer. He joined the Royal Navy in 1783 at the age of ten and remained in service until he died at the rank of admiral in 1853. This drawing was made between 1791 and 1795, when he served as midshipman under English explorer George Vancouver.

Richard Beechey was only seventeen years old when he made his rendering of Monterey (Plate 2-3). Since he was raised in an artistic family—both his father and his brother, Captain Frederick Beechey of the HMS *Blossom*, were artists—it is not surprising that he could devise such a classically pastoral scene. It follows the Claudian formula, named after seventeenth-century artist Claude Lorraine: foreground, middle ground, and background registers articulate the space, and trees frame the edges.

By 1827 an increasingly large number of settlers had been pouring into California—Mexicans attracted by the rich soil; trappers and hunters who had appeared from east of the Sierra Nevada; Russians from Russian America; sailors and adventurers of all nationalities who had escaped from merchant ships or who had been left

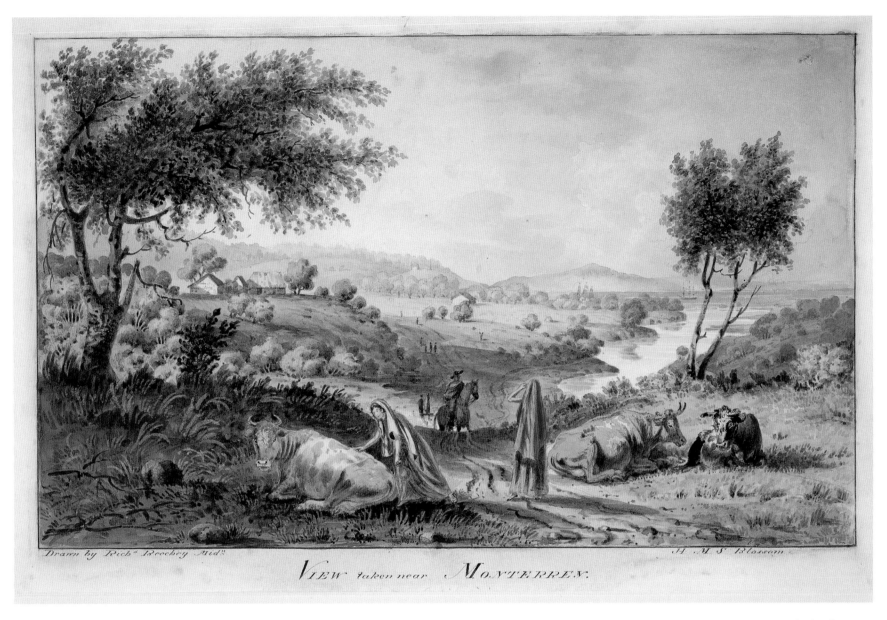

Drawn by Richᵈ Beechey Midᵖ H. M. S. Blossom

VIEW taken near MONTERREY:

PLATE 2-3. Richard Brydges
Beechey, Untitled (View
Taken near Monterrey [sic]),
c. 1826–27; painting on paper:
watercolor and pencil; 11 x 17 in

behind at their own request; and, occasionally, a citizen of the eastern states, more venturous than his neighbors.

The capital of California in 1770, Monterey played an important role as a strategic port city for Mexico. But none of this is reflected in Beechey's watercolor, which conjures up a sort of "Peaceable Kingdom" where lovely señoritas tend the cattle and await the approach of a vaquero, and the river flows slowly through a verdant landscape toward the bay. The faint outlines of two sailing ships appear in the distance; one may have been the *Blossom*, on which Beechey served as midshipman. This picture was likely made when the expedition was in Monterey from January 1 to 15, 1827, and again from October to December 1827.

In McMurtrie's painting (Plate 2-4), possibly of Angel Island, we experience the immediacy of the roiling sea from which the artist observed this land mass in San Francisco Bay. The rendering emphasizes two-dimensionality to the extent that the island seems to emerge out of the water directly in the path of the oncoming boat. In fact, catastrophes in the San Francisco Bay led the U.S. government to commission a survey of the Pacific coast in the 1850s, and McMurtrie was one of the topographical artists who served aboard these vessels.

McMurtrie was originally from a prominent family in Philadelphia. He may have studied with the painter and engraver William Russell Birch, for whom he was named. After moving to Washington, D.C., he secured a post with the U.S. Coast Survey. Although he suffered from severe rheumatism, he traveled from New York to California and extensively along the Pacific coast on the schooner *Ewing*, making a large number of drawings and watercolors. The Honeyman Collection contains one hundred of these works.

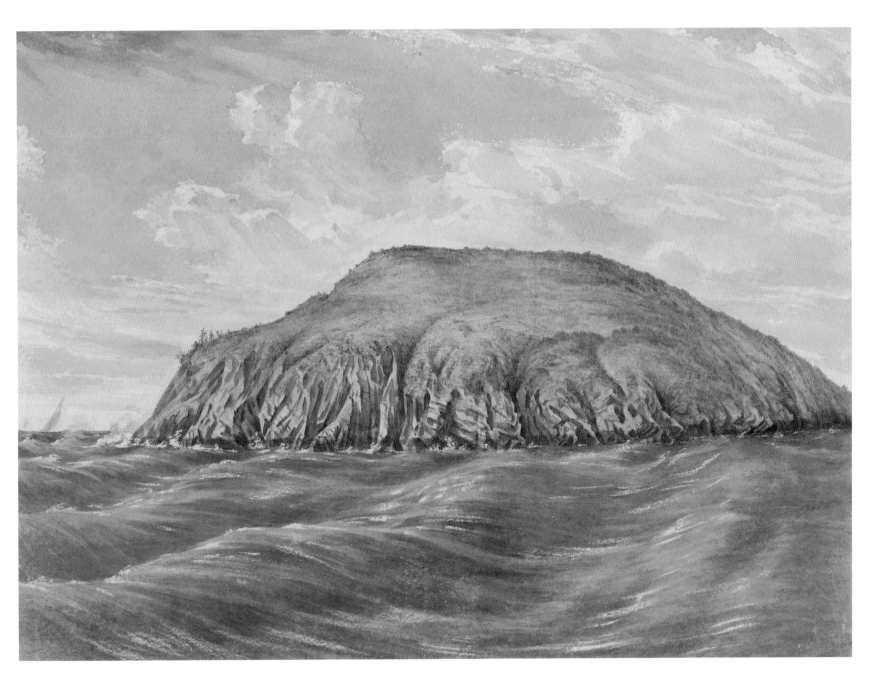

PLATE 2-4. William Birch McMurtrie, Untitled (Angel Island), c. 1850s; painting on paper: watercolor; 9 x 13 in

THOMAS AYRES WAS BORN IN New Jersey and moved to Wisconsin as a young adult. A draftsman there, he started painting in oils and watercolors. He sailed to San Francisco in 1849 when gold was discovered in California. Unsuccessful as an argonaut, Ayres found, as a number of other artists did, that his brushes and paints were more lucrative than a shovel and pick. Starting in Tuttletown Camp, Ayres sketched from 1850 to 1854 throughout California, concentrating primarily on the mining towns and rugged landscape.

Ayres's perspective in this portrait of a mining camp (Plate 2-5) is uncharacteristic of that of artists at the time. Sublime, perilously grand sights such as these were usually treated at a safe distance. In *Sunrise at Camp Lonely*, Ayres's vantage point does not afford safety; on either side of the river, the mountains rise precipitously, leaving the viewer trapped between the unassailable rock faces. The tiny tent in the shallow foreground space seems to be pitched dangerously close to the river, which flows rapidly toward it. Ayres's preferred medium — black charcoal on commercially available paperboard coated with a layer of sand — further heightens the impact of this dramatic and imposing scene.

In a cruel twist of irony, Ayres died at sea when the "reliable" *Laura Bevin* sank in 1858; the ship on which he had originally booked and then canceled his passage, deeming it unseaworthy, arrived in port without incident.

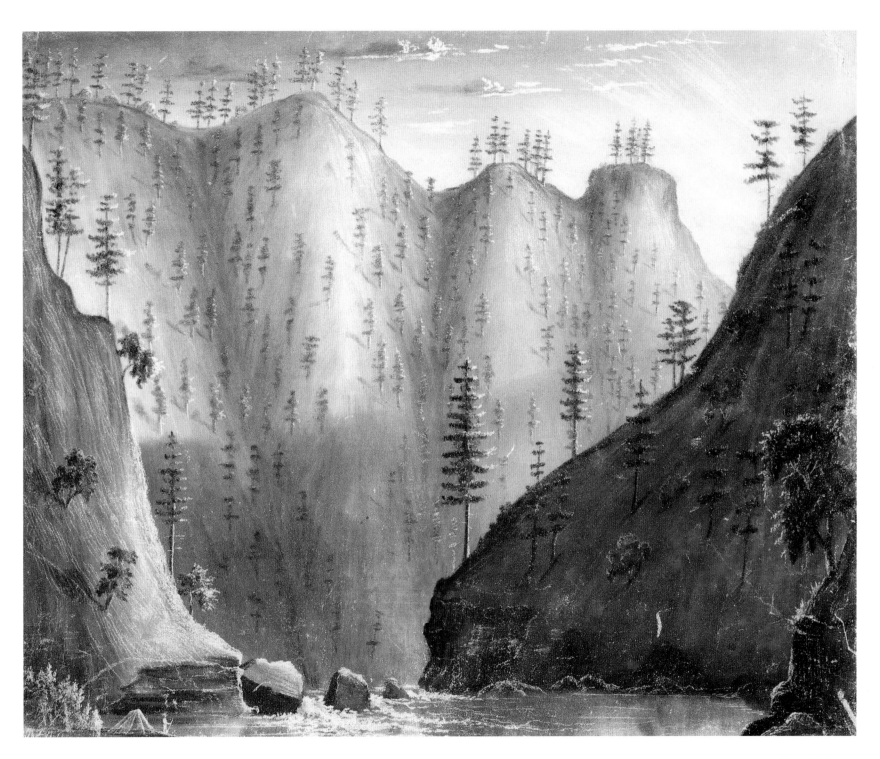

PLATE 2-5. Thomas A. Ayres,
Sunrise at Camp Lonely, c. 1850;
drawing on fine sandpaper:
charcoal; 7 x 10⁵/₁₆ in

From its discovery to the present day, Yosemite has inspired a multitude of artists. In 1855 James Hutchings employed Ayres to make the first views of the recently discovered wonder for his new publication, *Hutchings' Illustrated California Magazine.* The results were nothing short of spectacular. Ayres made thirteen views during his historic five-day stay in Yosemite, completing most of them in the field. The sketchlike quality of this work (Plate 2-6) indicates that the artist responded to the colossal walls and phenomenal waterfalls in a spontaneous and visceral manner. Hutchings published these works as woodcut engravings, enticing scores of artists and visitors to follow the trail he and Ayres had blazed.

Washington F. Friend's watercolor sketch of Yosemite (Plate 2-7) may have been completed on his three-year, five-thousand-mile sketching tour of the United States and Canada, from which he created a giant panorama. Appearing in several cities, the completed multimedia exhibition included a musical component (Friend singing folk songs), a thirty-two-page pamphlet with engravings, and original sketches for sale.

In this work the artist indicates monumentality with scale—the immense rock face that dwarfs the trees and figures at the water's edge. The thin sliver of sky and elongated composition stress the height of the falls; and yet the warm glow of autumnal colors, the soft reflections in the calm water, and the evidence of an indigenous encampment all contrive to palliate the raw power of the scene.

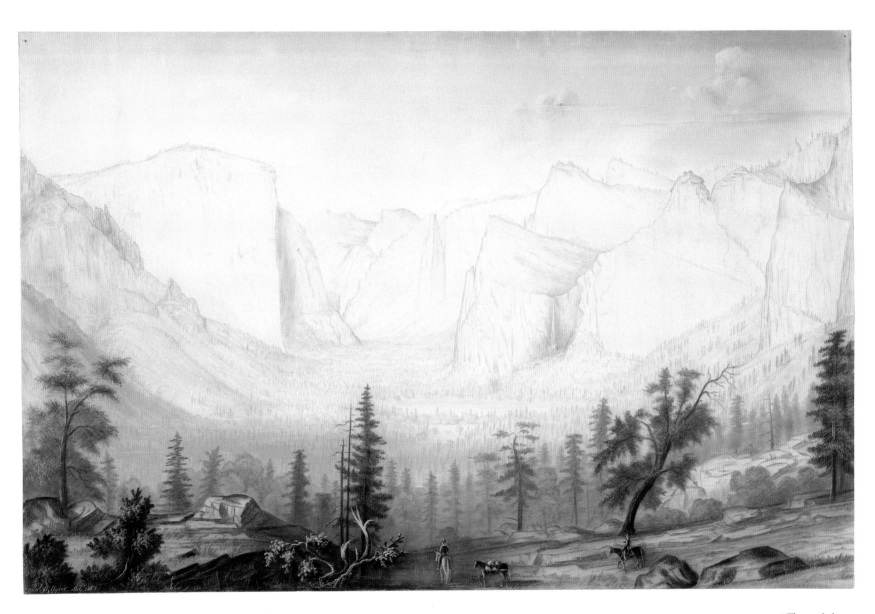

PLATE 2-6. Thomas A. Ayres, *Valley of the Yosemite at Source of Middle Fork of Merced River, California*, 1855; drawing on sandpaper: chalk and charcoal; 13 x 20 in

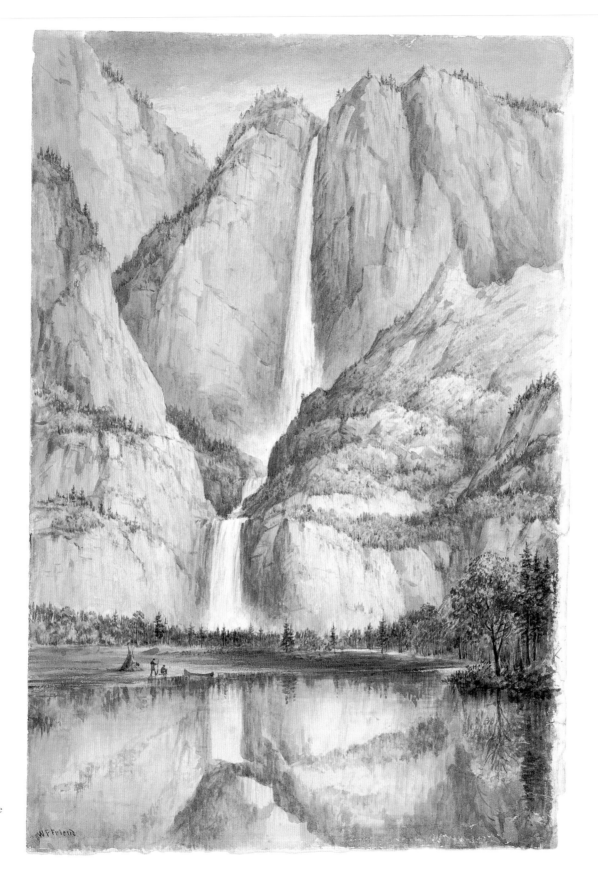

PLATE 2-7. Washington F.
Friend, Untitled (Yosemite
Falls, Autumn), c. 1855;
painting on paper:
watercolor; 15 x 11 in

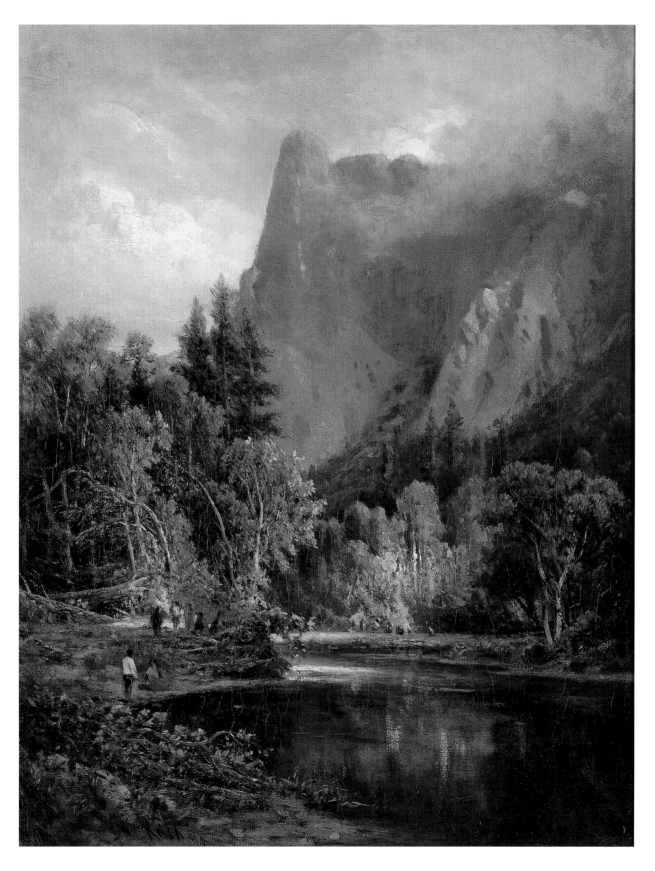

PLATE 2-8. William Keith, *Sentinel Rock, Yosemite*, 1872; painting on canvas: oil; 18 x 14 in

Two of the best-known painters drawn to the majestic vistas of Yosemite were William Keith and Thomas Hill. The highly accomplished European-trained artists were friends and often went together on painting expeditions to the valley. Although Keith achieved greater prominence—ultimately considered one of the most important painters to emerge from California—he owed a debt to Hill, who had a significant influence on the younger artist.

As illustrated by his painting of Sentinel Rock (Plate 2-8), Keith embodied a complex blend of European influences, spirituality, and science. He was born in Scotland but emigrated to New York in 1851 at the age of thirteen. Eight years later he traveled to San Francisco and took up landscape painting while earning a living as a wood engraver. In 1869 he returned to Europe to further his art training, but he resisted the academic formalism prevalent in Düsseldorf.

Instead, he found an affinity with the Barbizon School of painting, concerned with recording unadorned nature and the reality of a specific place and time, but with less emphasis on individual details and more on broad, animated brushwork. Like the Barbizon painters, he also subscribed to the inherent spirituality of nature. Keith's *Sentinel Rock* combines these ideas and techniques. He conjoins animated and somewhat loose brushwork with precise detail: the fallen branches are well defined, and individual trees are articulated. Curving trunks and blurred trees convey the sensation of wind and movement. The white-shirted figure in the middle ground as well as the highlights in the water draw the eye into the painting toward the source of the light and up the mountain. While the features of the distant Sentinel Rock are broadly indicated, its overall shape is specific and recognizable. Underscoring the immensity of the rock face, two diminutive groups of what appear to be Native Americans blend harmoniously with the colors of the foliage around them, suggesting a tranquil coexistence with nature.

Over the span of his career, Hill painted more than five thousand Yosemite scenes; this painting (Plate 2-9) is one of the later examples. Here, he has built up the canvas with broad brush strokes to create the rugged, rough surfaces of the mountainous terrain. Above all, this painting is a testimony to Hill's special genius for color. His gradations of greens, browns, and grays and his highlights in hues of pink define the landscape. And in spite of his painterly approach and loose brushwork, Hill gives us an identifiable view. He captures the formidable El Capitan and the snow-covered peaks in the distance, all of which evoke the beauty, power, and purity of nature. One can almost breathe in the high, clean mountain air and the tranquil spirit of the place.

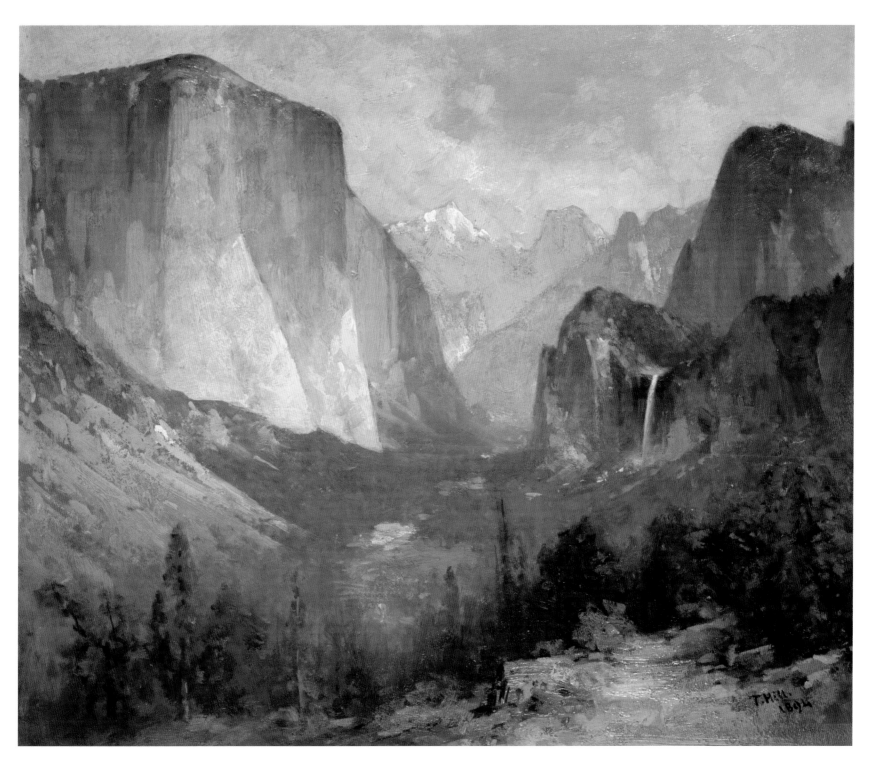

PLATE 2-9. Thomas Hill,
Untitled (El Capitan,
Yosemite, California), 1894;
painting on canvas: oil;
18 x 22 in

ALBERT BIERSTADT'S FIRST trip west with the Lander Expedition in 1859 resulted in a painting that would establish his reputation as a preeminent painter of the American West. An English railroad entrepreneur snatched up *The Rocky Mountains, Lander's Peak* for $25,000, a sizeable sum, and one of his associates expressed a desire for a similar canvas. With this directive, Bierstadt set off on an artistic journey that culminated in the dramatic *Storm in the Rocky Mountains—Mt. Rosalie* (Plate 2-10).

Bierstadt was in the Rockies with writer Fitz Hugh Ludlow and editor William N. Byers in 1863 when he encountered the vista that so entranced him. A storm was in fact brewing as the artist made his color study; low clouds rolled over the mountains and hail fell from the sky, while streaks of sunlight pierced through the cover, according to Byers's account.

Mt. Rosalie had important personal associations for Bierstadt. He took it upon himself to christen the peak Monte Rosa after Ludlow's wife. Three years later, Bierstadt married

Rosalie after Ludlow granted her a divorce. On the public stage, Bierstadt received mixed reviews for the painting: One critic proclaimed that the work was "the best production of American genius," while another called it a "subject much beyond his powers."

Bierstadt's uneasy relationship with art critics persisted for most of his career, although his work remained popular into the 1870s. A brilliant self-promoter, Bierstadt took for inspiration the moving panoramas and dioramas popular in his day and displayed giant canvases such as this one in special darkened rooms with lighting effects heightening the drama of the paintings. Audiences who paid to see the spectacle were also treated to explanatory pamphlets as well as advertisements for reproductions. Many of Bierstadt's works were reproduced as highly successful lithographs. This chromolithograph of Mt. Rosalie may have been one of those issued in London in 1869.

Bierstadt experienced both extraordinary success and utter devastation in his long career. From his humble

beginning as the son of a German cooper who emigrated to New Bedford in 1832, at the height of his career Bierstadt built a mansion on the Hudson. The Düsseldorf-trained artist failed to keep step with the progress of artistic currents in America, however, and his works were considered "old school" by the 1880s. His rags-to-riches story came full circle when his works began to plummet in value, at the same time that fire destroyed his home in 1882. He lost his wife in 1893, and by 1895 he was bankrupt.

In Bierstadt's lexicon of grandiosity, one entry depicting Lake Tahoe (Plate 2-11) is quite demure. It contains certain signature effects, such as atmospheric drama, but the work measures in inches instead of feet. Soft lines, rather than meticulous detailing, mark the presence of mountains, and muted green forms indicate the presence of trees. Likely an oil sketch, this painting gives us a rare and intimate glimpse into Bierstadt's process—a kind of backstage visit with the great theatrical artist.

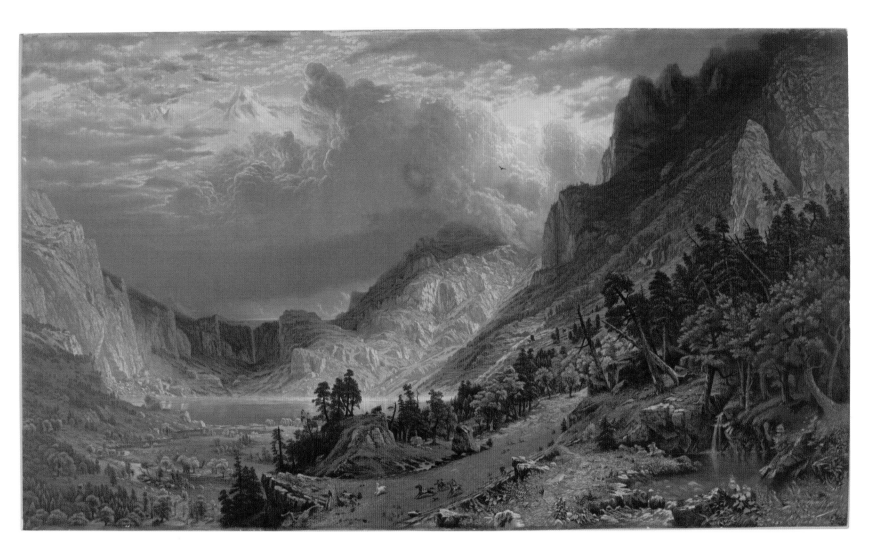

PLATE 2-10. Albert Bierstadt, artist; M. Long, lithographer, *Storm in the Rocky Mountains— Mount Rosalie*, 1866, not before 1866; print on paper mounted on board: lithograph, color; 18 7/8 x 32 in

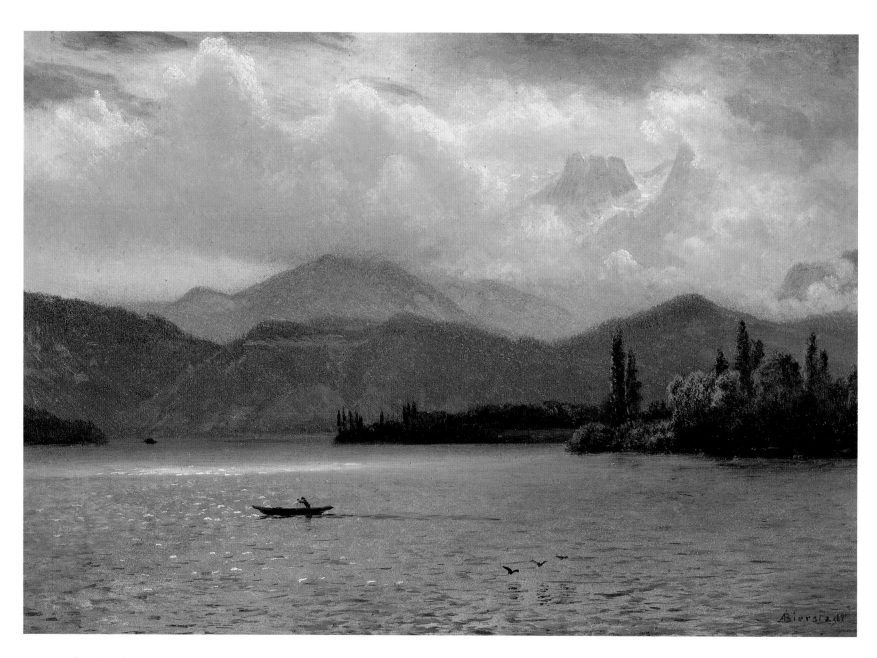

PLATE 2-11. Albert Bierstadt,
Lake Tahoe, California, 1863;
painting on canvas: oil;
14 x 19 in

GEORGE BURGESS, SON OF A prominent British surgeon, arrived in San Francisco with his brother Hubert in 1850; like many, they came for gold. Trained at the Somerset School of Design in London, Burgess worked as a lithographer for Britton & Rey before trying his hand in the gold-fields. It is doubtful that he and his brother found the fortune they were seeking, but they were able to open a jewelry and watch-repair store in San Francisco. Burgess continued to work as an artist and lithographer and became a founding member of the San Francisco Art Association.

This modest painting (Plate 2-12) speaks softly and eloquently of Burgess's life, his love of the outdoors and hunting small game. Unspoiled by human hands, this contemplative scene may have appealed to the very people who muddied the water in the quest for gold.

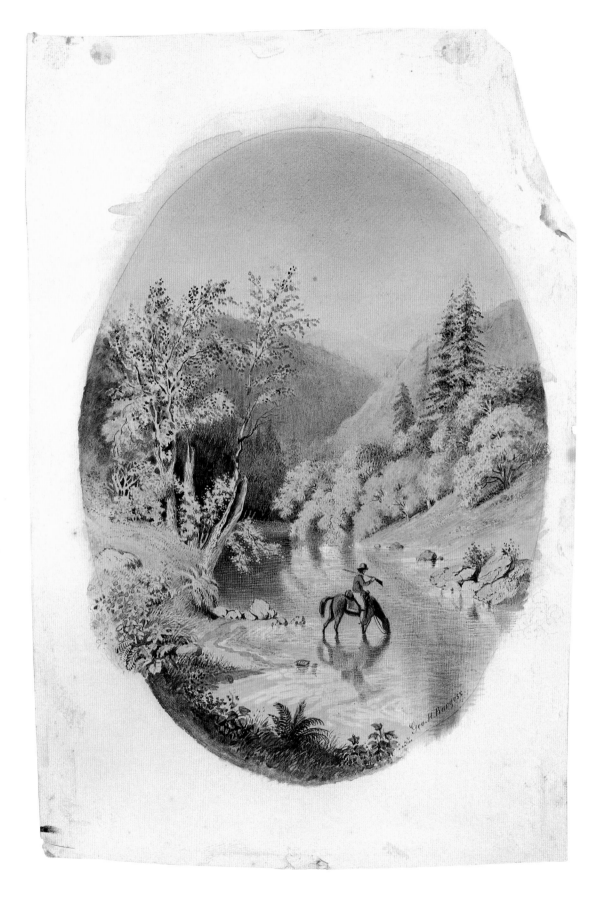

PLATE 2-12. George Henry Burgess, Untitled, 1800s; painting on paper mounted on board: watercolor; 6 x 4 in

In this work (Plate 2-13), Thomas Hill effectively transported the Hudson River style and aesthetic to the Stanislaus River. He placed himself in the scene—he is barely visible in the lower left corner of the image. From this perch, the artist, and by implication the viewer, is suspended precipitously above the scene. Only the small buildings, the winding path, and the ferry itself offset the spectacular topography, bringing the viewer gently back to earth. Human-made structures such as this ferry represent the first signs of civilization. Byrnes Ferry carried prospectors and supplies to the gold mining encampments along the rivers, bringing with them the potential for commerce. Hill has created a peaceful mood, in which all is right with the world; the ferry traverses the river, and man carries out his business in the autumnal light under heaven's blue sky.

Key's pastoral scene (Plate 2-14) follows Claudian conventions with its dark foreground, light middle ground, and framing trees. The drama of the hills and clouds in the background against the tranquility of the river and its vegetation, and the juxtaposition of the unruly foliage of the tree at center right with the softer, rounder bushlike forms all put this work firmly in the realm of the picturesque. This painting also presents a study of oppositions, giving the work a subtle tension: a dead tree trunk on the lower right is set against the flourishing example above it, two figures face each other— one standing and one seated—and the thin smoke from the fire contrasts with the fulsome cloud formation above.

Key studied art in Munich and Paris. In 1869 he moved to San Francisco, where he established a studio. His work focused on landscapes of Yosemite, Tahoe, Monterey, San Francisco, San Diego, Point Lobos, and the Mariposa big trees.

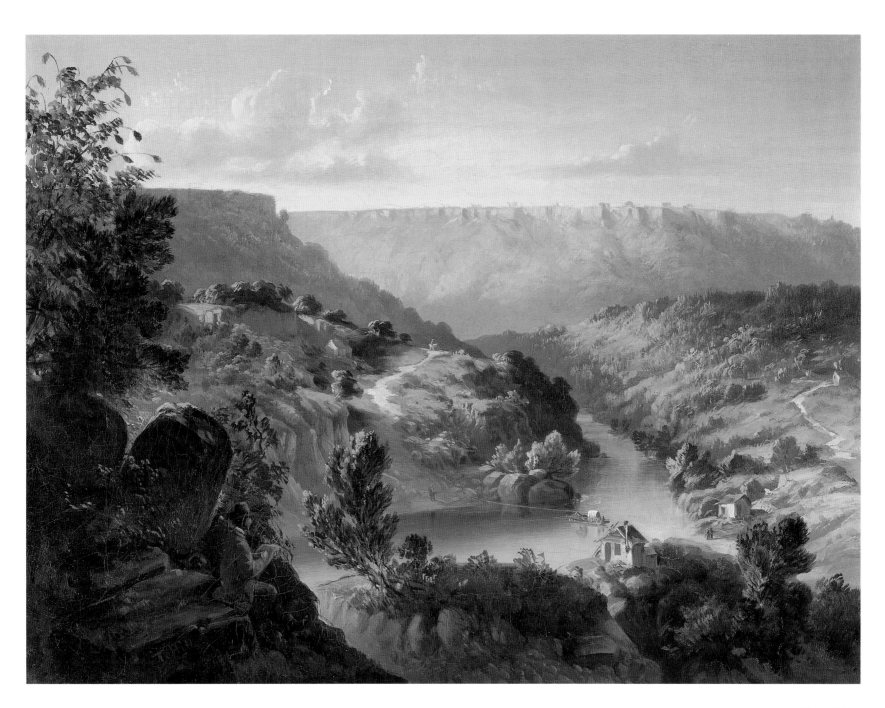

PLATE 2-13. Thomas Hill, *Byrnes Ferry on the Stanislaus River, Calaveras County, California*, c. 1860; painting on canvas: oil; 12 x 16⅛ in

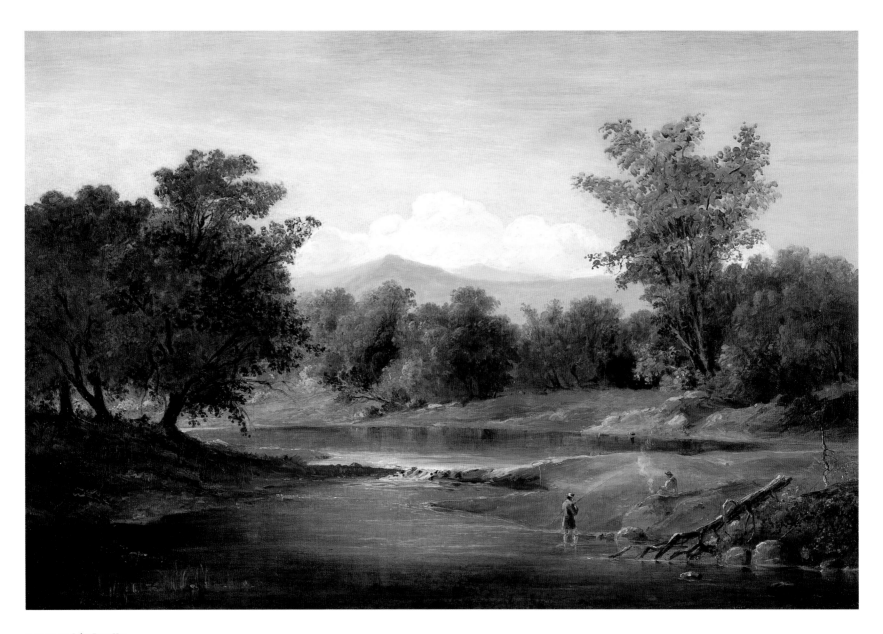

PLATE 2-14. John Ross Key,
Carmel River Scene, c. 1870s;
painting on canvas: oil;
16 x 23⅞ in

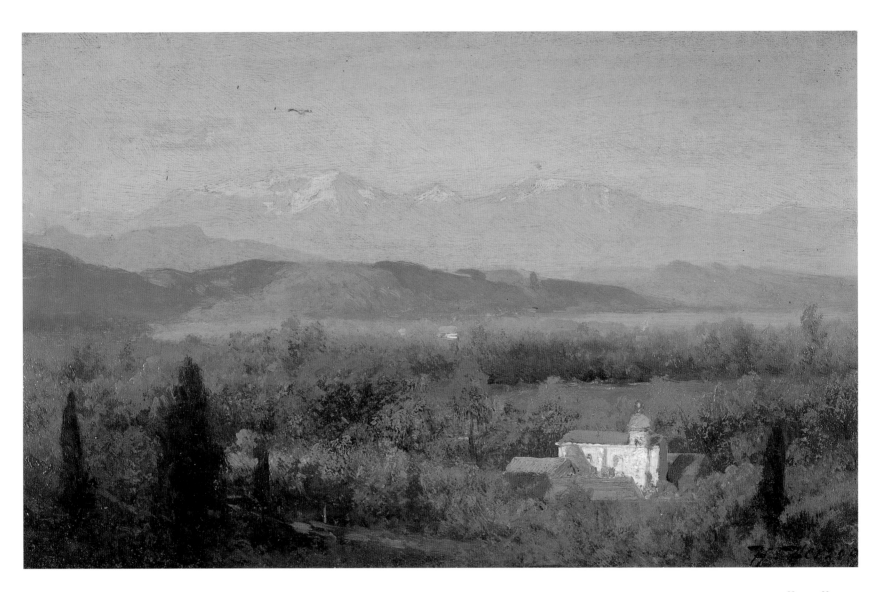

PLATE 2-15. Herman Herzog, Untitled (Valley near Los Angeles, California), c. 1870s; painting on board: oil; 7 3/8 x 11 7/8 in

Perhaps no other painter in the Honeyman Collection has captured the Southern California landscape more delicately than Herman Herzog. Two exquisite paintings of scenes near Los Angeles exemplify his signature style. Bright daylight is tempered by clouds through which one glimpses the pale blue sky. Shadows, though distinctly defined, are not harsh but draped softly over the hills. Trees in the foreground are not delineated but differentiated by gradations of green, from dark and lush to pale and yellow.

In the first of these paintings (Plate 2-15), the white walls of a Spanish-style church, with its characteristic orange-red roof and dome, shimmer in the sun. Before the church, a break of trees separates a field from a silvery blue body of water, their oval shapes echoing each other. In the far distance, the San Bernardino Mountains rise ghostlike, their peaks forming the horizon line. This scene is observed by Herzog's ever-present lone bird, which glides high above.

Perhaps what is most remarkable about Herzog is his ability to find the most advantageous viewpoint from which to frame and compose his picturesque landscapes. In this darkly toned work (Plate 2-16), the perspective pushes the viewer up against a dense screen of foliage in the foreground, while providing just enough height for us to peek over the treetops at the distant forms in the valley below. This position, in which we feel simultaneously elevated and sheltered by the vegetation, offers a privileged intimacy with the scene.

Born in Germany, Herzog entered the Düsseldorf Academy at the age of seventeen. He subsequently enjoyed a successful career as a painter in Europe, traveling around the Continent, Scandinavia, and the United States. When his home, the free Hanseatic State of Bremen, was absorbed by Prussia in 1869, he emigrated to Pennsylvania. He died in his adopted state in 1932, having lived for sixty-three years as a painter in America. Given the quality of his work, it is unfortunate that to date little serious study has been devoted to Herzog in the United States. One of the reasons for this may be that after having made some shrewd business investments, Herzog no longer needed to sell his paintings and seems not to have wanted to do so.

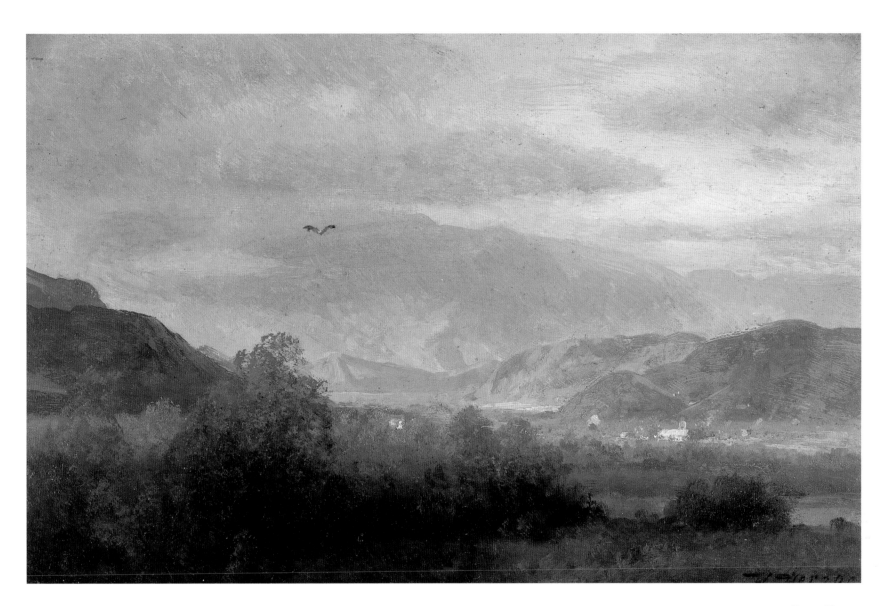

PLATE 2-16. Herman Herzog, Untitled (Valley near Los Angeles, California), c. 1870s; painting on board: oil; 7⅜ x 12 in

It is tempting to draw a connection between the biography of Harvey Young—who worked the California goldfields for six years—and this enormous golden mountain rising dreamlike out of the flat earth around it. Born in Vermont, Young traveled to California in 1860. He worked the mines in Salmon River country until 1866, when he opened a studio in San Francisco. Later he would travel to Paris to study under Carolus-Duran.

The composition of this work (Plate 2-17) defies artistic conventions by placing its subject in the very center of the frame, while the compression of the middle ground makes it difficult to assess the distance from viewer to mountain. Both effects contribute to the mountain's extreme verticality. Dwarfed by the grand formation, small figures give us a feeling for scale, but there is little mitigating scenery to temper the sublimity of this view. Young had a penchant for capturing nature's moods; here the golden-pink glow of light gives the mountain an otherworldly quality, particularly in contrast to its stark, white peak cutting into the sky.

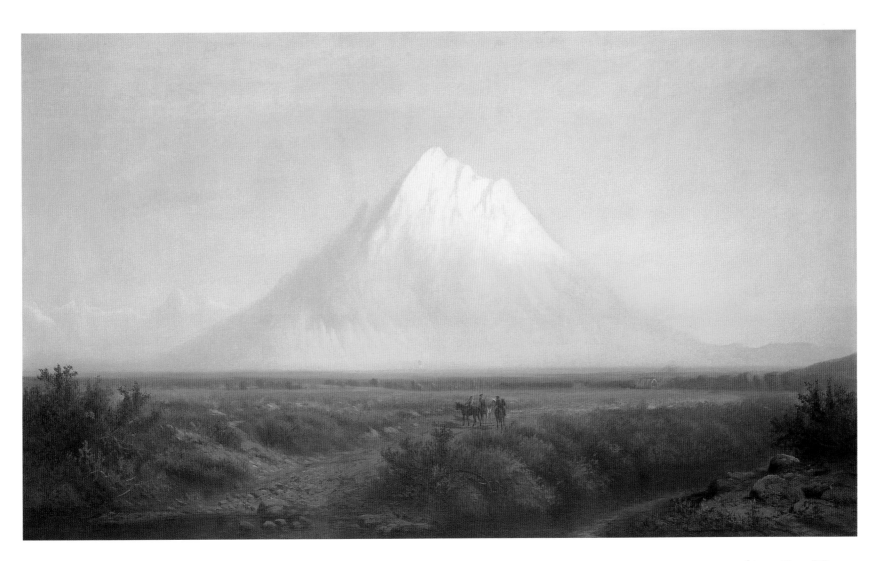

plate 2-17. Harvey O. Young,
Untitled (Mountain with
Prairie Landscape), 1871;
painting on canvas mounted
on board: oil; 30 x 50⅛ in

ALBURTUS DEL ORIENT Browere's "Mokelumne Hill" (Plate 2-18) offers rare evidence of the effects of the gold rush on the land. Roads line the valley below, where a paucity of trees bespeaks the heavy demands miners put on timber for housing and equipment. Deep ruts in the road in the foreground indicate that this route has been traveled frequently with weighty loads. Still, this expansive view evokes a feeling of placidity, broken only by the efforts of the horses to mount the hill.

The painting shows some hints of settlement but does not reflect its density—Mokelumne Hill supported a significant population. It was also home to a fifty-mile canal that delivered water to mining operations. Contrasting with Bierstadt's work, Browere's emphasis here is on the soothing shapes of the land rather than on atmosphere—a cloudless sky offers no competition to the earth below. The two thin trees on the right —one of the artist's visual signatures— puncture the blankness of the sky at the same time that they provide essential balance to the composition.

Browere was born in New York and ultimately made his home in the Catskills. In the 1850s he traveled to California, where he painted the numerous depictions of gold rush subjects that established his reputation as one of the preeminent painters of this genre.

PLATE 2-18. Alburtus Del Orient Browere, Untitled (Mokelumne Hill, Calaveras County, California), 1857; painting on canvas, mounted on board: oil; 34 x 49⅛ in

THE EXPLORATION OF THE West led to the greatest allocation of federal monies to the arts and sciences in American history. In the period between 1840 and 1860, Congress published sixty or so works on these explorations, and the cost of expeditions amounted to somewhere between one-quarter and one-third of the federal budget. A large number of Americans were exposed to images of the West through these government reports. The seven-volume Pacific Railroad survey report, for instance, disseminated more than six million images of western subjects to the public.

Frederick Butman's rendering of a surveyors' camp (Plate 2-19) was intended for just this sort of government publication. Captain W. E. Greenwell, head of the 1853 Pacific Coast Geodetic Survey between San Francisco and San Diego, commissioned six oil paintings of the camps, including this one by Butman and one by the Nahl brothers. Butman's work strongly favored the impressive topography of the location, treating the surveyors' shelters as mere forms that contrast with the hills above them.

Butman had the distinction of being the first resident artist to devote himself purely to landscape art in California. He hailed from Gardiner, Maine, where he owned an apothecary shop. With no formal art training, he traveled to San Francisco in 1857 and began painting views of California. His subjects also included Yosemite, the Sierra Nevada, and Washington territory.

PLATE 2-19. Frederick A. Butman, Untitled, 1858; painting on canvas: oil; 12 x 18¼ in

PLATE 2-20. Attributed to Augusto
Ferrán, *Vista de San Francisco 1850*
(View of San Francisco 1850), 1850;
painting on canvas: oil; 11⅞ x 23⁷⁄₁₆ in

AUGUSTO FERRÁN'S VIEWS of San Francisco from the early gold rush days are two of the gems of the Honeyman Collection. Both of these paintings glow with a luminescence that does not simply float on the surface but seems to emanate from their substrata. Though they have quality of light and rich, intense color in common, these images project two very different views of San Francisco. One emphasizes the pastoral—the copse of trees and the two tents on the left, the few people, and the man dressed in a large hat who stops and leans on his walking stick (Plate 2-20). All of this seems to evoke the Yerba Buena of yesterday, before the onslaught of the gold rush. Even though the ships in the bay confirm the presence of forty-niners, the sails appear distant and decorative. The other image (Plate 2-21) brings the viewer to the harbor, which is brimming with activity—boats are being built and repaired, oars are manned, and clippers wait expectantly offshore.

PLATE 2-21. Attributed to Augusto Ferrán, *Vista de San Francisco 1850* (View of San Francisco 1850) 1850; painting on canvas: oil; 11⅞ x 23⁷⁄₁₆ in

The water in the foreground seems to shimmer like gold, perhaps alluding to the reason for the bustling business at hand, while buildings in the middle distance are the harbingers of a future urban metropolis.

Trained as an artist at the Academy of San Fernando in Madrid, Ferrán painted in classical and religious genres, but he was best known as a sculptor. Gold may have been the reason for his stay in San Francisco, which was brief, lasting from 1849 to 1850. Ferrán finally settled in Havana, where he worked as a teacher.

it negotiates steep terrain; the elegance and dashing speed of coaches racing mail and people to the next stage; the abundant sails and smart, sleek hulls of clippers; and the mighty engine of the locomotive plowing earnestly through the landscape.

Yet at the dawn of the industrial revolution, the mythology of the New World as a garden paradise, a place of magnificent and boundless wilderness, remained central to the collective American identity. The image makers of the times played a complex role in reconciling the seemingly disparate drives toward nature and culture. Vehicles were often positioned against pastoral backdrops that received as much or more attention from the artist's brush. It was an opportunity to promote the splendor of the western landscape, but at the same time the image suggested the mastery over nature of human design and engineering. In his seminal work, *The Machine in the Garden*, Leo Marx describes this phenomenon as an inherent contradiction in the American ethos. With driving forces on either side of the mechanization debate, Marx suggests that artists often sought a "middle landscape" in which technology and nature are integrated.

In this collection of images we see wagons painted the color of the greenery around them and sails standing in for the natural white contours of the sky, but nowhere is the détente between nature and culture so complex as in portrayals of the railroad. The mobile steam engine stamped an indelible mark on the American imagination, altering forever all ideas of motion and communication. Up to this point, human travel could not exceed the speed of animals,

and information could not move faster than a stagecoach. Suddenly, the world was in possession of superhuman velocity. Nineteenth-century rhetoric claimed that the railroad "annihilated space and time." And so it did, making its way raucously through the landscape, leveling intractable earth, boring through mountains, leaping rivers and canyons. Ambitions for the locomotive were grand indeed. Prior to the Civil War, elected officials, including President Lincoln, believed the transcontinental railway might stitch together the fraying Union (while increasing the North's military span of control). Orators and writers claimed that the train heralded peace, unity, and civilization, and still others imagined the word of God laid down over the land on iron tracks.

The railroad also had prominent detractors, among them authors Henry Thoreau, Nathaniel Hawthorne, and James Fenimore Cooper. In *Home As Found* Cooper's character Mr. Effingham calls the railroad's destruction of everything in its path "all means and no end." All the same, a new paradigm overtook the nation. Progress in transportation became synonymous with the progress of the nation. The advances in design that led to the triumph of the clipper ship over all other sailing craft and the unprecedented speed with which the railroad veined the continent not only made the settlement of this country possible, they trumpeted the superiority of the American character. Business was well served by this outlook, and transportation concerns paid the bills of many an artist. The notion of the "middle landscape" served everyone's best interest. A Currier & Ives picture of the *Great West* bisected by the train (Plate 3-18)

signaled with nationalistic pride the beauty of the "virgin" territory and, concomitantly, the scenic possibilities of train travel. Transforming the locomotive, a black, smoke-billowing, deafening apparatus, into a germane feature of the natural world would seem a difficult feat, but artists found ways to blend smoke in with the contours of mountains, to align tracks with adjacent tributaries as if they simultaneously flowed into parallel estuaries. Walt Whitman likewise rationalized the increasingly incongruous complexion of America:

> *I see continual trains of cars winding along the Platte*
> * carrying freight and passengers,*
> *I hear locomotives rushing and roaring, and the shrill*
> * steamwhistle,*
> *I hear the echoes reverberate through the grandest scenery*
> * in the world . . .*

Certainly there was reason to celebrate the train. The hardships of the western pioneer seemed to vanish into so much smoke drifting over the plains. Months of travel metamorphosed into a journey of mere days at a significantly lower cost. The risk of contracting a fatal disease was greatly reduced. To droves of travelers, the railroad was a godsend. As historian Hubert Howe Bancroft commented,

> *The sunburned immigrant, walking with his wife*
> *and little ones beside his gaunt and weary oxen in mid-*
> *continent, the sea-sick traveler, the homesick bride whose*
> *wedding trip had included a passage of the Isthmus, the*
> *merchant whose stock needed replenishing; everyone*
> *prayed for a Pacific Railroad.*

Jubilation at the appearance of this *deus ex machina* bursts forth in H. Schile's *Across the Continent* (Plate 3-20) as people celebrate the arrival of the train in their town, which was likely built around the railroad stop. With a subtle reference to the dangers of past means of transportation, a game board by George Thistleton (Plate 3-21) embraces the great advances of travel by rail by making mere sport of the transcontinental journey. Finally, a palpable sense of well-being and serenity exudes from a work by Joseph Lee (Plate 3-22) depicting the railroad as it traverses an Oakland estuary. In this elegant, lyrical work, the train seems almost to walk on water as it makes its way toward the viewer and toward its assured place in history. The reality that train accidents occurred with alarming frequency is a subject for the "Incident and Accident" chapter of this book. That the railroad was built on a foundation of corruption and graft perpetrated by business monopolies; altered the social order of the country; caused dissent and rebellion, particularly in California; and was blamed for national moral decay and a host of physical illnesses are themes that only rarely emerged on any artistic canvas, and remain outside the purview of the Honeyman Collection. ❧

THE IMAGE OF THE PRAIRIE schooner—so called because its canvas shields resembled sails—endures as the icon of American pioneers making their slow passage west. Covering the more than two thousand miles from the common staging area in Independence, Missouri, to the west coast consumed five months. Still, more people transported their families west by wagon than by any other method.

Overland pioneers made enormous sacrifices in search of a better life. For the fairly steep cost (although significantly less than any other means of transportation) of $700 to $1,500 per family, they left behind their communities and shed themselves of everything that would not fit into a wagon already crowded with supplies for the journey. Although the standard ten-by-four-foot wagon could hold as much as twenty-five hundred pounds, there was rarely space for human freight—save for the very young, the sick, and the injured; everyone else hoofed it alongside the mules and oxen laboring with the load. They faced blinding dust and scorching heat

at one extreme and temperatures of forty degrees below zero and eighty-mile-an-hour winds at the other. Additional hazards included flooded rivers; buffalo stampedes; rattlesnakes; quicksand; Indian attacks (although this danger was frequently exaggerated); accidents; and, most deadly and pernicious of all, cholera and dysentery, often the result of previous emigrants having polluted the watering holes along the trail. Six percent of emigrants never saw their destinations, and some estimates number fatalities at one grave every eighty yards of the Oregon Trail.

These two images from the Honeyman Collection tell distinctly different stories about this vehicle and the journey it made. Albert Bierstadt's painting (Plate 3-1), which lacks the usual theatrics of his style, is likely an oil sketch. The work gives predominance to the landscape—the sails of the wagons appear almost as apparitions against the mountains towering above them, emphasizing the impuissance of the wagon train with respect to the obstacles they faced. Bierstadt

perceived this journey in religious terms: "The wagons are covered with white cloth. . . . As they move along in the distance, they remind one of the caravans described in the Bible and other Eastern books."

In the more pedestrian image of *The Old Reliable Schuttler Wagon* (Plate 3-2), an advertisement for the Chicago-based Peter Schuttler Wagon Company, scenery still has a prominent role, but here the grandiose cliffs and mountains in the background are props that adduce the prowess of this vehicle on any terrain. The row of wagons to the right has first negotiated a sharp curve at the top of the hill and now safely descends a steep and narrow passage. Below awaits the reward of a green pasture and a comfortable outpost, where the fires are burning. Whereas the Bierstadt work shows wagons facing in random directions, engulfed by nature, this advertisement depicts the orderly progress of technology and civilization toward its just deserts.

PLATE 3-1. Albert Bierstadt, Untitled, 1859; painting on board: oil; 13 x 10 in

PLATE 3-2. Unknown artist,
The Old Reliable Schuttler Wagon,
1800s; print on paper:
lithograph, color; 18 x 25 in

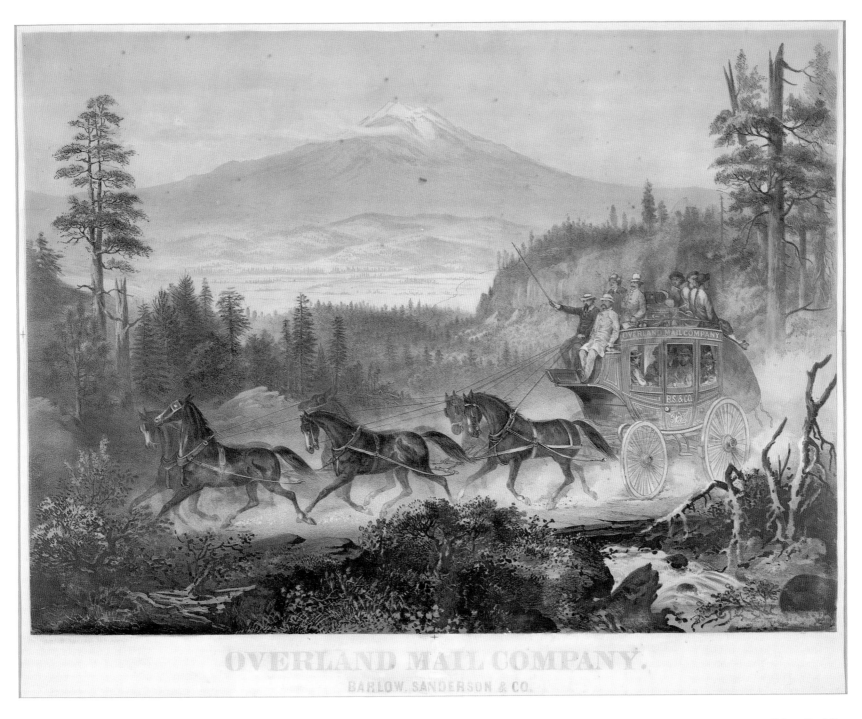

OVERLAND MAIL COMPANY.

BARLOW, SANDERSON & CO.

PLATE 3-3. Britton, Rey & Co., lithographer, *Overland Mail Company: Barlow, Sanderson & Co.*, 1800s; print on paper: lithograph, color; 18⅜ x 23⅝ in

Not for the faint of heart, stagecoaches carried passengers and mail to western destinations at what were considered rapid speeds — up to thirteen miles per hour. In 1857 Congress inaugurated the short-lived transcontinental stage line for mail and passengers, and as settlements bloomed across the frontier, stagecoaches buzzed from town to town and city to city, bringing news and visitors.

The trip by stage was bumpy — to say the least — as recorded by Waterman L. Ormsby, the first through passenger on the transcontinental stage line:

To see the heavy mail wagon whizzing and wheeling over the jagged rock, through such a labyrinth, in comparative darkness, and to feel oneself bouncing — now on the hard seat, now against the roof, and now against the side of the wagon — was no joke, I assure you.

The conditions of travel, including tight quarters in the carriage and other inconveniences, prompted a sign titled "Tips For Stage Coach Travellers" to go up at ticket stations. Passengers were advised:

Don't smoke a strong pipe inside the stage, and remember to spit on the leeward side. . . . Don't point out where murders have been committed, especially if there are women passengers. Don't shoot out the windows as the noise may frighten the horses. Don't grease your hair, because travel is dusty. Don't lag at the wash basin, and expect some annoyances, discomfort and hardship.

In terms of design, American stagecoaches garnered worldwide attention. To meet the rigors of rough roads, carriage makers set out to build a sturdier, more comfortable vehicle. Advances included an egg-shaped body, based on the idea that an egg on its end can support more than one hundred times its weight. Leather thoroughbraces suspended the body from the running gear, causing the carriage to rock rather than bounce with the shocks of the road.

Speed was crucial to a stagecoach, along with the rig's ability to manage difficult terrain. In an advertisement for the Barlow & Sanderson Overland Mail Company (Plate 3-3), dust streams from the quick feet of the horses, and in defiance of the rugged background topography — a mountain, a fast-running stream, hills, plains, and woods — the stage rides on firm, level ground.

Competition for mail contracts prompted races between stage lines and resulted in record-breaking times and lively exchanges between drivers and passengers of competing coaches. With mergers among companies, races soon became unnecessary. This primitive but lyrical watercolor (Plate 3-4) serves as an exuberant record of the "last race" taking place between the California-based McLaughlin and Cameron Stage Lines. The artist, who most likely created this painting for noncommercial purposes, directs our attention to the aesthetics of the coaches and horses and to the human emotion of the contest, letting the unremarkable scenery take a subsidiary position.

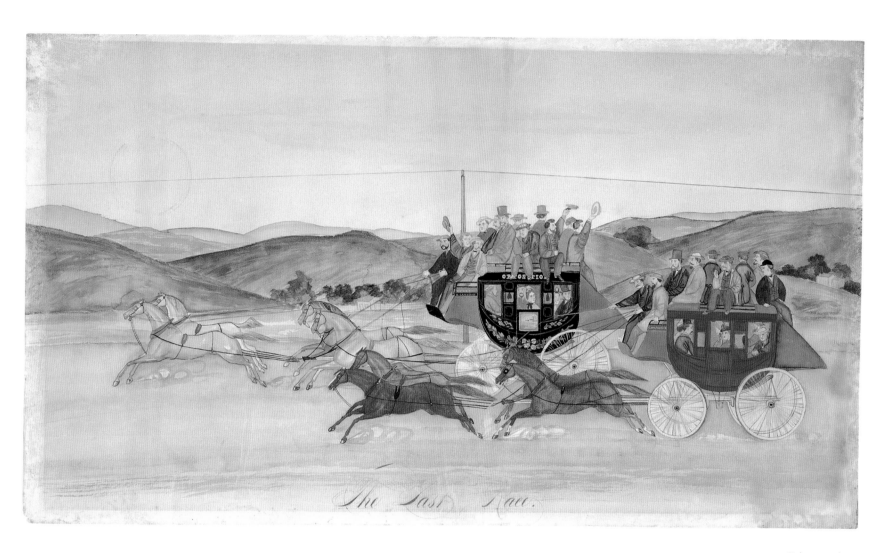

The Last Race.

PLATE 3-4. Unknown artist, *The Last Race: A Stage Coach Race between Oakland and San Jose, Cal*, 1800s; painting on paper: watercolor; 15 x 27 in

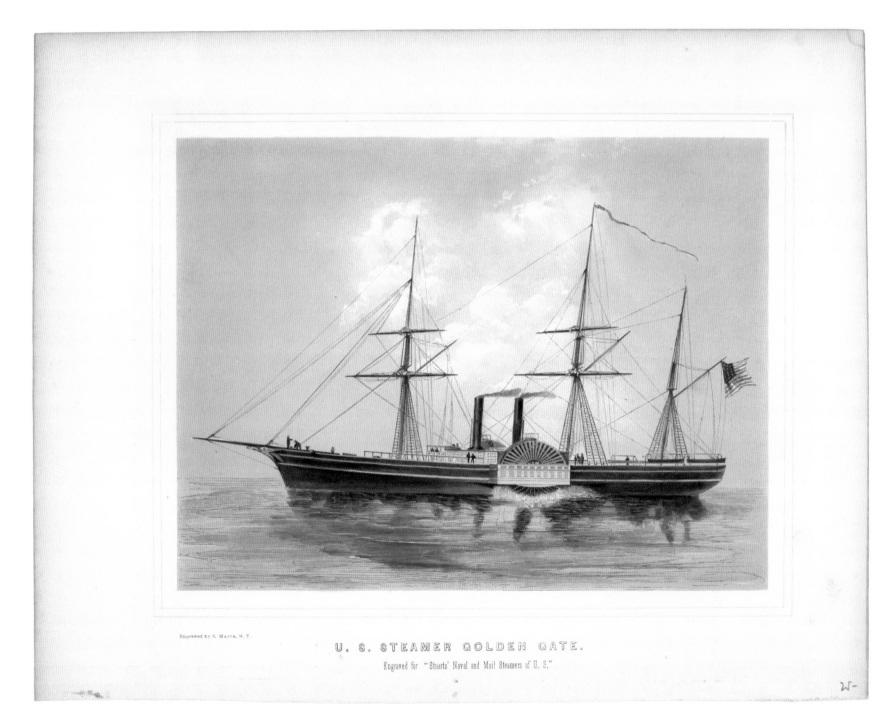

U. S. STEAMER GOLDEN GATE.

Engraved for "Stuarts' Naval and Mail Steamers of U. S."

Engraved by R. Major, N. Y.

PLATE 3-5. R. Major, engraver,
U.S. Steamer Golden Gate,
c. 1800s; print on paper:
engraving, hand colored;
10 x 12⅞ in

PRESIDENT POLK CONFIRMED the presence of gold in California at the same time that the first steamship of the Pacific Mail Steamship Company made its way around Cape Horn to begin service as a mail carrier between Panama and Astoria. By the time the *California* arrived in Panama, fifteen hundred people were waiting to board the ship, which accommodated only seventy-five. What had started out as a postal route metamorphosed overnight into one of the main avenues for gold seekers rushing to California. More and larger steamships soon graced both coasts, powered by steam-driven side-wheels with sails for additional muscle. The itinerary through Panama had the advantage of brevity compared with the thirteen-thousand-mile trip from the East Coast to the West around the South American continent. Indeed, the steamships had a number of advantages, not being solely at the mercy of the winds, and they would eventually dominate the world's waterways. Early steamships also possessed a number of flaws: wooden hulls and coal-burning engines often proved a fatal combination; coal bunkers stole a disproportionate amount of potential cargo space; and finally, fares for passage were high, making oceangoing steamships one of the most expensive travel options of the day.

This hand-colored portrait (Plate 3-5) illustrates what some considered the "finest specimen of naval architecture of the Pacific." Launched in 1851, the *Golden Gate* was hailed as the fastest and largest ship of its kind, traveling at twelve miles per hour and accommodating eight hundred passengers. Here white puffs of clouds gather around her masts as if she would never need sails.

A menu from the steamship *Constitution* (Plate 3-6) tells a one-sided story about life aboard these vessels. With fares from $600 for first-class and $300 for steerage passengers, this mode of travel attracted people of means. While first-class passengers dined on the mutton with oyster sauce and tenderloin of beef hand-scribed on the *Constitution*'s menu, steerage passengers received less glamorous fare, as indicated in an account relayed by historian John Haskell Kemble:

The passengers of the steerage, of which I am one, are divided up into messes of from 15 to 24—each mess eats their meals from two tin pans, one for the eatables, the other contains their drink. Our food is salt beef, pork, and yam principally, with a little fresh meat and half boiled rice occasionally. We have coffee mornings, and tea for supper. This half cooked food is passed from the galley, to a man chosen by the mess to receive it.

PLATE 3-6. Star & Herald, *P. M. S. S. Co's Steamship "Constitution" Dinner Bill of Fare*, c. 1860s; print on paper: letterpress; 12¼ x 5½ in

After the discovery of gold and until 1855, when the Panama Railroad was completed, argonauts hastening to the West Coast by steamship also had to cross the Isthmus by a series of conveyances barely adequate to the task. At the mouth of the Chagres River, native-guided *cayucas* (canoes) took on passengers for the three-day journey up the river to Gorgona or Las Cruces. In one of these villages travelers procured mules, if they were fortunate, to take them the rest of the way to Panama City. Thunderstorms, impossibly rocky terrain, and waist-deep mud were only a few of the hazards of the tropical jungle. A great number of travelers contracted yellow fever, cholera, malaria, and other diseases on the crossing, and some did not even survive the five-day journey.

Crossing the Isthmus (Plate 3-7) is one of the illustrations from Frank Marryat's witty firsthand account of the gold rush, *Mountains and Molehills.* Hailing from Norfolk, England, Marryat was acquainted with Charles Dickens, whose influence shows in Marryat's penchant for satire. On his first trip through the Isthmus, Marryat writes with tongue in cheek about the potential perils of the trip:

> *The town of Chagres deserves notice, inasmuch as it is the birthplace of a malignant fever that became excessively popular among the Californian emigrants, many of who have acknowledged the superiority of this malady by giving up the ghost, a very few hours after landing.*

The text becomes much more somber on a second trip across Panama later in the book:

> *Much trouble there was . . . much falling of mules and immersion of riders in thick ponds of mud, ere our party had proceeded a mile on the road. The rain, I believe, fell as if it would blind one, and as the thunder reverberated through the dark forest of palm trees, the lightning made the darkness of the black covered road before us more horrible.*

By this time, Marryat himself had contracted yellow fever, the complications of which would take his life shortly after he returned home with a new bride. He was twenty-eight.

Both the beauty and drama of crossing the Isthmus caught the attention of renowned artist Charles Christian Nahl, who made sketches for "Incident on the Chagres River, Panama" (Plate 3-8) when he and his half-brother traveled this route in 1850. Completed in 1867, this oil painting draws on the inherent tension of the Isthmus, as dangerous as it is picturesque. The serenity of the setting, with docile cows grazing on the bank above the flat, emerald water, is interrupted by the foreboding skeleton of a boat trapped on the rocks. In the occupied boat, three shirtless men exert themselves against poles lost in the murky water, while a fourth falls overboard. The currents of the Chagres flowed with such force that it was difficult to make headway at times, and the water was home to alligators and other lethal dangers.

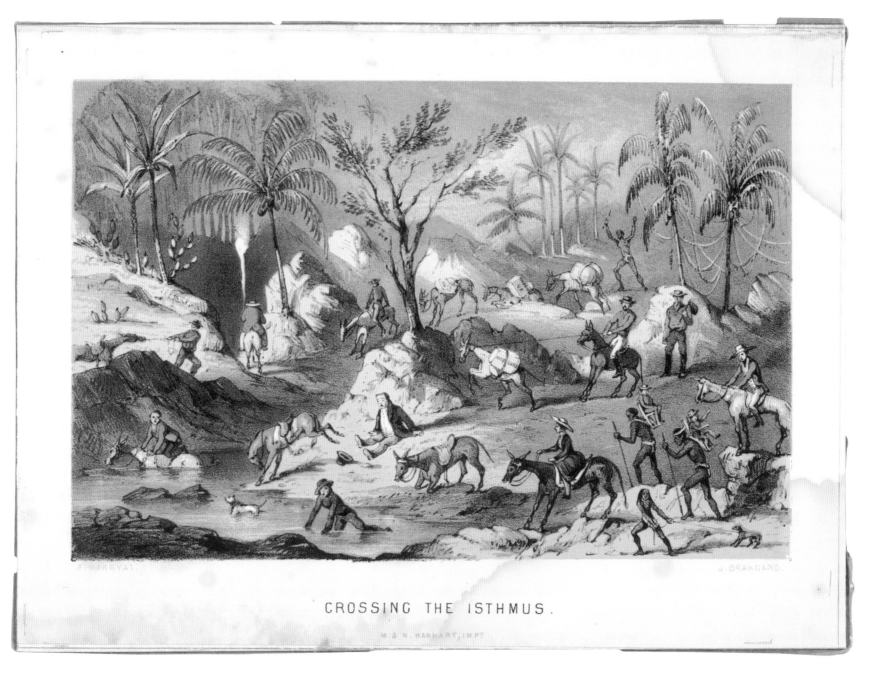

CROSSING THE ISTHMUS.

M. & N. HANHART, IMPT

PLATE 3-7. Francis Samuel Marryat, artist; J. Brandard, lithographer; printed by M. & N. Hanhart, *Crossing the Isthmus*, 1855; print on paper mounted on board: lithograph, color; 5 x 7⅛ in

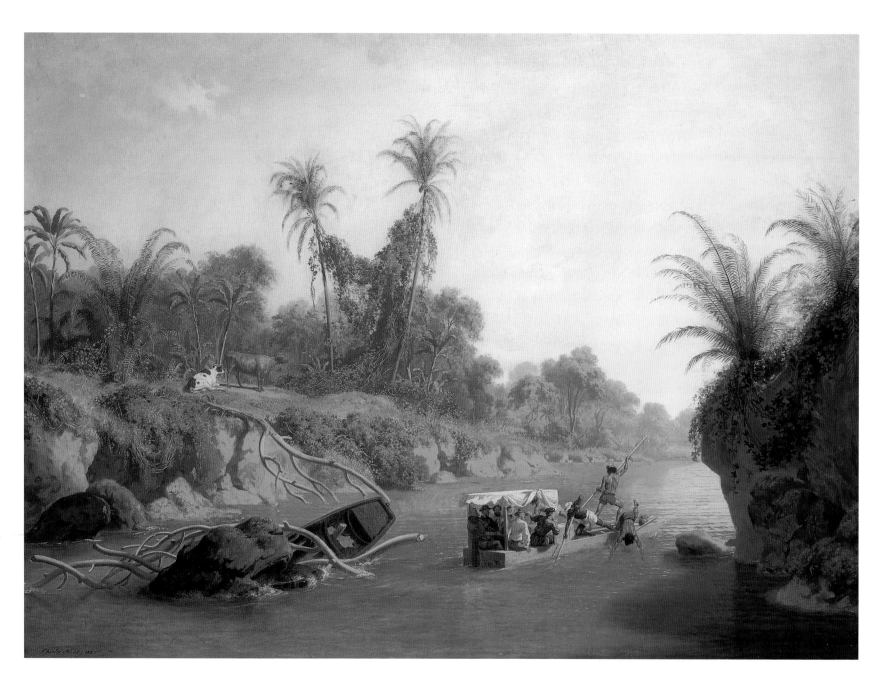

PLATE 3-8. Charles Christian
Nahl, Untitled (Incident on
the Chagres River, Panama),
1867; painting on canvas: oil;
26⅝ x 36⅞ in

CLIPPER SHIP "RED JACKET."

IN THE ICE OFF CAPE HORN ON HER PASSAGE FROM AUSTRALIA TO LIVERPOOL, AUGUST 1854.

Built by Geo. Thomas Esq. at Rockland, Me. 1854, for Messrs. Seccomb & Taylor, Boston, Mass.

NEW YORK. PUBLISHED BY N. CURRIER.

PLATE 3-9. J. B. Smith & Son, artist; Charles R. Parsons, lithographer; published by Nathaniel Currier, *Clipper Ship "Red Jacket,"* c. 1855; print on paper: lithograph, hand colored; 22⅜ x 29 in

THOSE WHO LACKED THE money for a steamship passage or who feared the diseases of the Isthmus had the option of booking passage on a ship that would travel down the Atlantic Coast, around Cape Horn, and up the Pacific to San Francisco. This journey took five to six months and entailed seasickness, to which many have preferred death; possible poisoning by improperly stored water or food; and the risk of violent squalls. Around the infamous Horn, feared by many a seasoned sailor, snow and hail often pelted the decks of vessels, and crews reported swells as high as fifty feet. Iceberg sightings were not uncommon, as depicted in the 1854 image of the clipper ship *Red Jacket* rounding Cape Horn (Plate 3-9).

Anxious gold seekers and emigrants greatly desired faster passage, and by fortunate coincidence, naval architects had been working on new designs for ships in the China tea trade. This confluence greatly accelerated the development and production of cutting-edge ship designs, and the clipper ship emerged as one of the fastest and most handsome sailing ships ever built. Some clippers could reach twenty knots under full sail, almost doubling the top speed of any steamship. There was no single design or rigging for a clipper—the moniker applied to the fast "clip" at which they traveled—however, defining features were usually a narrow beam and a sharp bow.

From the boatyard of designer Donald McKay, who became the most admired of these ships' designers, the *Flying Cloud* (Plate 3-10) was the largest clipper yet built, measuring 229 feet in length by 41 feet in width, with a mainmast of 200 feet—equivalent to a 20-story building. On her maiden voyage in 1851, the *Flying Cloud* weathered howling squalls that brought her topmasts crashing down on the deck, shredded sails, and an attempt at sabotage. But under the capable command of Captain Josiah Cressy and his navigator-wife, Eleanor, and with speedy repairs executed by the crew, the *Flying Cloud* recorded the unthinkable time of eighty-nine days from New York to San Francisco. The record set by the *Flying Cloud*—never equaled or bettered by another sailing vessel of her time—marked a new era of American nautical supremacy.

This print of the *Flying Cloud* formed part of Currier & Ives's extensive collection of maritime images. E. Brown Jr. and James Butterworth, a ship's portraitist specializing in clippers, rendered this image, in which the famous ship sails through white-capped waves under clear skies. Clouds would seem redundant to the cumulous canvas propelling this fine craft.

To Messrs Grinnell, Minturn & Co This Print of their Splendid

CLIPPER SHIP "FLYING CLOUD."

is Respectfully dedicated by the Publisher

NEW YORK PUBLISHED BY N. CURRIER, 152 NASSAU STREET.

DIMENSIONS:

LENGTH OF KEEL 208 FEET
LENGTH ON DECK 225 FEET
LENGTH OVERALL (FROM KNIGHT HEADS TO TAFFRAIL) 235 FEET

EXTREME BREADTH OF BEAM 41 FEET
DEPTH OF HOLD 21½ FEET
TONNAGE PER REGISTER 1750
BUILT BY DONALD Mc KAY AT EAST BOSTON MASS. 1851.

PLATE 3-10. James Edward Butterworth, E. Brown Jr., artists; published by Nathaniel Currier, lithographer, *Clipper Ship "Flying Cloud,"* c. 1852; print on paper: lithograph, hand colored; 19 x 25 in

COLORFUL CARDS SUCH AS these decorated the windows of shipping firms, banks, and shops along the waterfronts of East Coast ports from the 1850s through the 1880s. Appearing mere days before a ship's departure date (which was carefully omitted from the card itself) the advertisements were intended to entice last-minute passengers and to secure cargo for ships not yet filled.

Although many owners professed their ships to be clippers, a small percentage of vessels sailing at this time actually deserved the title. Still, agents made insistent claims. As we see here, no hyperbole was spared in either the text or the graphics of the clipper card —all ships were dubbed "extreme," "sharp," or "A 1." Declarations of pre-eminence began in the shipyard with the exultant names that adorned many a vessel's bow. This tendency to glorify every ship with an even more superlative title inspired parody, like this comment by American merchant, promoter, and author George Francis Train: "'The Wings of the Morning' came in day before yesterday, but the 'Utter-Most-Parts of the Sea' has not been heard from."

In this set of cards we find ships associated with classical myths, electricity, and heroic soldiers. One gory illustration (Plate 3-11) cites the story of Galatea, a sea nymph who jumped into the ocean after Polyphemus, son of Poseidon, killed her lover.

SUTTON & CO'S DISPATCH LINE FOR SAN FRANCISCO.

New and Elegant A 1 Mystic Built Sharp Clipper

SILAS FISH

(ONLY 800 TONS REGISTER,)
BRAND, Master,
Is Receiving her Cargo at Pier 14, East River.

This splendid Clipper is owned at Mystic, Connecticut, by the builder of the celebrated Clipper "GARIBALDI"—is of great capacity—entirely new, of the extreme clipper model, and worthy the attention of all shippers.

SUTTON & CO., 58 South St., corner of Wall.

The ships of this line insure at the lowest rates, and dispatched quicker than any other from New-York to San Francisco.

NESBITT & CO., PRINTERS, N. Y.

PLATE 3-12. Printed by G. F. Nesbitt & Co., *Silas Fish*, 1800s; print on paper: engraving, color, and letterpress; 4 x 6 in

The *Zouave* (Plate 3-15) was named for the infamous nineteenth-century North African soldiers-of-fortune, known for their great strength and courage in battle. The *Invincible* (Plate 3-13) needs no illustration, just the blaring type of its name. The *Franklin* (Plate 3-16) associated its vessel with other contemporary symbols of super-human speed: the train and the telegraph, the latter made possible by Benjamin Franklin's experiments with electricity. On a less boastful note, *Silas Fish* (Plate 3-12) (probably named after a relative of the owner) proffers an inventive graphic with a repeated eye that gives the impression of movement in the type.

With Perry's opening of Japan in 1853, a new word entered the English lexicon: tycoon, from the Japanese *taikun*, meaning a shogun or top leader. Just such an exotic personage is depicted in an advertisement for a ship by that name (Plate 3-14).

108 and 111 DAYS TO SAN FRANCISCO.
MERCHANTS' EXPRESS LINE OF CLIPPER SHIPS ONLY !
THE REPUTATION OF THIS SHIP REQUIRES NO COMMENT.
EXPECTED TO MAKE THE PASSAGE INSIDE OF 100 DAYS !

INVINCIBLE

HATCH, Commander, at Pier 16 East River.

Built by WM. H. WEBB,—diagonally iron strapped—and for speed, **supposed to be the fastest ship afloat.**

Agents in San Francisco, Messrs. DE WITT, KITTLE & Co. **RANDOLPH M. COOLEY, 88 Wall St.,** Tontine Building.

NESBITT & CO., PRINTERS.

Merchants' Express Line of Clipper Ships
FOR SAN FRANCISCO !

Dispatching the Greatest Number of First-Class Vessels.

Smallest, Sharpest and Fastest Clipper Loading. Carries only 1,300 Tons.

The Beautiful Little Out-and-out Clipper

TYCOON

AYERS, Commander, at PIER 16 E. R.

This magnificent little vessel was built at **Mystic** by
C. H. Mallory, Esq., the builder and owner of the celebrated
clippers "**Twilight**" and "**Mary L. Sutton.**" She is the
sister of the latter vessel, being of precisely the same
model and rate of speed.
She will have **Unprecedented Dispatch.**

RANDOLPH M. COOLEY, 88 Wall St.,

Agents in San Francisco, Messrs. DE WITT. KITTLE & Co. Tontine Building.

NESBITT & CO., PRINTERS, N. Y.

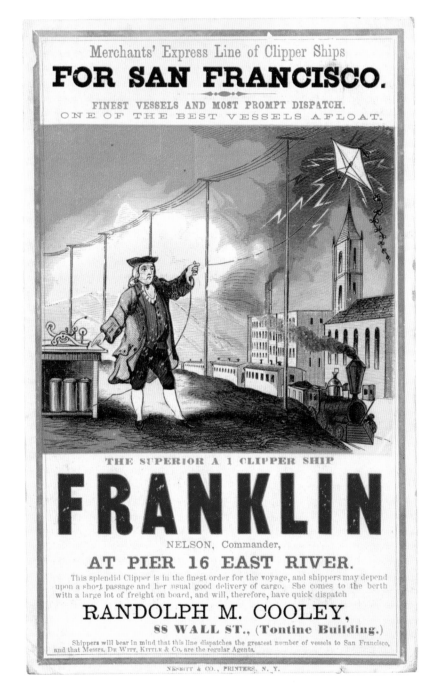

PLATE 3-15. Printed by
G. F. Nesbitt & Co., *Zouave*,
1800s; print on paper:
engraving, color, and
letterpress; 6 x 4 in

PLATE 3-16. Printed by
G. F. Nesbitt & Co., *Franklin*,
1800s; print on paper:
letterpress; 6 x 4 in

The penetration of the West by the transcontinental railroad was heralded as a godsend, but for many it now represents the final deflation of the indigenous social structure of the West by the long needles of American industrialization and imperialism. In this image by Herman Schuyler (Plate 3-17), the artist may take a neutral view of the clash of two worlds, but the implications are clear: the old ways will be supplanted by the new.

By the 1880s, the train was not yet ubiquitous in the West, but it had left impressions all over the land. Schuyler's portrait of the railroad as a minute insect in the distance is nostalgic, even ironic. The relative cultural dominance of foreground and background subjects was already reversed when this painting was made.

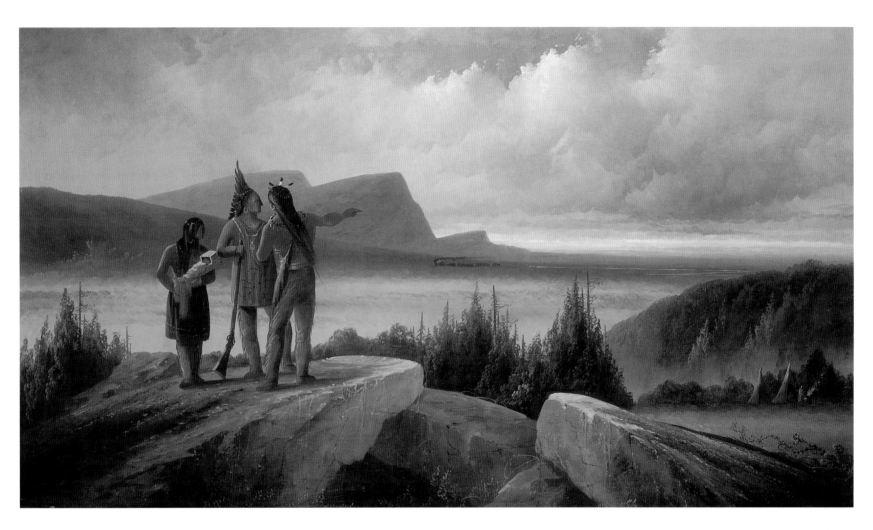

PLATE 3-17. Herman Schuyler,
The First Train, c. 1880;
painting on canvas mounted
on board: oil; 27⅝ x 47 in

Only five days after the historic joining of the rails in Promontory, Utah, passengers piled onto the first transcontinental railroad for daily service traveling either west from Omaha, Nebraska, or east from Sacramento. The trip, once a half-year odyssey, now took less than a week. For $100, a passenger could ride in the lap of luxury with fine furnishings, fresh linen, and steam heating; for a little more, a comfortable berth could be secured. The days of the prairie schooner rolling slowly over the plains seemed like a bad dream from which the nation had awoken. One hundred and fifty thousand people rode the Omaha-Sacramento line in 1870, the first full year of operation. Between 1865 and 1917 a staggering three hundred thousand miles of track were completed—mostly in the West and South.

Railroad companies knew that the success of the new networks depended on carrying both freight and passengers, and they launched extensive marketing and publicity campaigns to woo potential travelers. Consequently they were one of the principal generative forces behind promotional artwork at this time. These works often situated the railroad in dramatic western scenery—real and idealized—such as in the two Currier & Ives prints *The Great West* and *The Route to California* (Plates 3-18 and 3-19). The less than subtle message of the former image is that the West has been made "great" by the introduction of the train. Moreover, this sleek and powerful machine enables people to take in panoramic scenery previously unavailable to them. This work also shows the settlements that have sprung up around the railroad almost as if, like Johnny Appleseed, it dropped the germs of civilization as it flew by. *The Route to California* advertises another unique view as a cheery, brightly colored engine inserts itself between a cliff and the glistening Truckee River. The smoke clouds pouring from the train replicate the shape and color of the side of the cliff, implying that they are both made of the same stuff.

Railroad tracks also cleave compositions into settled and untamed halves, again suggesting that the train is the civilizing engine of the West. This divide appears in H. Schile's work *Across the Continent* (Plate 3-20). On one side of the print "savages" rear up on wild horses and flee as the train approaches. On the "other side of the tracks," as it were, neat rectilinear buildings—one with a steeple—attest to the orderliness of the railroad town, and neatly dressed people hail the arrival of the train.

The notion of travel by rail enchanted Americans, who soon began to book passages primarily for pleasure. A wonderful gameboard (Plate 3-21), created by San Francisco author and publisher George Thistleton, takes players on a journey from San Francisco all the way across the country to New York, with representations of the major stops in between. A ghost of bygone days, the remains of a ship have washed up on the San Francisco shore, a symbol of how dangerous travel was before the advent of the train.

The train symbolized progress, and artists often used techniques that emphasized its forward movement. Joseph Lee's painting of the Oakland estuary (Plate 3-22) employs plunging orthogonals—perspectival lines of sight moving from foreground to vanishing points. Lee was known for his highly detailed work, which almost always included water and often incorporated repetitious patterns, such as those made here by railroad tracks. In this work, the details of the tracks come into sharp focus as they run off the left side of the canvas. We are left with an impression of the march of time: the steady progress of the train from the hazy past into a certain future.

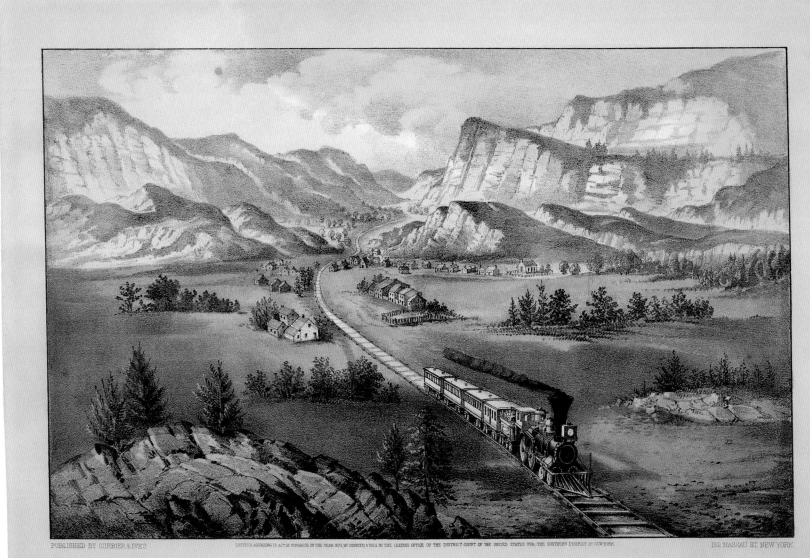

THE GREAT WEST.

PLATE 3-18. Published by Currier & Ives, *The Great West*, c. 1870; print on paper: lithograph, hand colored; 9 x 14 in

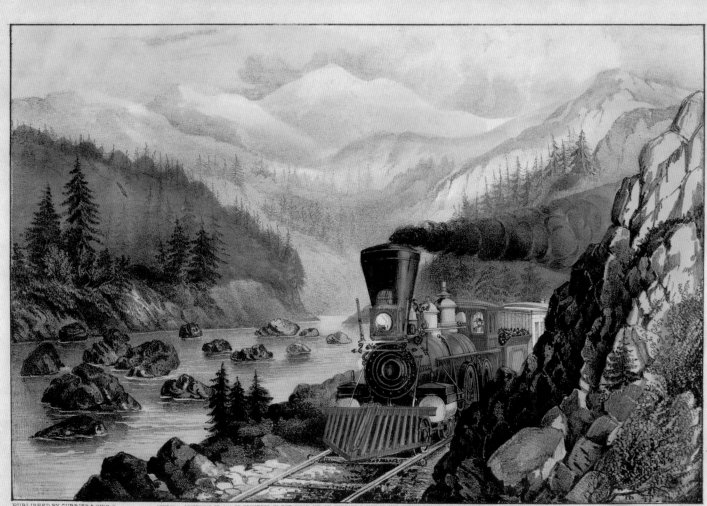

PUBLISHED BY CURRIER & IVES.S ENTERED ACCORDING TO ACT OF CONGRESS IN THE YEAR 1871 BY CURRIER & IVES IN THE OFFICE OF THE LIBRARIAN OF CONGRESS AT WASHINGTON 152 NASSAU ST. NEW YORK.

THE ROUTE TO CALIFORNIA.
TRUCKEE RIVER SIERRA-NEVADA.

PLATE 3-19. Published by Currier & Ives, *The Route to California: Truckee River, Sierra Nev.*, c. 1871; print on paper: lithograph, hand colored; 10⅞ x 14 in

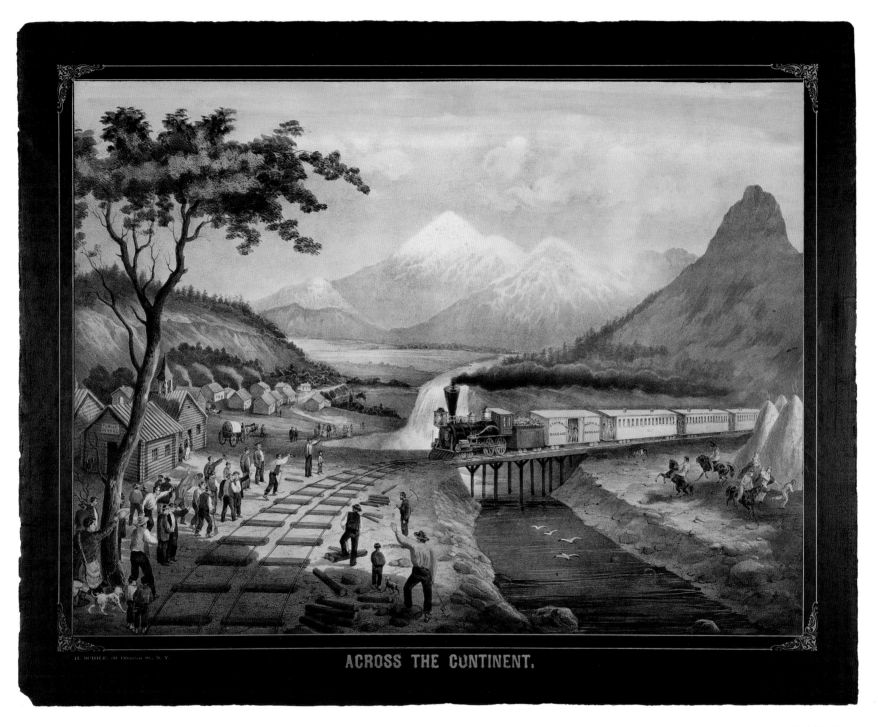

ACROSS THE CONTINENT.

PLATE 3-20. H. Schile, *Across the Continent*, c. 1870s; print on paper: lithograph, hand colored; 21⅞ x 27⅝ in

PLATE 3-21. George Frederick Keller, lithographer; published by Colonel George Thistleton, Untitled, c. 1872; print on paper mounted on board: lithograph, color; 22 x 18⅞ in

PLATE 3-22. Joseph Lee,
Untitled (Oakland Estuary
near Lake Merritt Inlet from
7th Street, California), 1800s;
painting on canvas: oil;
23 x 42 in

Chapter Four

Incident and Accident

Not simply as a matter of rhetoric, but in frightening actuality, Americans seemed strangely able to accept the possibility of violent death on a mass scale.

Fred Somkin, Unquiet Eagle

On a bone-chilling day in December 1835, a fire broke out in downtown New York and raged for fifteen hours, destroying 674 buildings. An eyewitness described the blaze as "a great loss" that "made every heart sad." But for the enterprising Nathaniel Currier, the incident helped to put a fledgling business on the (albeit charred) map of that city. Before the embers had even cooled, Currier produced the *Ruins of the Merchants' Exchange N.Y. after the Destructive Conflagration of Decbr 16 & 17, 1835*. Five years later, Currier responded to another fire, this time aboard a steamship, with an image titled *Awful Conflagration of the Steam Boat LEXINGTON In Long Island Sound on Monday Eve.g Jan 13th 1840 by which melancholy occurrence 123 Persons Perished*. Requests for this print came in from all over the country; the aspiring publisher had garnered national recognition.

Currier and his eventual partner, James Ives, may have excelled in this area, but they were certainly not alone in their penchant for documenting fatalities, ruins, and mayhem. In the Honeyman Collection, we find multiple images of shipwrecks, floods, fires, and earthquakes. Letter sheets — the postcards of the day — detail assassinations and executions; canvases by the renowned Charles Nahl and respected Hudson River School artist Samuel Colman re-create Indian attacks; and music sheets tunefully memorialize sinkings and inundations. As Currier's case illustrates, wreckage and doom were hot commodities in the nineteenth century, and sales figures alone would have served as strong motivation for publishers and artists to disseminate highly dramatic literature and imagery. The American appetite for and reaction to "sensational" imagery is a more complex subject, and one that offers rich avenues of exploration in the context of the Honeyman Collection.

The catastrophic and morbid have always enjoyed widespread spectatorship. Vivid life-and-death struggles have filled everything from coliseums to canvases for many hundreds of years. In our own day we are subject to relentlessly graphic television coverage of gore and devastation. Modern horror films, tabloid newspapers, video games, and the death-and-dismemberment-oriented artworks of figures like Andy Warhol and Francis Bacon are just a few examples of imagery addressed to our inner voyeur. Yet, as we will see, it was a unique combination of forces that powered the sensationalism of nineteenth-century America.

The images in this chapter pit humans against the forces of nature (floods, storms, fire, earthquakes, and, in the mindset of the era, Indians), against technology (the locomotive and newly invented steamship), and against each other. In the romantic vein, they focus on the individual in relation to the cosmos, the search for human significance in a universe seemingly growing larger and colder with every new technological or scientific discovery. In this context, audiences fastened onto epic tales of human struggle against the elements, technological calamities, and skirmishes with evil. People wanted to be moved, and artists and publishers wanted to tell a good story, to appeal directly to the sympathies of their viewers.

As artists began to branch out from biblical or classical subjects in the nineteenth century, a new proliferation of imagery addressed actual news items about actual people. Observers could project themselves into catastrophic scenes with greater ease, indulging their desires to experience shock, awe, and fear, to revel in the miracle of survival, or to commune with fellow sufferers. And as anxiety grew about the dehumanizing aspects of mechanism and urbanization, there may have been something cathartic in seeing a great human-made contrivance sink, or a town under water or on fire, particularly for those individuals at some distance from the tragedy. This sort of depiction accorded with the romantic tendency to posit lessons about human ambition and the moral consequences of progress.

The western frontier was fertile ground for both epic confrontation and moral admonition. The lengthy and dangerous journey to the West was itself the stuff of legend. During the gold rush, some distant observers found the mad dash for the elusive ore, the hasty urban development, and the lawlessness that ruled newly settled western towns a subject for derision and censure. Behind at least some of this imagery we sense a wagging finger directed at the impulse to greed and expansionism.

The 1857 print *Wreck of the Steamship Central America* (Plate 4-3) by Philadelphia publisher J. Childs in many ways embodies the mid-nineteenth-century zeitgeist. Rendered in shadowy contrasts of black and white with only hints of hand-painted color, this print depicts the final moments of a steamship and its passengers, most of whom are returning from California gold mines. As, in the words of Herman Melville, the "wildest winds of heaven and earth conspire" to scuttle this human creation, the nineteenth-century viewer is reminded of the insignificance of man, the folly of human aspirations. Here also are extreme emotions: the despair of the half-sunken ship appears against an evanescent symbol of hope — a rescue vessel waiting in the distance. And the tiny figures enact a little allegory of human nature: some people leap from the ship, fight their way to the bow, or climb the masts; some cling quietly to debris in the water; others throw up their arms and cry out. Meanwhile, Captain Herndon, the good romantic hero, stands firm on deck, still giving directions. This single print covers the emotional spectrum, from stoicism and courage to cowardice and desperation. Below this spectacle of failed technology and its human cost, the caption reads "Appalling Disaster." To ground the image in reality (or, conversely, to overwhelm viewers with the magnitude of

the statistics), it goes on to dispassionately list the number of people lost and saved and, of course, the dollar value of the gold that the ship carried to the bottom of the sea.

It was technological progress—*steam*-powered printing, along with advances in lithography and paper manufacturing—that made it possible for exponentially larger audiences to become acquainted with the news of *steam*ship disasters. It was also steam power that led to catastrophe on a massive scale, notably ship and train explosions and collisions. While some raised questions about the hubris of mechanical advancement, others argued that the American desire for convenience and speed drowned out the shrieks of mass fatalities. In *The Gilded Age*, Mark Twain gives an account of an impromptu race between two steamboats—the *Amaranth* and the *Boreas*—that ended in calamity. After describing the many horrors that ensued after the *Amaranth* caught fire, he concludes:

> *But these things must not be dwelt upon. The* Boreas *landed her dreadful cargo . . . amounting by this time to 39 wounded persons and 22 dead bodies. And with these she delivered a list of 96 missing persons that had drowned or otherwise perished at the scene of the disaster.*
>
> *A jury of inquest was impaneled, and after due deliberation and inquiry they returned the inevitable American verdict which has been so familiar to our ears all the days of our lives—"NOBODY TO BLAME."*

This "inevitable American verdict," in essence, trivialized the loss of many lives. The notion of "speed at any cost" also helps to explain why people continued to board trains despite all-too-frequent horrific accidents. A cool, almost clinical dissociation from the

human costs of progress seems apparent to observers today in, for instance, the translation of a deadly locomotive collision into stationery for casual correspondence in the letter sheet *The Late Collision between the Trains of the Western Pacific and S. F. & Alameda R. R. Cos. near Simpsons Station, Sunday Nov. 14th, 1869* (Plate 4-14).

If people were somewhat inured to death in the nineteenth century, it may have been the consequence of frequent exposure. The period between 1853 and 1904 saw an inordinate number of calamities on a mass scale, leading one writer to call America "the land of disasters." Moreover, mortality rates from disease and accidents at home were high—as many as one third of all children did not live to see the age of ten. Average life spans were short by contemporary standards: individuals could expect to live forty years in 1850. At the end of the century, this figure had risen only to forty-seven. The personal journals and letters of early nineteenth-century Americans brimmed with references to death and dying. Even schoolchildren obsessed on the subject. The 1852 penmanship book of a young boy was full of ominous reminders such as "Remember this life is not long" and "Remember you must die."

Living in the West was a particularly dangerous proposition in the 1800s. In California alone, there was a seemingly perpetual string of casualties caused by natural and unnatural circumstance. San Francisco experienced six major fires between 1849 and 1851, floodwaters from the American River frequently turned Sacramento into an inland sea, and one or two major seismic events shook the westernmost territory

every decade in the second half of the century. People also posed an uncommonly high danger to each other—at the height of the gold rush, the city of San Francisco witnessed two murders a day.

Early westerners may have greeted catastrophe and death with resignation, but it was no doubt balanced by feelings of dread, fear, and sadness. Some of the imagery we see in this chapter may have helped settlers exercise reason over emotion by documenting and codifying their experience. Artists also employed humor—in a way that would be unimaginable today—in their compositions: the *California Flood Mazurka* (Plate 4-6) is an example of a music sheet offering dancers a three-quarter-time disaster romp, and satirist Edward Jump's *Earth Quakey Times* (Plate 4-16) caricatures the frightening 1865 event. Another, more subtle artistic strategy that may have provided comfort to viewers was the bird's-eye or panoramic view (Plate 4-15). These views situated observers at a safe distance from calamity, giving them some sense of perspective and control.

Perhaps as a result of so many upheavals, western Americans developed a remarkable resilience to the unexpected. Accidents yielded new, improved technologies. Out of the ashes of burned settlements, bigger, better cities arose with stunning alacrity. Among the citizens of a wrecked community, some were probably reconciled to the Sisyphean task of continually rebuilding; some were brightly optimistic about the future; and some knew for a fact that urban disaster generated new development and capital, and thus greater profits. We may never completely grasp the feelings of people living in a world so different from ours. Nonetheless, we can enjoy an occasional glimpse into their psyches, such as the one provided by travel writer and artist Frank Marryat in his description of the aftermath of San Francisco's June 1850 fire. Landing in California for the first time on the day after the disaster, he concluded, "Everybody seems in good humour." He then toured the damaged city, stopping to capture this wonderfully pithy dialogue between two men (Jones and Smith) who were standing in the ruins of their businesses:

> *[Smith] says to Jones interrogatively,—*
> "Burnt *out?*"
> JONES.—"*Yes, and* burst *up.*"
> SMITH.—"*Flat?*"
> JONES.—"*Flat as a d—d pancake!*"
> SMITH.—"*It's a great country.*"
> JONES.—"*It's nothing shorter.*" ֎

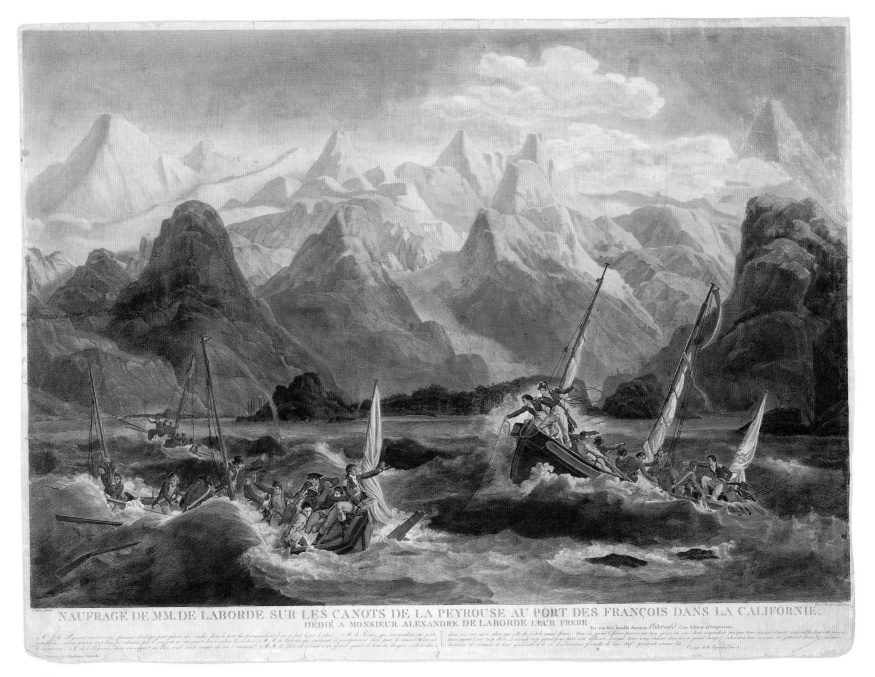

NAUFRAGE DE MM. DE LABORDE SUR LES CANOTS DE LA PEYROUSE AU PORT DES FRANÇOIS DANS LA CALIFORNIE.
DÉDIÉ A MONSIEUR ALEXANDRE DE LABORDE LEUR FRERE

FRENCH NAVIGATOR JEAN François de Galaup, Comte de La Pérouse, set off on a grand national expedition from France in 1785, followed by the cheers and high hopes of the French government. As he was on the way to the west coast of North America, winds took him north to Lituya Bay in Alaska, which he mistook for California. Three boats set out to sound the bay. Heavy currents capsized one of the boats and dashed it into the rocks. Another attempted a daring rescue, but this only resulted in greater tragedy. La Pérouse stayed on for three more weeks, hoping for signs of survivors. Finally he declared the twenty-three men dead (among them six officers and his own nephew) and erected a monument in their honor.

PLATE 4-1. Louis Philippe Crépin, artist; Prot & Dissart Sculpserum, engravers, *Naufrage de M.M. de Laborde sur les canots de la Peyrouse au Port des François dans la Californie . . .* (Shipwreck of Messers de Laborde in the boats of La Pérouse in Port des François, California . . .), 1800s; print on paper: engraving, hand colored; 20⅞ x 28⅛ in

THE LURE OF THE SHIPWRECK is as ancient and powerful as a siren's song. Even today the idea of a ship, its passengers, and treasures swallowed by a vast, mysterious, and rapacious force continues to capture the imagination as salvage and scientific crews endlessly pick over the bones of great hulls resting on the ocean floor.

Shipwrecks were common in the nineteenth century: in 1853 the *New York Times* reported the loss of no fewer than 130 ships and with them two thousand lives in a single twelve-month period. At the same time, the shipbuilders of the era dazzled the public with vessels of greater size and power. But the old adage relating the size of an object to the magnitude of its failure—"the bigger they come, the harder they fall"—operated with respect to these new contrivances, making their demise all the more spectacular to witness.

One of Nathaniel Currier's many disaster images, *Burning of the Clipper Ship "Golden Light,"* illustrates the catastrophe on board this vessel, when she was struck by lightning on her maiden voyage (Plate 4-2). This hand-colored lithograph focuses above all on the golden light (an irony certainly not lost on the printer) billowing from the doomed ship. In fact, the orange coloring extends impossibly beyond the flames and into the clouds of smoke above the ship's transom. Precise coloring was not a hallmark of the Currier shop, which turned out high volumes. The printer paid a colorist to make a master and then an "assembly line of girls" copied it, adding one color apiece.

The *Wreck of the Steamship Central America*, showing the final moments before the ship succumbed to a brutal hurricane, is as romantic as it is simple (Plate 4-3). Barely delineated sticklike figures fall from the bow or cast about in despair in the dark, tempestuous ocean. In reality, every able-bodied man on the ship stood in a long bailing line for more than twenty-four hours, heaving buckets of water overboard. Finally the steam engines completely flooded and failed, and the sea sucked the ship downward. The small brig *Marine* (seen in the distance), herself nearly dismasted, tried valiantly to rescue as many people as she could, but only gathered the women and children who had been aboard the steamer. Sixty hours after the ship went down, some of the men were picked out of the Atlantic by another boat. By then the *Central America* had gone down with 346 people and her full cargo of gold.

Illustrated music sheets such as *I Do Not Want To Be Drowned* (Plate 4-4) provided Americans with the means, in a day without radio or television, to learn and share songs. Although many people had doubtless heard of the *Golden-Gate*'s unfortunate demise, this image helped singers picture the conflagration, which began in the engine room and consumed the entire ship, until she broke up in the waves. The song title allegedly refers to the plaintive cry of a little girl, while its verses describe her safe passage to the shore. Although the title of this song is so baldly maudlin as to seem laughable, some 180 passengers were lost in this wreck, many others were badly burned, and those who survived went through more trials onshore, waiting to be rescued. This popular music sheet sold in the thousands.

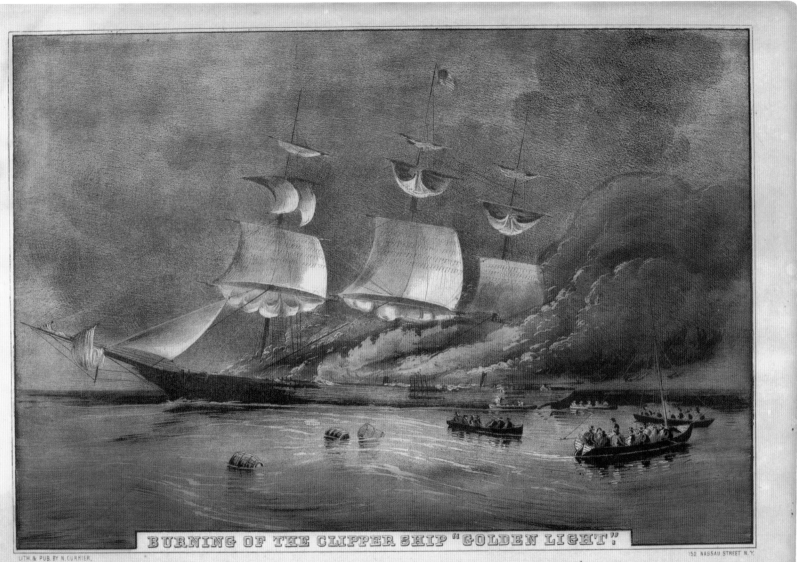

BURNING OF THE CLIPPER SHIP "GOLDEN LIGHT."

LITH. & PUB. BY N. CURRIER. 152 NASSAU STREET N.Y.

The "GOLDEN LIGHT" sailed from Boston for San Francisco February 12th 1853, at nine o'clock P.M. on the 22nd during a thunder storm, she was struck by lightning, and set on fire and at 6.P.M. of the 23d all hands were driven to the boats, leaving the ship entirely in flames.

PLATE 4-2. Nathaniel Currier, *Burning of the Clipper Ship "Golden Light,"* c. 1853; print on paper: lithograph, hand colored; 10 x 14 in

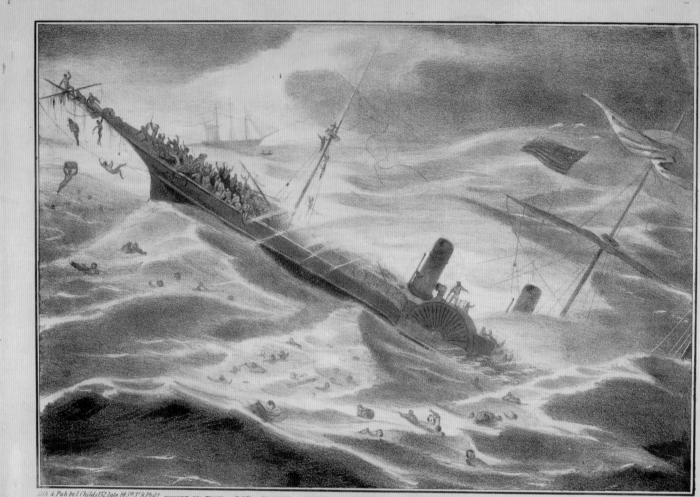

WRECK OF THE STEAMSHIP CENTRAL AMERICA.

APPALLING DISASTER.

On Saturday, September 12th, 1857, Capt. Herndon, bound to New York, from California, with the Pacific Mails,
Passengers and Crew, to the number of 592 persons, and treasure to the amount of over
$2,000,000, foundered in a hurricane, off Cape Hatteras.

Whole number on board, 592. Number saved, 166. Number on board whose names are known, 134. Names unknown, 292.

PLATE 4-3. Published by
J. Childs, lithographer, *Wreck
of the Steamship Central America*,
c. 1857; print on paper:
lithograph, hand colored;
13 x 17 in

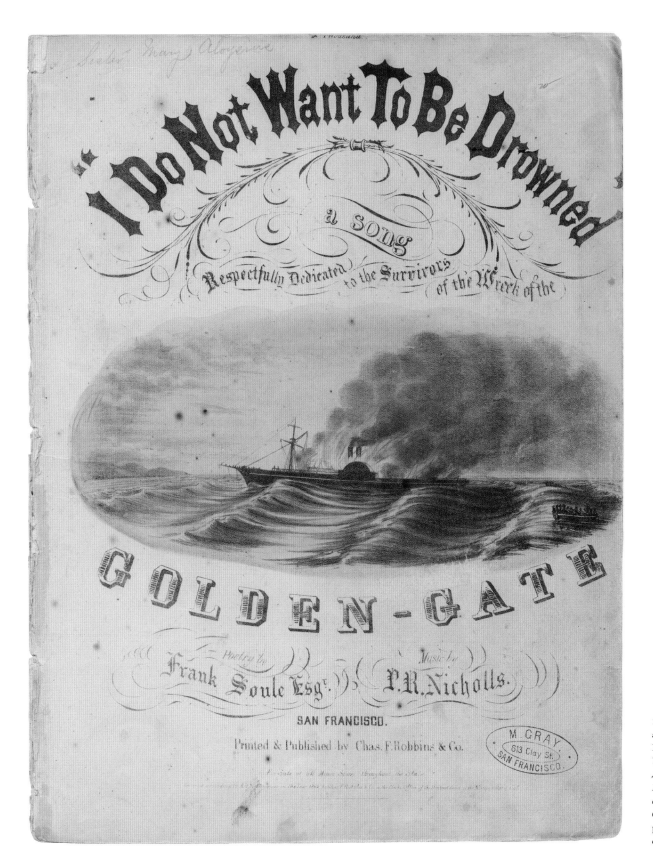

PLATE 4-4. Published and printed by Charles F. Robbins, *I Do Not Want To Be Drowned: A Song Respectfully Dedicated to the Survivors of the Wreck of the Golden-Gate*, c. 1862; print on paper: lithograph, hand colored; 13 x 10 in

In retrospect, the settlement of Sacramento in the late 1840s strikes some modern observers as preposterous. Signs of high floodwaters in the valley were recorded as early as 1808, when Spanish Ensign Gabriel Moraga led a small expedition up the Sacramento River. In 1841 the Indians living in the area warned Lieutenant Charles Wilkes of the United States Navy of extensive annual flooding. Still, the discovery of gold at Sutter's Mill inspired thousands of people to set down roots at the intersection of the American and Sacramento Rivers.

To their great surprise, in January of 1850 residents of the new town found themselves in very deep water following a strong storm. Many people actually drowned in their beds, and one man made a fortune ferrying the dead to burial sites. After this famous inundation, levees appeared, successfully protecting the city until the winter of 1861-62. At this juncture Sacramentans decided to raise the city above the flood plain, and after some trial and fairly serious error, this method saved the state capital. That is, until hydraulic mining in the Sierra sent massive amounts of silt and debris into the river, causing it to again flow over the city in 1881.

These images present different perspectives on the disastrous flooding of the Sacramento Valley. The first, *View of Sacramento City as It Appeared during the Great Inundation in January 1850* (Plate 4-5), does not bespeak disaster as much as it offers a scenic view of the city transformed into an American Venice. The text below the image consists primarily of information that would appeal to a tourist—hotel locations and points of interest. Town dignitaries, including Captain John Sutter, authenticated the image with their signatures. In view of the history of the area, we note that the caption mentions a small, nearly invisible island, "made by the Indians," the "only dry spot visible for miles."

The upbeat *California Flood Mazurka* (Plate 4-6) might have satisfied the urge of waterlogged Sacramentans to laugh at, or at least dance to, their troubles. Again people seem to travel in boats more for recreation than necessity. This interesting lithograph includes the names of several businesses on J Street, continuing the job of advertising despite the countervailing circumstances.

Artist Charles Hittell's sketch creates a more personal and ominous mood (Plate 4-7). Here water has half-submerged a railroad station and washed out the tracks leading to it. The telegraph poles traveling along the rail route sink into progressively higher waters. Bleak are the prospects for these, the two most powerful icons of progress in the nineteenth century. It may not have been lost on the young Hittell that he was in the hometown of Big Four railroad magnates Stanford, Hopkins, Crocker, and Huntington when he chose to capture this pathetic scene.

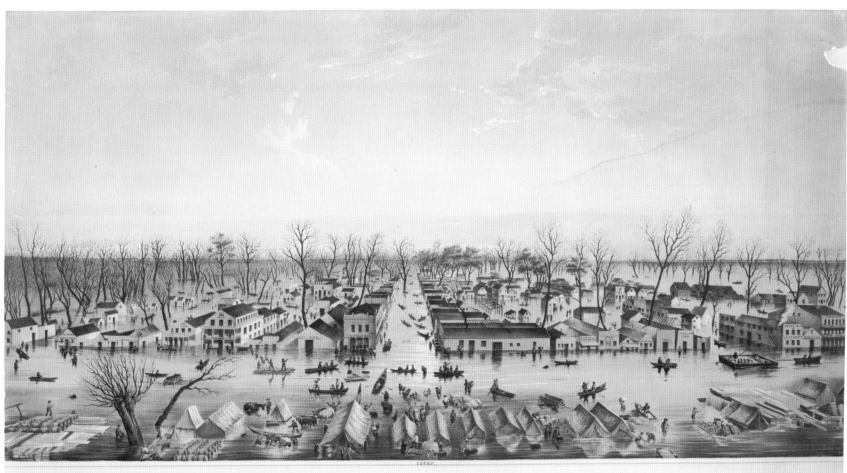

VIEW OF SACRAMENTO CITY.

AS IT APPEARED DURING THE GREAT INUNDATION IN JANUARY 1850.

PLATE 4-5. George William Casilear and Henry Bainbridge, artists; W. L. Ormsby, engraver, *View of Sacramento City as It Appeared during the Great Inundation in January 1850*, c. 1850; print on paper: lithograph, hand colored; 22 x 35 in

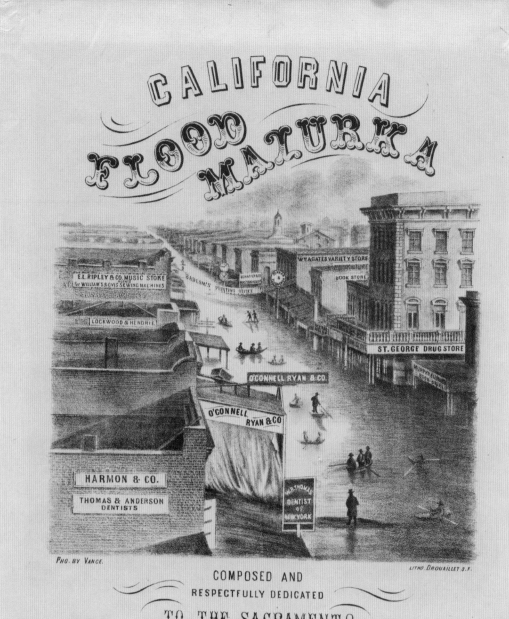

PLATE 4-7. Attributed to
Charles (Carlos) Joseph
Hittell, *Flood, Feb 17th '81
Sacramento*, 1881; drawing
on paper: pencil; 4¼ x 10 in

THIS AMUSING IMAGE OF San Francisco (Plate 4-8) chronicles a day in November 1849 when the city received a reported nine inches of rain. It also serves as a reminder of the trying mud problem experienced by denizens of this gold rush port in its early days. Frank Marryat did not actually witness this scene—he arrived in San Francisco in 1850—but he offers a secondhand historical account of the muddied town:

"It is said that . . . the whole town . . . was a perfect quagmire; all rubbish and hard materials that could be procured were thrown into the streets to form a pathway, but to no purpose, for owing to the peculiar soil of the place, the mud was unfathomable. . . . [I]n those streets which had been connected by means of a pathway of bales of damaged merchandise, it was necessary to exercise great caution in crossing, for one false step would precipitate the unwary passenger into a slough on either side, in which he stood a chance of meeting a muddy grave.

Satirical views of West Coast conditions frequently emerged from East Coast and European artists and printers. The message here seems to be that if you care to join the goldseekers, you will be subjected to all kinds of danger and indignity, regardless of your station in life.

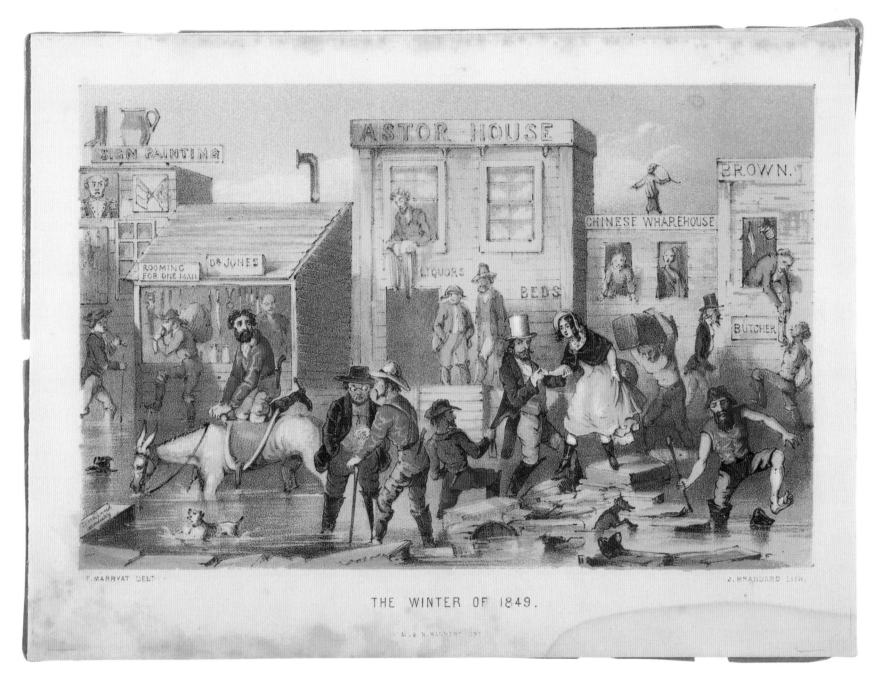

THE WINTER OF 1849.

PLATE 4-8. Francis Samuel Marryat, artist; J. Brandard, lithographer, printed by M. & N. Hanhart, *The Winter of 1849*, 1855; print on paper mounted on board: lithograph, color; 5 x 7 in

The letter sheet, with a newsworthy image on the front and a blank writing space on the back, was a popular type of stationery in the nineteenth century. In *Pacific Arcadia*, Claire Perry suggests that publications such as these served political purposes, helping promoters to shape perceptions of the West in the minds of outsiders. Two examples, the *Assassination of James King of Wm.* and the *Execution of José Forner*, may have been intended to displace images of the notorious barbarism and lawlessness of western settlements with impressions of command and control.

In the letter sheet depicting the assassination of James King of William (Plate 4-9), the text is clearly biased in favor of the actions of the members of the Committee of Vigilance, who took it upon themselves to try to hang the murderer, James Casey, as well as Charles Cora, who had shot a U.S. Marshal. Interestingly, the illustrator has chosen to depict the "assassination" in close detail, down to the smoke issuing from the gun, whereas the emphasis in the "execution" is on the crowd—a large but orderly mass of citizens doing their civic duty—and on the rectilinear plane of the plaza and buildings. Two minuscule figures hanging from the second story of Fort Gunnybags to the left of the frame are the only evidence of the actual hanging.

James King of William was the founder of the *Evening Bulletin*, a four-page publication that served up rabble-rousing invective against crime. In it he accused Casey, a city supervisor, of having been incarcerated in a New York prison before taking his public post. Until the very moment of his death, Casey continued to assert that his actions were merely the appropriate response to the insult.

As a bonus, the verso of this letter sheet presents the correspondence between San Francisco resident Robert N. Cropett and his "Friend 'Billy'" in South Boston. The writer mentions bad times but does not address the assassination directly, stating only that "our city as you will see by papers is in a bad state, hope these troubles may be soon Ended.

God only knows what will be the final result hope as I did at first for best." In the next sentence the letter abruptly changes topics to the mundane: "Billy, did you leave your watch. I have one I think must be yours in my drawer." Some writers made no reference—oblique or otherwise—to the pictorial element on their stationery; a somber letter sheet about a brutal crime might contain a complaint from a son to his mother about his lack of socks.

The image of José Forner hanging from the gallows (Plate 4-10) also presents a well-behaved crowd of onlookers, but the figure of the hanged man takes a vivid central role in the composition. The headlands in the background and the gossamer ships in the bay give this image a serene, pastoral quality, as if the execution were a reaffirmation of the natural order. According to his confession—also published as a letter sheet—Forner's crime was that he had stabbed his assailant, José Rodrigues, after Rodrigues had held him up with his own knife.

ASSASSINATION

Pub. by Britton & Rey. FUNERAL OF J. KING.

Assassination of James King of Wm.

BY JAMES P. CASEY.

San Francisco May 14th, 1856.

This city was thrown into a great state of excitement to day, by the assassination of Mr. King.

THE ASSAULT.

Mr. King did not draw any weapon, but was met in the midst of the street by Casey, who said, "Are you armed?"—to which Mr. King made no reply but looked at Casey.— Casey threw off his cloak and presented a large navy revolver, saying — "Draw and defend yourself," at the same time taking deliberate aim and covering his victim with a well directed shot, the result of which is known.

He then cocked the pistol again, but seeing his opponent stagger into the Pacific Express office, did not attempt a second shot; some person caught hold of him and told him to give up his arms, which he refused, and showed fight; but on the approach of two or three officers, he remarks that he would go, but they must not take his arms, as he was not going to be hung.

The horrible and heart-rending occurrence, the shooting down of Mr. King in broad daylight, in the public street, has justly aroused the indignation of the entire community.

THE CAPTURE FROM THE JAIL, MAY 18TH.

The Executive Committee were formed into a solid square of about ten deep, directly in front of the jail, and the "Citizen's Guard" formed a hollow square about them, and all appeared ready for action. A deputation of the Committee were delegated to call at the door and request the Sheriff to place them in possession of the prisoner, Casey. Without any hesitation the Sheriff repaired to the cell of the prisoner and informed him that the Vigilance Committee were waiting at the door and demanded his person, and that he was compelled to yield him up.

THE FUNERAL MAY 22ND.

Long before the hour fixed for the ceremonies at the church, Stockton street was literally thronged by men, women and children, almost blocking up the street, from Washington to California street.

At the conclusion of the church services, the most imposing procession we have ever witnessed in California, was formed, and followed the remains to Lone Mountain Cemetery.

The procession moved along Stockton street to Washington, thence down to Montgomery, thence to Bush and up Bush to the Lone Mountain Cemetery. The time occupied in passing a point which is Montgomery street, was thirty-five minutes. When the last portion of the procession left the corner of Stockton and California streets, its front had reached the corner of Dupont and Bush, a distance of about one mile.

EXECUTION OF CASEY AND CORA.*

While the last tokens of respect were being paid to the memory of Mr. King, at the church, a very different proceeding was going on at the Rooms of the Vigilance Committee.

Notwithstanding the great gathering at the funeral, the rooms of the Committee were surrounded by about 20,000 people, who had got an intimation of the proposed execution, and hurried to the spot.

The most formidable guard was arranged, which embraced all the arms of the Committee, consisting of about 3,000 stand of muskets and two field pieces. The streets in the immediate vicinity of the rooms were cleared by the soldiers, and the bristling bayonets that were displayed in every direction, made the scene one of great solemnity. One of the field pieces was planted so as to command Davis street from Sacramento street, and the other so as to command Front street.

At 20 minutes past one, o'clock every thing being ready to carry out the designs of the executioners, the signal was given and the cord that held up the outer end of the scaffolds, or platforms, was cut upon the roof of the building, and the doomed men were both launched into eternity. During this solemn and awful ceremony a perfect stillness and silence was observed by the vast throng who were spectators in the scene.

* Cora was executed for the murder of Gen. Richardson.

SURRENDER OF THE JAIL

EXECUTION

PLATE 4-9. Published by Britton & Rey, *Assassination of James King of Wm. by James P. Casey, San Francisco May 14th, 1856*, 1856; print on paper: lithograph; 10⅞ x 16⅝ in

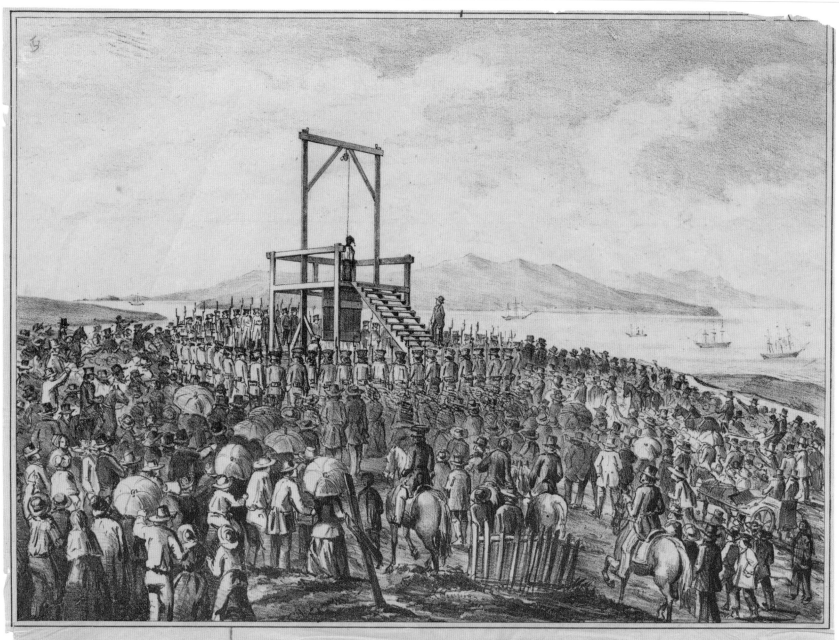

EXECUTION OF JOSE FORNER, DEC. 10, 1852.
on Russian Hill San-Francisco,
FOR THE MURDER OF JOSE RODRIGUES

PLATE 4-10. Justh, Quirot & Co., lithographers; printed by Noisy Carrier's Book and Stationery Co. (Ch. P. Kimball), *Execution of José Forner, Dec. 10, 1852. On Russian Hill San-Francisco, for the Murder of José Rodrigues*, 1852; print on paper: lithograph; 8 x 10 in

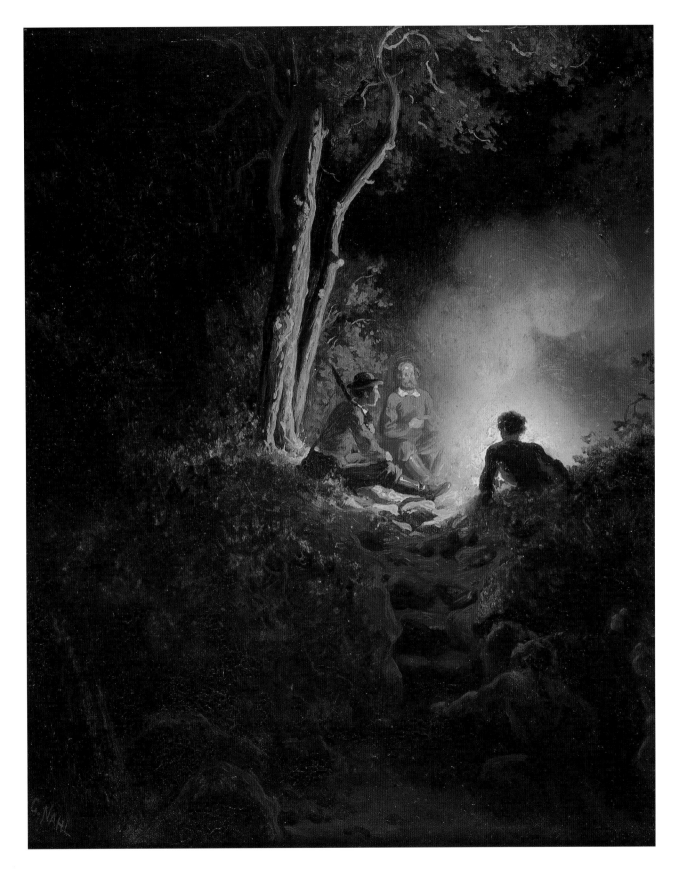

PLATE 4-11. Charles Christian Nahl, Untitled (Indian Ambush), c. 1860s; painting on board: oil; 12 x 9⅝ in

Exponentially more Native Americans died of diseases spread by Euro-Americans than settlers perished at the hands of hostile tribes. Nonetheless, stories of "redskins" assaulting parties of trappers and settlers with axes, taking scalps, and even drinking the blood of the dead terrified American audiences and, as the ubiquity of literature and art on the subject indicates, titillated them.

Charles Nahl's personal experiences may have inspired this painting (Plate 4-11). The German-born Nahl and his family arrived in a gold mining camp in California in 1851. The characters in this scene sport neat European garb, up to their white collars, as the Nahls likely did in their early days in their new country. And the figure with the hat strongly resembles Charles Nahl's brother Arthur. Nahl frequented a village near their mining camp to make a close study of Native Americans. In this image, however, the Indians are hardly discernable, mere phantoms in the night.

Although Englishman Arthur F. Tait never ventured farther west than Chicago, he created numerous paintings about life on the frontier, often translated into prints by Currier &

Ives. In *American Frontier Life*, (Plate 4-12) something suspiciously similar to English ivy climbs the large tree in the composition. Tait, as was common, portrays the hunters as steady and neatly clothed, while the Indians appear as half-naked savages on a rampage. In fact, assuming these men are trappers—as they appear to be—they and their Indian counterparts had much in common. Bernard DeVoto, in *The Year of Decision: 1846*, recorded the comments of trapper Jim Beckwourth on the ways of these hunters:

He dressed like an Indian in blankets, robes, buckskins, and moccasins, and it was sometimes his humor to grease his hair and stripe his face with vermilion. He lived like an Indian in bark huts or skin lodges, and married a succession of squaws. He thought like an Indian, propitiating the demons of the wild, making medicine, and consulting the omens. He had on call a brutality as instant as the Indian's and rather more relentless.

Tait's image presupposes an immutably adversarial relationship between trapper and Indian, with attacks always initiated by the latter; a preemptive strike—as indicated in the subtitle "The Hunter's Stratagem"—

would be the logical recourse. Tait made this image retrospectively, as the trapper was on the extinction list by the date of the print, and likely researched the work of other artists, such as Ranney (Plate 1-9).

Samuel Colman's *Emigrant Train* is also a retrospective image. When he painted the stark rock formations of this landscape (Plate 4-13), in the 1870s, its former inhabitants, the Ute Indians of Utah and Colorado, were being forcibly relocated to a single reservation in Utah. Travel on the overland trail by wagon train had become a thing of the past upon the completion of the transcontinental railroad in 1869. Moreover, Indians very rarely assaulted wagon trains such as this one. Whether or not Colman knew the statistics on such attacks, he would have certainly understood the primordial effect of this subject matter on his audiences.

Son of a bookseller and publisher, Colman was a second-generation Hudson River painter, based in New York and Rhode Island. While history records his visits to the Pacific Coast in the 1870s and again in 1899, he may never have set foot in the landscape rendered in this painting.

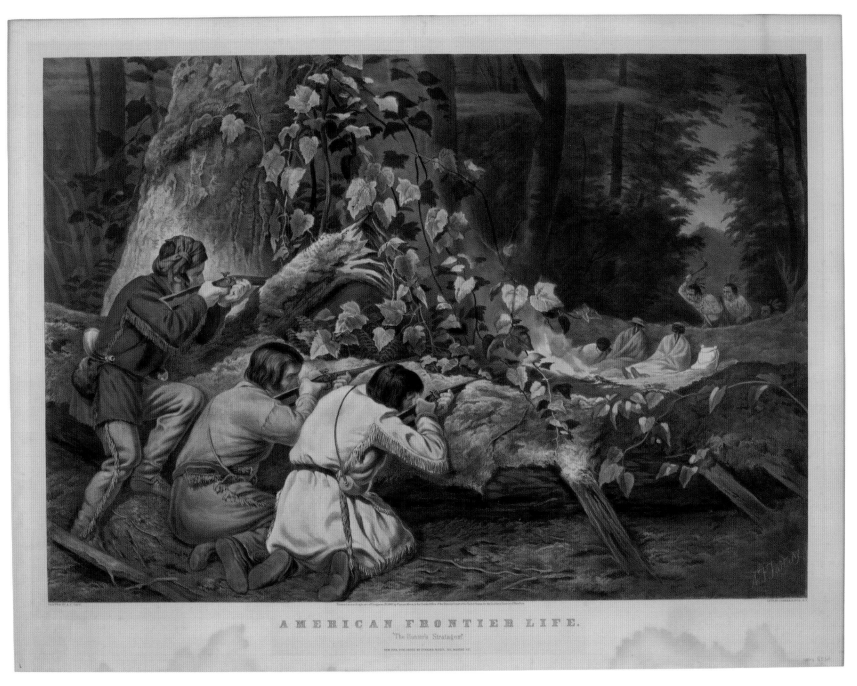

AMERICAN FRONTIER LIFE.

"The Hunter's Stratagem"

PLATE 4-12. Arthur Fitzwilliam Tait, artist; published by Currier & Ives, lithographers, *American Frontier Life: "The Hunter's Stratagem,"* c. 1862; print on paper: lithograph, hand colored; 22 x 29⅝ in

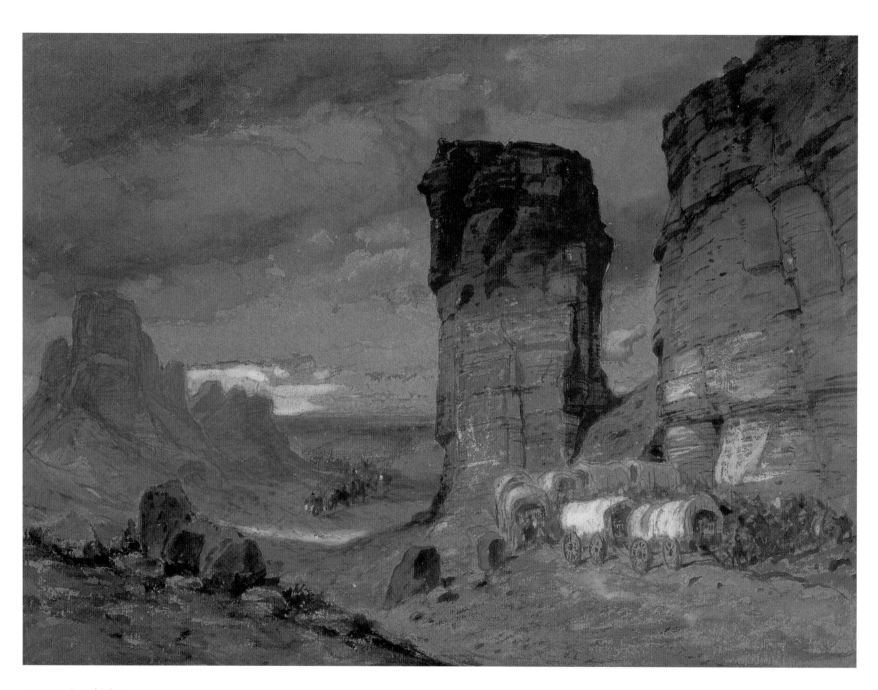

PLATE 4-13. Samuel Colman,
*Emigrant Train Attacked by
Indians, Ute Canyon, Utah,*
c. 1870s; painting on tinted
paper: watercolor and
gouache; 9 x 12⅞ in

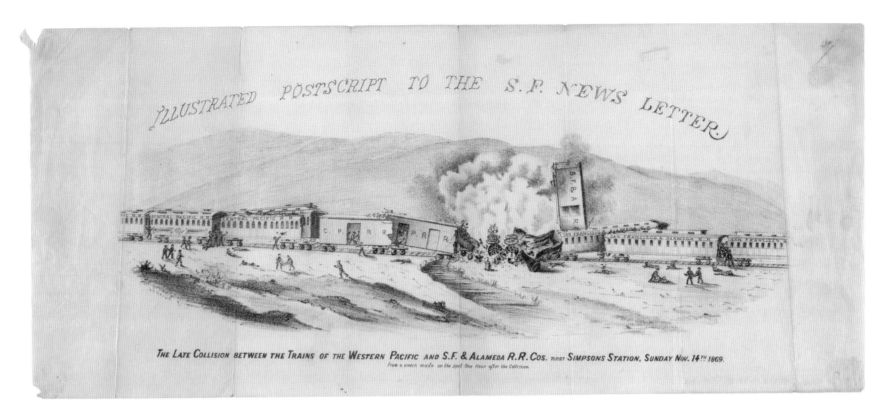

ILLUSTRATED POSTSCRIPT TO THE S.F. NEWS LETTER

THE LATE COLLISION BETWEEN THE TRAINS OF THE WESTERN PACIFIC AND S.F. & ALAMEDA R.R. COS. near SIMPSONS STATION, SUNDAY NOV. 14TH 1869.
From a sketch made on the spot One Hour after the Collision.

PLATE 4-14. Published by "San Francisco Newsletter," *The Late Collision between the Trains of the Western Pacific and S. F. & Alameda R. R. Cos. near Simpsons Station, Sunday Nov. 14th, 1869,* 1869; print on paper: lithograph; 7 x 17 in

Mere months after the triumphal celebration of the joining of the transcontinental railroad, two passenger trains collided in Northern California. More than a dozen people were killed. This letter sheet (Plate 4-14) details a confusion of wheels and stacks where the engines demolished each other, with a derailed car on its end pointing to the sky. People lie on the ground by the wreckage, and rescuers carry bodies away from the cars. The *Oakland Daily News* was philosophical about the calamity: "So long as railroads are used accidents will occasionally occur." More than occasional, train wrecks registered in the thousands by the end of the century in spite of improved safety measures. Accidents were popular spectacles, drawing people from neighboring towns to gawk at the ruins of locomotives. They were so entertaining that William George Crush, general passenger agent of the Missouri-Kansas-Texas line, actually staged a collision between two trains, which forty thousand people attended. When both boilers exploded, shrapnel killed two spectators.

FIRE IN SAN FRANCISCO.

In the Night from the 3ᵈ– 4ᵗʰ May, 1851.

Loss $ 20,000,000.

S OME HAVE SAID THAT LIVING in San Francisco between 1849 and 1851 was a "baptism by fire." The town, so hastily assembled out of tents and ship hulls and wooden lean-tos, was highly susceptible to the ravages of a blaze. Remarkably, San Franciscans, in spite of their losses, rebuilt repeatedly. Each fire brought improvements in city services and construction, but the destruction continued. Some fires were accidental, others set by arsonists. The statistics are astounding: six major fires broke out between December 24, 1849, and June 22, 1851.

Frank Marryat witnessed these events and, putting aside his usual witty tone, offered a wrenching account of the catastrophe pictured on this letter sheet (Plate 4-15):

No conception can be formed of the grandeur of the scene; for at one time the burning district was covered by one vast sheet of flame that extended half a mile in length. But when the excitement of such a night as this has passed by, one scarcely can recall the scene. The memory is confused in the recollection of the shouts of the excited populace—the crash of falling timbers—the yells of the burned and injured—the clank of the fire-brakes—the hoarse orders delivered through speaking-trumpets— maddened horses released from burning livery stables plunging through the streets—helpless patients being carried from some hospital, and dying on the spot, as the swaying crowd, forced back by the flames, tramples all before it— explosions of houses blown up by gunpowder—showers of burning splinters that fall on every side—the thunder of brick buildings as they fall in a heap of ruin—and the blinding glare of ignited spirits.

Unlike Marryat's prose, this bird's-eye view of the great fire of May 1851 keeps viewers at a comfortable distance from the flames, showing the people fleeing from the fire like so many ants. A correspondent thought to mark the spot on this letter sheet where the conflagration started.

PLATE 4-15. Justh & Co., lithographers, *Fire in San Francisco in the Night from the 3rd–4th May, 1851,* 1851; print on tinted paper: lithograph; 9 x 11 3/8 in

PLATE 4-16. Edward Jump, *Earth Quakey Times, San Francisco, Oct. 8, 1865*, c. 1865; print on paper: lithograph, color; 25 x 37⅜ in

In the nineteenth and early twentieth centuries, Californians were particularly sensitive to the potential instability of the earth beneath them, and promoters attempted to downplay seismic activity. Referring to the 1865 earthquake in San Francisco, estimated by the U.S. Geological Survey at magnitude 6.5, Hubert Howe Bancroft stated dismissively that the quake "merely cracked a few weak walls." Mark Twain was less nonchalant after witnessing a streetcar passenger hurled halfway through a window as the event unfolded. Afterward he created a satirical "Earthquake Almanac," including these four entries:

> Oct. 25.—*Occasional shakes, followed by light showers of bricks and plastering. N. B.—Stand from under.*
>
> Oct. 26.—*Considerable atmospheric foolishness. About this time expect more earthquakes, but do not look for them, on account of the bricks.*
>
> Nov. 2.—*Spasmodic but exhilarating earthquakes, accompanied by occasional showers of rain, churches and things.*
>
> Nov. 8.—*The sun will rise as usual, perhaps; but if he does, he will be staggered some to find nothing but a large round hole eight thousand miles in diameter in the place where he saw this world serenely spinning the day before.*

Similarly, Edward Jump took a mordant view in his *Earth Quakey Times* (Plate 4-16). This image is at once humorous—a series of pratfalls performed by comedic characters—and horrifying, as we witness a man and a woman being hurled from windows, possibly to their deaths. Jump's cartoons and caricatures secured his popularity in the public mind, but on the tragic-to-comic continuum exhibited in his work, Jump landed on the unfortunate end. In a drunken stupor, the French-born artist shot himself in the head at the age of forty-five.

All reasonable efforts to quell seismic squeamishness attended the great earthquake of 1906. The magnitude-8 event caused unimaginable devastation, first from the severe shocks and then by the enormous conflagration set off by bursting gas mains: 4.7 square miles were leveled, 28,188 buildings demolished—about half the built area of the city was burned. The damage registered at a billion dollars, and the death toll has recently been estimated at twenty-five hundred. City and state administrators immediately embarked on their own form of damage control, which was to craft public perceptions of the calamity in what they believed was their favor. Now the history of repeated fires in San Francisco became a boon: incendiary events had only caused the city to renew itself with greater vigor, increasing property values manyfold. Images such as *The Burning of San Francisco* (Plate 4-17) were important promotional tools. Although the subtitle reads, in very small type, "The Greatest Conflagration in the History of the World," the image shows the flames and smoke in the distance and in only one part of the city. The condition of the buildings closest to the viewer is difficult to discern—some still seem to be standing, while others may have melted. In reality, only six major structures remained intact in the fire zone when the flames died down.

THE GREATEST CONFLAGRATION IN THE HISTORY OF THE WORLD.

SCHMIDT LITHOGRAPH. CO. S.F.

"THE BURNING OF SAN FRANCISCO" APRIL 18, 19, 20, 1906.

OVER 450 SQUARE BLOCKS WERE DESTROYED WITH A LOSS OF OVER 500 MILLION DOLLARS.

IN THE ABOVE SCENE THE FIRE LINE IS OVER FIVE MILES IN LENGTH ON THE EVENING OF THE FIRST DAY.

PLATE 4-17. Carl A. Beck, artist; printed by Schmidt Lithograph Company, "*The Burning of San Francisco*" *April 18, 19, 20, 1906: The Greatest Conflagration in the History of the World*, c. 1906; print on paper: lithograph, color; 25 x 37 3/8 in

Chapter Five

Enterprise

Providence, casting her eye into the far future, had need to assemble a million men in a given corner of the hemisphere, so gold served for her excuse. Later on she will supply them with industrial activities by way of compensation.

Alexandre Dumas, A Gil Blas in California

I WAS twenty-four years old and out of work," begins Alexandre Dumas's nineteenth-century picaresque narrative about a young gold seeker. "Throughout France the sole topic of conversation at this time was the gold mines of California." In *A Gil Blas in California*, the young protagonist comes to America to try his luck prospecting, but by the time this "true" account winds to its philosophical close, he has plied the trades of lumberman, porter, miner, hunter, waiter, wine merchant, and sailor. The Frenchman's serial careers happen as much by choice as by the necessity that ensues when his ambitions collide with one obstacle after another. Dumas introduced this work to his editor with a letter claiming that it was the actual journal of a man he had met in France. After it was published, much scholarly debate ensued about the authorship of *Gil Blas*—was it Dumas's imaginings or did the adventurer actually exist? Two things are certainly true about this account: multiple careers were common during the gold rush, and everything about the business enterprises of California in the second half of the nineteenth century was more complicated than it appeared.

This suite of images from the Honeyman Collection, a small sampling of those devoted to enterprise in the period between the 1840s and 1900, hints at both the diversity and the complexities of the economy on the Pacific Coast. The works focus overwhelmingly on California; the productiveness of California's soil and the delirium of "gold fever" spawned a surfeit of compelling stories.

Taken as a whole, these images reveal certain truths about industry in California and debunk one pervasive myth of the nineteenth century. Nothing looms larger in the iconography of the American West than the notion of the fiercely independent individual. The lone trapper and prospector who appear in the first chapter of this book are perfect examples. A spate of books, films, and artworks bolsters the myth of the frontier loner working for no one but himself, making up his own rules, often with the stated or unstated suggestion that he (and they were overwhelmingly male) is an antisocial outcast. But walking through these images, we are in the company of groups of men and women working collaboratively, and we observe the signposts of highly structured systems.

California defied the efforts of the solitary entrepreneur in most of her primary industries. Surface deposits of gold, easily mined by the individual, played out early. New techniques designed to exploit deeper

layers of earth or process more soil required cooperative efforts and better equipment. In the progression of images here, we first see picks, shovels, and pans; then rockers and cradles operated by two or three people; followed by the use of sluices and waterwheels built and operated by larger crews; and finally hydraulic mining, which employed significant manpower. Hard-rock extraction propelled entire spin-off industries such as the manufacturing of explosive powder and mercury mining, also shown here. With organized efforts (and more people mining), gold production shot up from $245,301 in 1848 to the all-time high of $81,294,700 in 1852. In fact, Dumas's narrator, who worked in partnership with one fellow countryman, despaired over the necessity for collaboratives:

> All the workers found gold, but it was only those who were organized in large groups that accomplished anything. But societies or rather group organization with its concomitant responsibilities are naturally distasteful to Frenchmen; whereas, on the other hand, Americans seem to have a predilection for organization.

Although the generalizations are specious at best, it is noteworthy that this narrator believed that Americans were so cooperative—contrary to frontier mythology.

Many, like the narrator of *Gil Blas*, had little to moderate success in the mines, and the expense of equipment at grossly inflated prices usually equaled or exceeded their take. But there were many more opportunities to strike it rich. The industries that grew up around mining, or that found new markets and thus expanded, offered an escape from the hard labor and disappointment of the mines.

With a voracious demand for wood to build homes for the onslaught of argonauts and to make mine shafts, elaborate water-diversion systems, and other equipment, the lumber industry exploded. In 1849, at the start of the gold rush, the ten or so sawmills in California produced approximately twenty-five million board feet per year; ten years later, the aggregate of lumber concerns generated around twelve times as much: three hundred million board feet annually.

The first professional loggers in this territory were disenfranchised sailors who deserted their ships and fled to the woods around San Francisco and Monterey. Beginning in the 1820s, these fugitives sold timber to anyone who would handle it. Others joined them, and eventually there was a kind of "timber rush" that brought entrepreneurs from the East Coast and loggers from all parts. The rules of the trade were altogether different from those of eastern forests, where the ratio of lumberjack to tree was one to one. The easy prey of an efficient saw, eastern white pines average one hundred feet tall and two to three and a half feet in diameter. The primary lumber tree of the West, the Douglas fir, averages twice that height, and some giant redwoods sport ninety-foot girths. It took a team of men to fell trees and haul timber. Getting the wood to market demanded new transportation networks, as documented in two images in the Honeyman Collection (Plates 5-13 and 5-14).

California's enormous trees were just one feature of an embarrassment of riches that also included fertile soil and a temperate climate. The Spanish padres had discovered that Mediterranean species—fruits, vegetables, and nuts—grew in their mission gardens,

although the requirements of these crops delayed their production on any significant scale for three-quarters of a century. Instead husbandry focused on cattle and wheat: the former grazed freely on sprawling, unfenced ranchos; the latter flourished without special irrigation and could be shipped long distances without spoiling. The vicissitudes of the California climate — in this case drought and flood — severely curtailed the cattle industry in the 1860s, while wheat farming, suffering from overproduction, competition, and exhausted soils, diminished in importance after the 1880s.

To deal with the terra incognita of California, farmers shared information and pooled resources from the time of the earliest American settlements. Later, in the 1870s, when growers turned to delicate specialty crops, these groups became even more powerful, particularly as marketing and lobbying cooperatives. The most successful of them, the California Fruit Growers' Exchange, emerged in 1893 and became famous under its logo, Sunkist.

Specialty crops precipitated the development of extensive irrigation systems, such as the one depicted in Thomas Hill's pastoral painting "Irrigating at Strawberry Farm" (Plate 5-16), and they demanded sophisticated transportation methods. The railroad played a key role in getting agricultural products to consumers, as illustrated in *A Birds-eye View on the Cattle Ranch of Daniel McCarty* (Plate 5-17) and *Nouveau Medoc Vineyard and Wine Cellars* (Plate 5-18).

Although the artists represented here probably did not set out to reveal evidence of systems in a culture that lionized individualism, they were well aware of the universal popularity of the concept of progress — the ethos of organized enterprise. In the nineteenth century, progress superseded all other values; to most Americans, the loss of natural beauty registered as an unavoidable consequence of civilization. This message comes through clearly in Grafton T. Brown's lithograph of the silver mines of Virginia City (Plate 5-12), a collage of factories, their industrial stacks proudly pumping smoke into the air.

A more complicated and subtle treatment of this subject can be inferred from the oil paintings of Ernest Narjot, Alexander Edouart, and an unknown artist who captured a hydraulic mining scene in Weaverville. All three of these mining depictions feature tree stumps, which, according to art historian Nicolai Cikovsky Jr., often symbolized progress in nineteenth-century American art. In his persuasive 1979 essay, "The Ravages of the Axe," he records the strong yearning of American settlers to clear the land of trees and be rid of these impediments to human advancement. James Fenimore Cooper's woodsman from *The Pioneers*, for example, calls trees "a sore sight at any time, unless I'm privileged to work my will on them." The three stumps in Edouart's painting of the Enrequita mine at New Almaden (Plate 5-8) may be a sore sight to modern eyes, but in the value system of the day, they are offset by the display of civilization — in the form of a religious ceremony — below. In the rendering of hydraulic mining (Plate 5-7), corpses of trees rest on the artificially created canyon floor while water jets slice through a forested hillside, as if the remaining trees marked the distance left to conquer. Cikovsky also points out that the tree stump is the "emblem of

the white man's civilization, the stump represent[ing] the very cause of the Indian's lamentation." In Narjot's painting (Plate 5-5), a lone Indian, his back to the viewer, observes a mining operation. Perhaps not accidentally, the Indian, the largest human figure in the work, is parallel to a truncated tree standing prominently in the composition. Cikovsky concludes that the stump represents a duality in American thinking about the march of civilization: it is both the positive subjugation of nature and a melancholy reminder of mortality—of a past that can never be recaptured.

Along these lines, artists often tried to place industry within the natural order of things. In *California Powder Works* (Plate 5-11), the factory takes on the same hues of the landscape, and the fuming smoke replicates the clouds on the skyline. Artists were guilty of other distortions and manipulations—often for the sake of audience—in their portrayals of enterprise. Many tried to appeal to the miners who might buy the works, often in lithographic form, as well as the "folks" back home. In a mid-century lithograph by a French printing company (Plate 5-2), a ship in the harbor flies what seems to be a French flag, and Frenchmen wearing something like Phrygian caps (the renowned liberty cap) assume the role of arbiters of the bullion exchange. The English music sheet *Pull Away Cheerily!* (Plate 5-3) is ridiculous on a number of levels, especially in its assertion that mining is a wholesome family activity in which children playfully participate. Conversely, a stereotypical depiction of Chinese miners (Plate 5-4) confirmed public prejudices.

As with literature, such as Dumas's *Gil Blas*, the reality of nineteenth-century California, its industry, and its people is hard to distill from the fiction of its visual art. The range of styles and diverse agendas in this selection confront us with the complexity of the era, while the naiveté and pastoral quality of many of the images lull us into an impression of simplicity, of innocence. Any juxtaposition of this type elucidates meaning as much as it creates new mysteries, drawing us deeper into the images and uncovering new areas for future viewers of the Honeyman Collection to mine. ❧

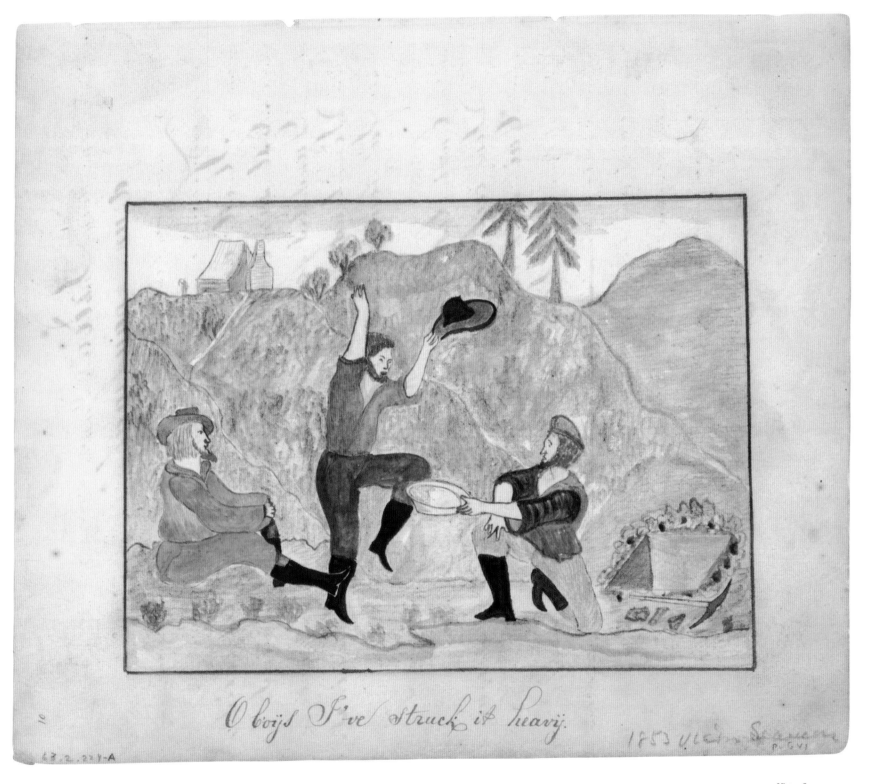

O boys I've struck it heavy.

1853 Victor Seamon
P. 641

PLATE 5-1. Victor Seamon,
Oh Boys I've Struck It Heavy,
1853; drawing on paper:
watercolor, pen, and pencil;
6 x 7 in

PLATE 5-2. Dembour et
Gangel, *Découverte des riches
mines d'or de Sacramento en
Californie* (Discovery of Rich
Gold Mines in Sacramento,
California), c. 1848; print on
paper: woodcut, hand colored;
7 x 11 in

THE CRY OF "GOLD!" IN California was answered all over the world, not only with pick and shovel, but with pencil and sketchbook. Little is known of Victor Seamon, who created the naive, charming image (Plate 5-1) of a small group of miners. Its oddities include the identical boots and elfin feet of the men; the blob of yellow shapes resting in a gold pan; and the perfectly square, perfectly smooth hole that represents their diggings. Still, this simple rendering makes us want to dance a jig to celebrate the good fortune of *Oh Boys I've Struck It Heavy*.

A view of Sacramento during the gold rush (Plate 5-2) by a French publisher collapses both time and space. We might easily mistake it for a village in medieval Europe. Here the diggings are portrayed as proximate to an urban center and what was probably San Francisco harbor. Mining camps were, of course, much more remote and rugged than this scene suggests. The back of this print contains text reporting true accounts of fabulous wealth and a poem idealizing California and its golden prospects, at the same time that both narratives posit the message that the French should not jump into the greedy fray for individual gain, but instead take advantage of the situation for the betterment of the country. This crudely hand-colored woodcut is in the French genre of *epinal* prints, which were inexpensive renderings of social types and of tradespeople.

PLATE 5-3. Published by Musical Bouquet Office, *Pull Away Cheerily! The Gold Digger's Song*, 1800s; print on paper: engraving; 14 x 10 in

Presenting a far-fetched view of the diggings, a music sheet in the collection (Plate 5-3) turns gold mining into child's play. This portrayal would have appealed to the families of argonauts and the curious who stayed behind. In reality, mining was backbreaking, often dangerous work, and the tenor of the diggings was hardly suitable for children. Nor do the lyrics to "Pull Away Cheerily!" betray any sense of irony: "There's Dick a young digger / Works a cradle much bigger / Than his own little self." However winsome the idea of a baby rocking the device known as a "cradle," this piece of equipment required three men to operate — one who shoveled dirt, one who poured water over it, and one who did the rocking.

Misperceived by Americans as slaves, many Chinese miners were in fact indentured to contractors for the fare to San Francisco, which they were rarely able to repay and have enough left over to return home. Many lived in horrible conditions and earned pitiful wages for their work in the mines, but some formed companies and earned enough money to buy claims. Americans resented this competition and lobbied for a revival of the Foreign Miner's Tax Law, under which anyone not eligible for citizenship, which by statute included everyone but "free, white people," paid a monthly tax. When this did not suffice in driving out the "Celestials," white miners resorted to beatings and lynchings. The Chinese had no legal recourse — classed with Indians, they were prohibited from testifying against whites. In 1882, Congress pushed the racism still further with the Chinese Exclusion Act, prohibiting workers from entering the United States on the basis that "the coming of Chinese laborers to this country endangers the good order of certain localities within the territory thereof."

In Stewart Edward White's disquisition on the market for gold rush images in his 1939 book *Old California*, he claims (erroneously) that the Chinese were the only nonwhite ethnic group to appear in mining lithographs of the period. In his analysis, "The Celestial differed so radically from any other human being . . . that he took rating not so much as a human being [but] as a natural curiosity, sure of certain sale along with 'Mammoth Arbor Vitae' . . . and similar picture-postals of instructively educational character."

CHINESE, GOLD MINING IN CALIFORNIA.

PLATE 5-4. Unknown artist, *Chinese, Gold Mining in California*, c. 1850s; print on paper: engraving; 4 x 4 in

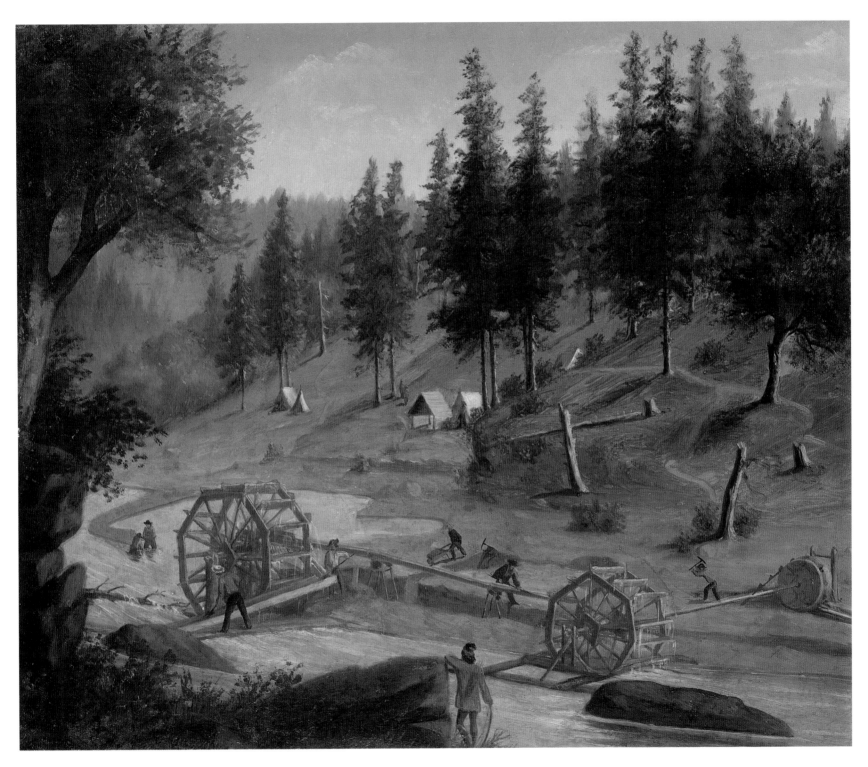

PLATE 5-5. Ernest Narjot,
Untitled (Placer Mining at
Foster's Bar), 1851; painting
on millboard: oil; 11 x 13⅞ in

As GOLD BECAME SCARCER and harder to extract, mining operations employing more sophisticated technologies and greater numbers of people began to subsume small concerns. The scheme of waterwheels in this image by Ernest Narjot (Plate 5-5) diverted water into sluices in order to wash a far greater amount of gold-laden soil than could be managed with rocker and cradle. Sluices, and their shorter relatives, long toms, functioned in essentially the same way as rockers but were more efficient. As illustrated here, teams of eight or so men built, operated, and tended these structures with which they could process up to one hundred cubic yards of dirt a day. Water played a monumental role in gold mining, and larger companies often diverted and dammed rivers to obtain it. In 1851 the entirety of the American River — thirty miles long — was temporarily rerouted from its natural channel.

Experienced Mexican miners introduced a number of gold mining tools in California, such as the *arrastra* shown in Plate 5-6. Harnessed animals propelled stones around a circular, rock-lined basin, gleaning precious mineral deposits from hard rock by crushing the gold-veined granite brought up from deeper mines. This image shows the Chilean improvement on the technology — the stone wheel. Pulverized rock then fed into cradles where it could be rinsed for gold. The noise of the arrastra — stone crushing stone — must have been boneshaking, but this pleasant scene — the only known work by J. Boot — featuring a rounded worker with delicately thin, crossed suspenders strikes the viewer more as an agrarian landscape than as a documentary of mining.

With the invention of hydraulic mining in the early 1850s, high-powered hoses began boring through the landscape with terrible ferocity. The equipment was immensely expensive and a sizable labor force was needed, but the technique was highly successful, if dangerous. The force of the water and other hazards sometimes took lives. An account from *Beadle's Monthly* of August 1866 offers this graphic description:

At ten feet from the nozzle it would cut through a man like a cannon-ball. At forty feet it would crush him to jelly. . . . Sometimes the undermined hills cave in, and bury the laborers. While working, they glance up uneasily at the melting hill, which, any instant, may fall upon them.

Hydraulic mining was an environmental catastrophe. Debris-filled streams devastated farming in some areas and caused flooding in others — such as one major inundation of Sacramento. Eventually an 1884 federal injunction restricting hydraulic mining effectively terminated it.

With its tiny figures of men (and even a small goat watching the spectacle from the precipice above) and brilliantly white clouds of water, *La Grange Mining Co.* (Plate 5-7) possesses charms that hydraulic mining did not. Distant and elevated, this point of view makes the mining operation look like a depopulated ant farm. The complex of trestles, sluices, and hoses pulls the eye toward the jets of water cutting into the hills; the barren foreground is the evidence of this operation's efficient destruction.

PLATE 5-6. J. Boot, *California Miners Working an Arrastra*, 1853; painting on paper: watercolor; 9 3/8 x 13 3/8 in

PLATE 5-7. Unknown artist,
La Grange Mining Co., Weaverville,
Trinity County, California, c. 1870;
painting on canvas: oil;
23 x 31 in

PLATE 5-8. Alexander Edouart,
Untitled (Blessing of the Enrequita
Mine), 1860; painting on canvas:
oil; 30 x 48 in

Extracting gold from hard rock also boosted another form of mining. Mercury, itself extracted from cinnabar, could be used to separate gold or silver from quartz. Also called quicksilver, mercury binds to these ores and forces out impurities. A final step separates the mercury from the gold using heat.

Named for the Almadén mine in Spain and established in 1845 before the discovery of gold, San Jose's New Almaden, the subject of two images in the collection, was the oldest mercury mine in California, and also the richest. These two images present a kind of upstairs-downstairs account. The oil painting by Alexander Edouart, situated on a hillside, shows the colorful celebration of the blessing of the mine, while the drawing by Fritz Wikersheim presents a bleaker view, of the processing plant below.

"The Blessing of the Enrequita Mine" (Plate 5-8) is perhaps Edouart's most important painting; shortly after it was completed, the London-born, California-based artist turned to the medium of photography. In all likelihood the owners of the mine, the Eldridge brothers, commissioned Edouart to paint a souvenir of the 1859 dedication. The two brothers are shown standing at opposite sides of the gathering, while a curate conducts the ceremony for the assembled workers and their families kneeling in front of the altar. Edouart seems to suggest a certain harmony with nature, while the reality of the full works of the mine, carried out in factory buildings below, appears only as a jet of steam to the lower right of the image. This work can be seen as an endorsement of the mine, an embodiment of nineteenth-century progress and civilization blessed by the Almighty. The idea of righteous progress seems further enhanced by Edouart's elevated view of the scene. There is no evidence of the dangers of working in the mine—the fumes from quicksilver smelting were so toxic that miners could only work for three weeks at a time. Small wonder that the workers are praying.

Down below, in what Wikersheim called the *asiento*, or seat, of the mine, are the buildings in which ore was processed (Plate 5-9). The large logs lining the road undoubtedly served as fuel for the furnaces, which apparently operated night and day. Wikersheim's far grimmer, industrial view is emphasized by the drawing's absence of color, by its numerous smokestacks, and by the gnarly limbs of the trees on the hill. In contrast to the Edouart, this work, part of an album of forty-five sketches in the Honeyman Collection, was likely made as a private record.

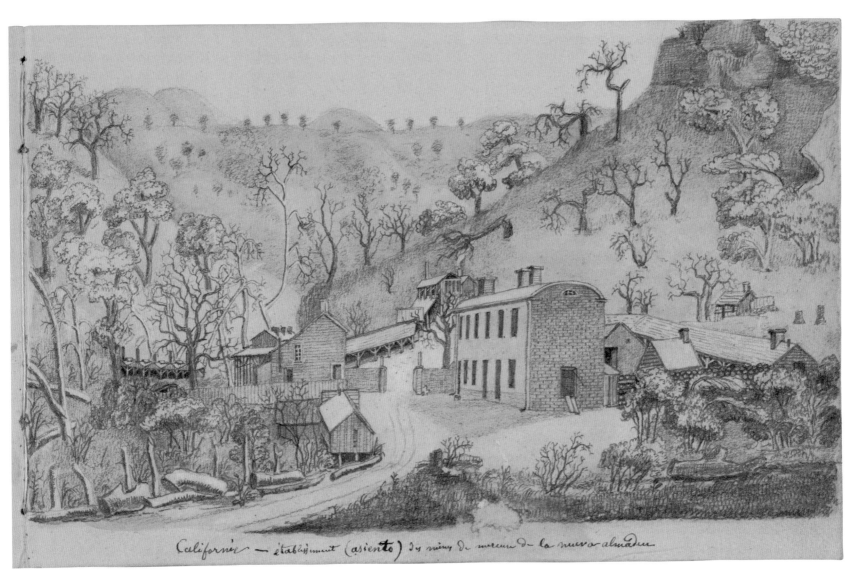

Californie — établissement (asiento) de mines de mercure de la nueva almaden

PLATE 5-9. Fritz Wikersheim, *Californie—Établissement (asiento) du mining de mercurie de la nueva almaden* (Factory [seat] of the Mercury Mine at New Almaden, California), 1845–51; drawing on paper: pencil; 5 x 8⅜ in

As placer mining in California became more and more difficult in the late 1850s, a few people headed over the Sierra Nevada to try their luck in what would become Nevada Territory. Efforts to find gold were thwarted by an abundance of a bluish clay. That clay turned out to be silver, and a new rush for precious metal began. Although he was the namesake for the new "lode," gold prospector Henry Comstock did not get rich from it. Many others did, however, including George Hearst, father of newspaper magnate William Randolph Hearst. As the center of the silver rush, Virginia City grew virtually overnight into a cosmopolitan center — its

six-story hotel boasted the only elevator west of Chicago. Numerous mines punctuated the new city, as shown here (Plate 5-12).

Silver mining presented multiple dangers. Miners had to worry about cave-ins, underground fires, and floods. When they penetrated rock below seven hundred feet, steam and scalding water spewed from crevices, propelling the miners into cages with hoisting mechanisms that (they hoped) would lift them to safety. As with all mercury-based extraction techniques, processing the ore presented other hazards — some of the mines are still contaminated.

This softly toned view of the

burgeoning city gives little indication of the dangers of silver mining, although, interestingly, the lower-left thumbnail shows a pile of slag, the unsightly detritus of the industry. Otherwise, this work has a clearly commercial agenda: advertising the city and its successful mines. The artist who created it, Grafton Tyler Brown, was the first professional African American artist to work in California. He founded his own lithography business in San Francisco in 1866 but later sold it to return to landscape painting. He was twenty-three when he made *Virginia City*.

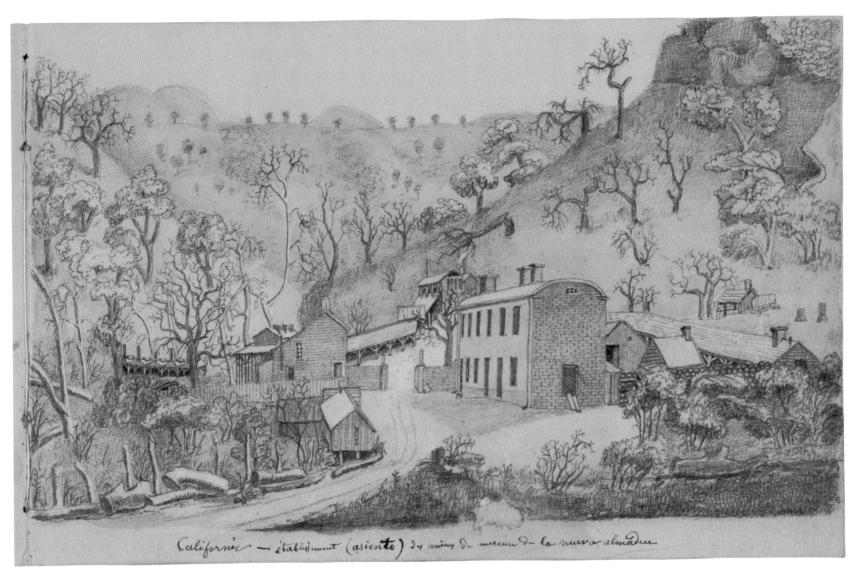

Californie — établissement (asiento) de mines de mercure de la nueva almaden

PLATE 5-9. Fritz Wikersheim,
*Californie—Établissement
(asiento) du mining de mercurie
de la nueva almaden* (Factory
[seat] of the Mercury Mine
at New Almaden, California),
1845–51; drawing on paper:
pencil; 5 x 8⅜ in

TWO IMAGES, EACH FANCIFUL in its own way, point to some of the spin-off enterprises of the hunt for gold. The first (Plate 5-10) is a farcical vision of an enterprising gentleman packing women into a box under a sign that reads "Marriage Business" and exporting them to California. Although the image is facetious, the idea of such a business was not entirely absurd. It crossed the minds of more than a few unscrupulous speculators to transport women and sell them to the highest bidder, although marriage was not a part of this equation. But the earnest and highly optimistic widow Eliza Farnham tried to export women from New York to the West Coast because she believed that their presence "would be one of the surest checks upon many of the evils that are apprehended [in California]." Horace Greeley, William Cullen Bryant, and the Reverend Henry Ward Beecher all backed Farnham's proposal to ship one hundred "respectable, marriageable" women to California. Two hundred women responded to Farnham's circular, but only two committed to the passage; gossip and suspicion about the morality of the venture swiftly unraveled her California Association of American Women.

Based in Santa Cruz, the California Powder Works (Plate 5-11) manufactured blasting powder for mining, railroad, sporting, and military purposes. It operated continuously in Santa Cruz County from 1864 to 1902

M. Williaume exportant en Californie un *article* qui est excessivement demandé.

and eventually opened six plants that branched into dynamite, "brown prismatic powder," and smokeless powder. The 1896 publication *Santa Cruz County: A Faithful Reproduction in Print and Photography of Its Climate, Capabilities, and Beauties* announces that the works

> are rated as second to none in Europe or America, whether the magnitude of their operations be considered, or their skillful use of the best knowledge of their art; and it is certain that their high position in the manufacturing world will never be lightly surrendered.

This visual advertisement takes a more subtle approach than the verbal one. The scenic rendering of hills sloping toward the ample curves of the San Lorenzo River begs to be framed and hung on a wall. In chameleon fashion, the factory assumes the colors of nature around it, serving as an asset to the landscape rather than a detraction. Probably a lure to potential developers, the "faithful" Santa Cruz County barker does not overlook the business potential of such scenery:

> The California Powder Works are very fortunate in respect to location. The canyon of the San Lorenzo supplies them with an abundance of wood and water, and their proximity to the sea and to the railway gives them the requisite facilities of transportation.

PLATE 5-10. Cham (Amédée Charles Henri de Noe), artist; P. S. and Diolot, engravers, *Croquis Californiens, par Cham: M. Williaume exportant en Californie un article qui est excessivement demandé* (California Sketches by Cham: Mr. Williaume Exports Goods which Are in Great Demand in California), c. 1850s; print on paper: engraving; 14 x 10 in

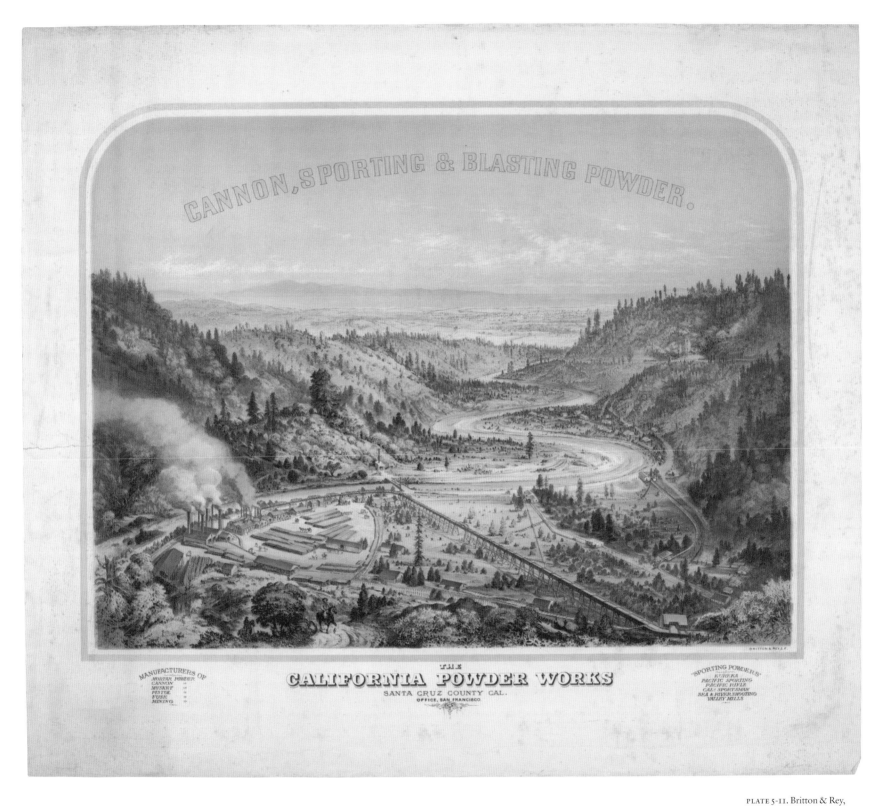

CANNON, SPORTING & BLASTING POWDER.

MANUFACTURERS OF
MORTAR POWDER "
CANNON "
MUSKET "
PISTOL "
FUSE "
MINING "

THE
CALIFORNIA POWDER WORKS
SANTA CRUZ COUNTY CAL.
OFFICE, SAN FRANCISCO.

"SPORTING POWDERS"
EUREKA
PACIFIC SPORTING
PACIFIC RIFLE
CAL: SPORTSMAN
SEA & RIVER SHOOTING
VALLEY MILLS

PLATE 5-11. Britton & Rey, lithographers, *The California Powder Works, Santa Cruz County, Cal.,* 1800s; print on paper: lithograph, color; 24 x 27 in

As placer mining in California became more and more difficult in the late 1850s, a few people headed over the Sierra Nevada to try their luck in what would become Nevada Territory. Efforts to find gold were thwarted by an abundance of a bluish clay. That clay turned out to be silver, and a new rush for precious metal began. Although he was the namesake for the new "lode," gold prospector Henry Comstock did not get rich from it. Many others did, however, including George Hearst, father of newspaper magnate William Randolph Hearst. As the center of the silver rush, Virginia City grew virtually overnight into a cosmopolitan center—its six-story hotel boasted the only elevator west of Chicago. Numerous mines punctuated the new city, as shown here (Plate 5-12).

Silver mining presented multiple dangers. Miners had to worry about cave-ins, underground fires, and floods. When they penetrated rock below seven hundred feet, steam and scalding water spewed from crevices, propelling the miners into cages with hoisting mechanisms that (they hoped) would lift them to safety. As with all mercury-based extraction techniques, processing the ore presented other hazards—some of the mines are still contaminated.

This softly toned view of the burgeoning city gives little indication of the dangers of silver mining, although, interestingly, the lower-left thumbnail shows a pile of slag, the unsightly detritus of the industry. Otherwise, this work has a clearly commercial agenda: advertising the city and its successful mines. The artist who created it, Grafton Tyler Brown, was the first professional African American artist to work in California. He founded his own lithography business in San Francisco in 1866 but later sold it to return to landscape painting. He was twenty-three when he made *Virginia City*.

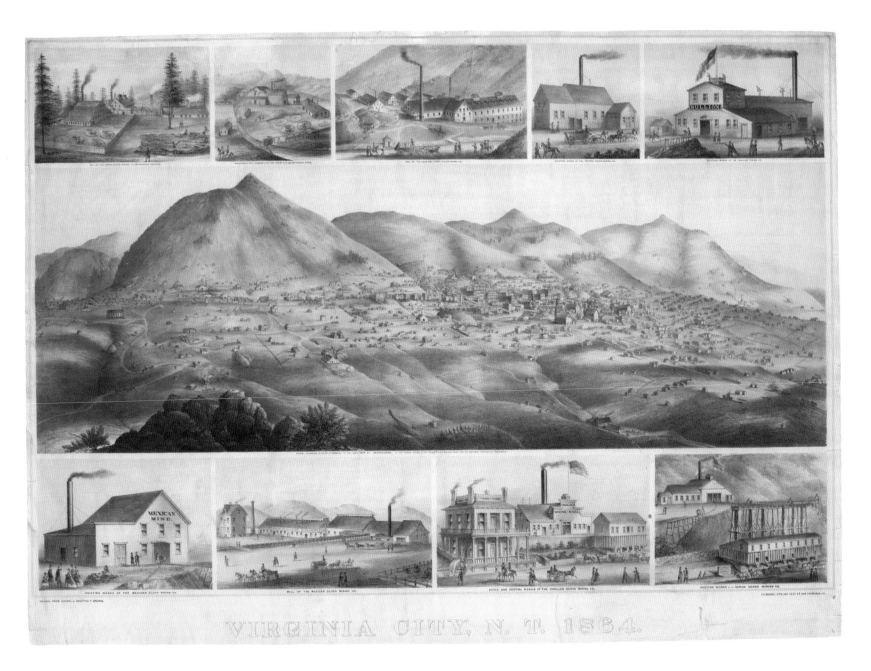

THE EXIGENCIES OF GETTING timber from the forests of California to consumers prompted the development of special conveyance systems. Here Charles Hittell (Plate 5-13) captures the loading of a lumber schooner. Few navigable harbors existed between Oregon and San Francisco, the coast that hemmed some of the richest forests in the world. But before the railroad, the sea was the only route available to lumber merchants. Compact two-masted schooners could successfully enter "dog-holes," a moniker allegedly coined by a sea captain who said these harbors were hardly big enough for a dog to turn around in. To get timber to the schooners, loggers built long, trestle-supported docks that spanned the rocky shore and bluffs. Wooden chutes at the ends of the wharves propelled boards onto the ships. After 1870 the high-strength wire cable used on streetcars in San Francisco inspired the design of new loading devices, which led to the expression "under the wire."

This drawing is one of seventy-five works by Charles Hittell in the Honeyman Collection. Completed just two years after *Flood, Feb 17th '81 Sacramento* (Plate 4-7), the fine pencil work in this image possesses an elegance and refinement not present in the earlier work.

The most significant labor-saving innovation in lumber history to that point, the steam engine that was used for hauling lumber — first introduced by John Dolbeer and dubbed the "donkey" — rendered the oxen team and bull whacker (its driver) obsolete. Charles Graham's painting (Plate 5-14) may document the Roberts and Doan Traction Engine, which was in use in the Sierra. This impressive machine weighed thirty tons and cost $28,000.

Charles Graham had no formal training when he joined a survey party for the Northern Pacific Railroad as an artist in the early 1870s. He served as an illustrator in the field for *Harper's Magazine* from 1877 to 1892, mainly focusing on the West, and his work appeared in a number of other periodicals. Joseph Armstrong Baird Jr., in his catalogue of the Honeyman Collection, speculates that Graham executed *Steam Wagon* for reproduction in *Picturesque California* or *Century*. Graham was a member of the San Francisco Art Association and of the Bohemian Club.

Wednesday June 13th
1883

Lumber Chute at
Fisk's Mill.

PLATE 5-13. Charles (Carlos)
Joseph Hittell, *Lumber Chute
at Fisk's Mill*, 1883; drawing
on paper: pencil; 9 x 11⅝ in

A·STEAM·WAGON·HAULING·LUMBER·IN·THE·SIERRAS·

PLATE 5-14. Charles Graham,
*A Steam Wagon Hauling Lumber
in the Sierras*, 1800s; painting
on paper: gouache; 12 x 18 in

PLATE 5-15. Jules Tavernier,
Untitled (The Blocks' Farmyard
on Dry Creek near Healdsburg,
Sonoma County, California),
1883; painting on paper:
watercolor and pencil;
10 x 16 in

Works in the Honeyman Collection by Jules Tavernier and Thomas Hill offer two very different views of farms in Northern California. The French-born Tavernier arrived in the United States in 1873, settling in California in 1874. He was notorious for his anti-bourgeois bohemian lifestyle and for his casual attitude toward bill paying, which in 1884 forced him to flee to Hawaii. This watercolor (Plate 5-15) portrays the farm of Mr. Block, formerly the chef of the famous San Francisco restaurant the Old Poodle Dog. Tavernier lends dignity to the rustic quality of the setting—these solid, handsome barns are weather-beaten but unbowed. A healthy grouping of trees blends with the buildings, obscuring the line between natural and human-made structure. While wild birds make their homes on the roofs, their domestic counterparts ramble freely on the ground below.

By contrast, in Thomas Hill's oil painting of a California strawberry farm (Plate 5-16), a Mediterranean-style estate stands majestically in the background, and the twin fountains in the waterway and field seem as decorative as they are practical. The well-dressed, gray-bearded "lord of the manor"—the only figure facing the viewer—gives direction to the apparent foreman of the farm's Chinese workforce. The muted tones of the composition seem to enhance the formality and respectability of the scene, creating a flattering portrait of a California entrepreneur and of California agriculture.

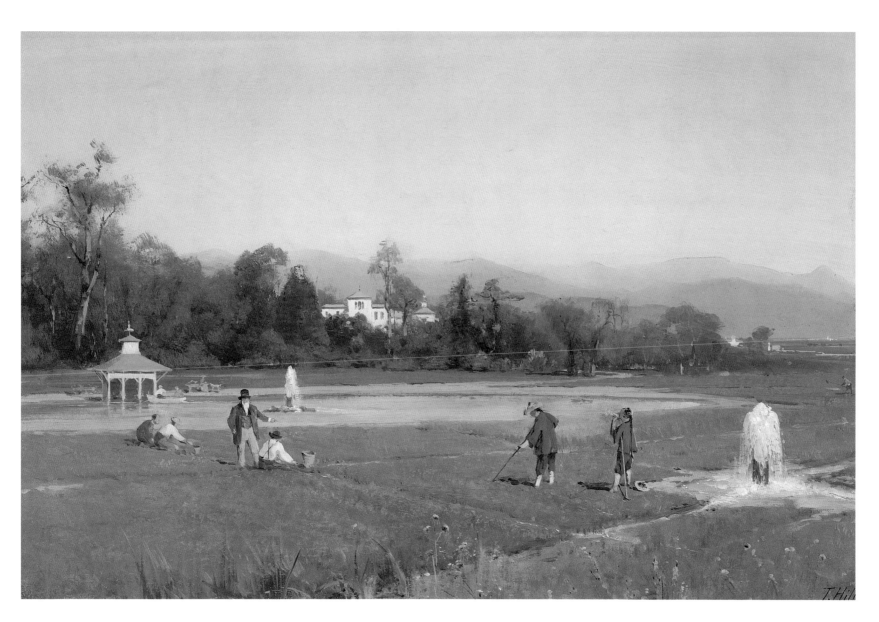

PLATE 5-16. Thomas Hill,
Untitled (Irrigating at
Strawberry Farm), 1888;
painting on board: oil;
12 x 18 in

In the 1860s, the cattle industry in California suffered devastating losses from drought, overgrazing, and the ranchers' failure to modernize. The surviving cattle farmers instituted a number of improvements such as new breeding and feed techniques that raised the weight of yearlings by as much as two hundred pounds. Large, unfenced Spanish-style ranchos gave way to arrangements under which breeding and grazing could be controlled. Delivery systems for livestock products also improved, as suggested here by the railroad running through Daniel McCarty's ranch near Sacramento (Plate 5-17).

A BIRDS-EYE VIEW ON THE CATTLE RANCH OF **DANIEL M? CARTY,** 352 ACRES, PURCHASED IN 1878, ALONG THE AMERICAN RIVER 1½ MILE EAST OF SACRAMENTO, CAL.

PUBLISHED BY THOMPSON & WEST.

PLATE 5-17. Published by Thompson & West, *A Birds-eye View on the Cattle Ranch of Daniel McCarty . . . East of Sacramento, Cal.,* c. 1878; print on paper: lithograph; 11 x 13⅞ in

FRENCH IMMIGRANTS JEAN Brun and Jean Chaix were the proprietors of the Napa Valley Nouveau Medoc Vineyard featured in this lithograph (Plate 5-18). Brun and Chaix pioneered a growing technique that significantly improved California wines. Whereas the valley had been the choice planting ground for California grapes, Chaix speculated that vines grown on a mountainside, specifically in the red volcanic soil of Howell Mountain, would produce better wines. In fact, vines on hillsides yielded fewer but superior grapes; in addition, these vines resisted the severe frost that hit the valley in 1882.

At 20 by 34 feet, Brun and Chaix's first winery was a tiny affair. In 1877, their first year in business, they quickly expanded to a space of 160 by 34 feet and moved their operation in Oakville closer to the railroad. Here they were able to produce more than one hundred thousand gallons of wine per year and easily load it onto the railroad cars that would transport their products to San Francisco. The vintners brought nine grape varieties from the famous Medoc wine region in France, so it seemed fitting to name their vineyard Nouveau Medoc.

This print of Brun and Chaix's vineyard, with its symmetrical, rolling hills lined with neat rows of vines, its stately building in the circle to the left, and its large fermenting compound (wines were aged out of doors rather than in cellars)—all buttressed by the fastest overland transportation system ever devised—served as a powerful advertisement for California viticulture. A special feature for a winery, the water tower in the center of this image served as the communication link (by means of signal and telescope) with the Nouveau Medoc vineyard on Howell Mountain ten miles away.

Nouveau Medoc Vineyard and Wine Cellars

PLATE 5-18. V. Duhem, *Nouveau Medoc Vineyard and Wine Cellars*, c. 1890; print on paper mounted on board: lithograph, color; 20 x 25 in

OFFERING A PARABLE OF THE perils of independence in California enterprise, the promising beekeeping industry in San Diego County foundered in the 1870s due to a lack of organization on the part of the "bee-men." Without a unified front, beekeepers failed to make headway with the monopolistic Central Pacific Railroad, which charged high tariffs for the transportation of honey and refused either to ship it nonstop (as they did fruit) or to store the product. The erratic marketing and delivery tactics of these small producers also caused wholesale prices to fluctuate daily and led to a glutted market in San Francisco, followed by a two-year embargo on Southern California honey and similar problems on the East Coast. Finally the San Diego Beekeepers Association formed to disseminate information, improve marketing, reduce transportation costs, establish and monitor standards, and so on. As a result, apiculture in San Diego became a major industry in the 1880s.

Meanwhile, in a land that seems far, far away, this collage of a Santa Rosa bee ranch (Plate 5-19) gives a narrative summary of the activities of the bee-men (leaving out the messy problems of marketing and transportation). From following a single bee to its hive to packaging the honey for shipment, we are treated to the adventure of "smoking the bees out," "intrepid handling" (without gloves!), and the frenzied retreat of a man "attacked" by a swarm. The endearing style of these illustrations makes it seem more like a children's story than an account of a complex and burgeoning enterprise.

FOLLOWING A BEE TO THE HIVE. SMOKING THE BEES OUT.

GATHERING THE HONEY. SAWING OFF THE LIMB. INTREPID HANDLING.

HUNTING WILD BEES.

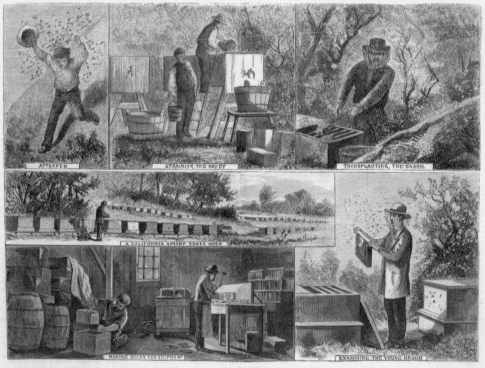

ATTACKED. STRAINING THE HONEY. TRANSPLANTING THE SWARM.

A CALIFORNIA APIARY SANTA ROSA.

MAKING BOXES FOR SHIPMENT. EXAMINING THE YOUNG BROOD.

BEE-CULTURE.

A CALIFORNIA BEE RANCH.—[SEE PAGE 274.]

1881

PLATE 5-19. Published by *Harper's Weekly, A California Bee Ranch*, 1881; print on paper: engraving, hand colored; 14⅞ x 10⅝ in

Oceanside retreats like the Riverside House depicted in this lithograph (Plate 5-20) catered to a class of tourist that did not exist before the nineteenth century—the haute bourgeoisie. The advent of a shortened workday, vacation time, and disposable income created the right conditions for resort towns to thrive.

In this print, we see people playing croquet and tennis and strolling along a boulevard. Earlier bird's-eye views might have presented the town or city surrounded by images of establishments that fell into the category of civic necessity, such as banks, schools, and government buildings. The print advertisements that frame this view of Santa Cruz emphasize pleasure rather than stability. They promote specialty businesses in which consumers can spend money on inessentials, such as the wares of Tikeman's Palace of Sweets; Misses Neary's Artistic Millinery; Mr. And Mrs. Morris, Leading Photographers; and the Neptune Baths.

CALIFORNIA'S PROXIMITY to Pacific Rim ports figured in the state's history in a way that cannot be overemphasized. At the start of the gold rush, almost everything had to be brought to California—from lumber and food to clothes and equipment, and everything in between. Eventually, because of the ingenuity and doggedness of the many enterprises outlined in this chapter, California produced a large surplus of goods for export. In the late twentieth century, the state would become the second largest exporter in the nation and one of the top ten largest economies in the world. Concurrently, the countries of the Pacific Rim emerged as the primary trading partners of the United States.

This highly graphic image advertising "Japan Tea" as imported by a Los Angeles company (Plate 5-21) now seems to foreshadow the enormous networks of exchange to come. The East Cowan Co. lithograph even goes so far as to fuse American and Asian cultures: its elevated view of the town of Avalon on Catalina Island is cleverly rendered in the idiom of a Japanese woodblock print.

PLATE 5-21. Unknown artist, *Cowan Catalina Brand Japan Tea*, c. early 1900s; print on tissue paper: engraving, color; 12⅝ x 10⅝ in

Chapter Six:

Wonder
and Curiosity

In America, therefore, animated Nature is weaker, less active,
and more circumscribed in the variety of her productions; for we
perceive, from the enumeration of the American animals, that the
numbers of species is not only fewer, but that, in general, all the
animals are much smaller than those of the Old Continent.

Georges-Louis Leclerc, Comte de Buffon, Histoire Naturelle, 1749–1804

A MOOSE by mail, gigantic sheets of bark on tour, a tree stump turned dance floor and bowling alley—young America could not boast as many cultural achievements as her parents across the Atlantic, but she did have a rich natural history to promote and defend, and demonstrations of her prodigality took striking forms in the late eighteenth and nineteenth centuries. When, for instance, the Comte de Buffon theorized that species in the Americas were weaker, "degenerate" versions of their European counterparts, a rather large rebuttal appeared at his door in the form of a moose carcass. U.S. minister to France Thomas Jefferson was the sender; in 1786 he had the moose and a number of American specimens of elk and caribou shipped from New Hampshire to the Jardin du Roi, the natural history center over which Buffon presided. The letter accompanying the package signaled gracious intentions: "I wish these spoils, Sir, may have the merit of adding anything new to the treasures of nature which have so fortunately come under your observation." The real message was no doubt evident to Buffon, who had already received a copy of Jefferson's *Notes on Virginia*. This volume trounced the French naturalist's theories both in text and with visual aids, including charts of the relative sizes of American and European animals.

Little did Buffon or Jefferson know what plants and animals awaited "discovery" in the American West. In the years following their correspondence, expeditions left France, Spain, Russia, and England and landed on Pacific shores, sending home accounts of the prodigious natural phenomena there. Overland explorers Lewis and Clark reported their astonishment at western wildlife to their scientifically inclined sponsor, now President Thomas Jefferson. Soon others followed their course across the continent, and then at mid-century an onslaught of gold seekers descended on California from all directions. Among these travelers, professional and amateur artists dedicated themselves to rendering this new organic world. Their purposes in committing pen to paper varied, as we see in these works from the Honeyman Collection, from personal record to commercial enterprise, from scientific document to artistic expression, and combinations thereof. These images are also inflected by nineteenth-century beliefs about nature—ideas that were eventually supplanted by the theories of Darwin and other scientists. To fully appreciate the artists' intentions, we must return to that earlier context in which these works

were made. Happily this journey also affords us the experience of awe and delight that early explorers must have felt on encountering the wonders of the American West for the first time.

The journals and letters of early explorers give us insight into the powerful impressions Western American flora and fauna made on them, at the same time that they suggest the filters through which they viewed the assets of this land. With uncanny consistency European sea voyagers George Vancouver, Jean François Galaup de La Pérouse, Nikolai Petrovich Rezanov, and Frederick William Beechey used words such as "abundant" with respect to wildlife and "luxuriant" to describe the vegetation around them. Naturalists and artists meanwhile made visual records of individual specimens, represented here by Georg Heinrich von Langsdorff (Plate 6-1) and William Smyth (Plates 6-2 and 6-3). The perspectives of expedition leaders, and of the governments and organizations that sponsored them, tended much more toward consumerism than science. California's plentiful animal life signified product for the fur trade, food, and, for hunters, entertainment; fertile soils meant advantageous farming conditions. As it turned out, these resources were much more exhaustible than some visitors might have imagined. Rezanov's Russian-American Company, along with other fur traders, so diminished the sea otter population in the northern Pacific that as early as 1820 the species was already in serious decline.

Concomitant with simple heedlessness, a belief system began to emerge at the turn of the nineteenth century that rationalized the exploitation of the land and all its living things at the same time that it elevated the discipline of natural history to a new plane. *Natural theology* suggested that the beauty and perfection of nature's design confirmed the existence of God and that a close examination of nature would bring the student to a better understanding of the Almighty. The next step in this line of thinking, taken by many but never endorsed by natural theology's foremost champion, William Paley, who authored the widely read 1802 tome on the subject, was that all of nature was created by God to serve or entertain man. These ideas, along with the notion of the fixity of species, persisted through the first half of the nineteenth century and beyond. Even after the debates about evolution started to bubble up and Darwin published *The Origin of Species* in 1859, natural history books avoided the subject of Darwinism or made light of it.

With this divine endorsement, naturalists achieved a kind of celebrity in the first half of the century. Books and articles on natural history were wildly popular in England, for instance, and budding botanists and zoologists cropped up everywhere. The last great advances in this science had been the extensive taxonomic systems of Swedish botanist Carl Linnaeus, in the mid-eighteenth century, and the French comparative anatomist and paleontologist Georges Cuvier (1769–1832). Thus the main task of the naturalist, along with decoding God's Book of Nature, was to index it by identifying and documenting new species. The process generally entailed a field observer who sent his or her drawings and specimens to an established naturalist, who would research and finally publish the findings—if merited. Lucky discoverers were

rewarded with their own namesakes. In the competitive atmosphere of the day, finding a new species was extremely gratifying.

The pleasure of discovery is evident in the works of Louis Jules Rupalley, a French amateur botanist and artist who went to America in 1851 seeking gold and returned with the more than one hundred botanical drawings that are held in the Honeyman Collection. In his bright, careful renderings (Plates 6-5 through 6-9), Rupalley tries to serve the two masters of art and science concurrently, finding, in the words of author Wilfrid Blunt, "beauty in truth." We don't know whether Rupalley intended his work for private or public consumption, but his brother George apparently assembled this album from a series of original notebooks, perhaps with the ambition of publication.

A few naturalists did publish their own field discoveries, most notably John James Audubon, but as errors in his work attest, there were dangers in proceeding without the oversight of another researcher. Audubon did the greatest harm to the credibility of American natural history, however, through a practical joke he perpetrated on fellow naturalist Constantine Rafinesque. This colorful character possessed among his faults a tendency to invent species, coupled with acute gullibility that proved too tempting for Audubon. During Rafinesque's visit to his Henderson, Kentucky, home in 1818, Audubon fed his colleague's hunger for new species by giving him illustrations and field notes of creatures he had mischievously concocted, such as the Devil-Jack Diamond-fish with bulletproof scales. Much to the prankster's chagrin, Rafinesque published the ten imaginary species in his work *Ohio*

Fishes, citing Audubon as authority for the discovery. The unfortunate effects of this ruse persisted for decades. Forty years later, English naturalist Philip Gosse could still remark, "We do naturally look with a lurking suspicion on American statements, when they describe unusual or disputed phenomena."

It was against this backdrop—the ideas and distortions of natural theology, new species obsession, and a country still struggling to prove its worth—that one of the most astounding discoveries of all was made in California. Publisher James Mason Hutchings wrote in 1861, "It is much to be questioned if the discovery of any wonder, in any part of the world, has ever elicited as much general interest, or created so strong a tax upon the credulity of mankind, as the discovery of the mammoth trees in California." Indeed, Augustus T. Dowd, the man who first came upon the Calaveras Grove in 1852, failed to convince his friends at Murphy's Camp of the existence of the giant trees— he had to resort to luring them to the site with a story about a big grizzly.

If the mammoth grove stretched credulity to the breaking point, it also provided the locus for the aggressive promotion of conflicting agendas. While English and French naturalists quibbled over naming the new species after a war hero (*Wellingtonia gigantea*) or after a seemingly similar species (*Sequoia gigantea*), enterprising Americans pursued the tandem problems of proof and profit. In the summer of 1854 George Gale removed to a height of over one hundred feet the bark from the tree known as the "Mother of the Forest," a sequoia measuring ninety feet in circumference at the base. He then shipped it in sections

for display at New York's Crystal Palace. A dubious public soon regarded the reassembled sylvan as a sham. Although Gale's fortune was not made, the bark eventually traveled to London, where it remained on exhibit for several years. Tourism, however, would provide a more reliable stream of revenue, and it was the publisher of *Hutchings' California Magazine* himself who led the first group of potential gawkers into the grove in 1855. Already one of the giant trees had been felled, despite the tremendous effort involved. The stump became a dance floor (as shown in Plate 6-13), and part of the now horizontal trunk was converted into a two-lane bowling alley. Lodgings and other amenities soon sprung up at this scenic destination. Probably with some thought toward market potential, the entrepreneur and artist Edward Vischer published in his *Pictorial of California* views such as the scaffolded and denuded *Mother of the Forest* (Plate 6-11) and *The Mammoth Grove Hotel, Grounds, and General View of the Forest* (Plate 6-12).

Conversely naturalists, religious figures, and politicians jumped into the fray with the object of rescuing the trees from further shame. The symbolic currency of the trees broke into several denominations. For some, the giant sequoias were a spectacular example of God's Design, dating to biblical times — they were contemporaries of Christ. Luminaries such as Thomas Starr King, Unitarian minister of the First Church of San Francisco, heralded them as sacred objects, a sentiment seconded by naturalist John Muir, who called them the "Holy of Holies" and the "noblest of God's trees." Incomparably grand, inherently spiritual, they were also uniquely American. Like Thomas Jefferson before him, Abraham Lincoln must have recognized the importance of delineating America's natural triumphs in the portrait of national strength and prosperity. In 1864, in the midst of the Civil War, Lincoln signed into law an unprecedented bill reserving the trees "for the benefit of the people . . . to hold them inalienable for all time."

For all time, also, these images attest to the enchantment of natural phenomena on the human psyche. While revealing the countervailing lenses applied to the resources of the American West, they celebrate and preserve its wonders and curiosities. ❦

Twenty-nine-year-old Georg Heinrich von Langsdorff was not originally selected for the Rezanov expedition, the first Russian attempt to circumnavigate the globe. Desperate to make the voyage, he traveled to Copenhagen in 1803 and tracked down the expedition's officers. Although his enthusiasm impressed Captain Krusenstern enough to get him aboard ship, the hopes of the young physician and naturalist would eventually wane. His journal entry on May 21, 1806, reveals his disappointment with Rezanov: "Though at Kamschatka large promises were made me, both in writing and orally, as to what should be done for the promotion of scientific undertakings, no alacrity has been shown in fulfilling these promises." The expedition was then at the half-starved Russian colony in Sitka, Alaska. Rezanov took several men, including Langsdorff, on a side expedition to Northern California to secure "breadstuffs" for their outpost. Upon their return, Langsdorff decided to leave Rezanov and return to Russia overland through Siberia, arriving safely in St. Petersburg two years later. Rezanov, however, died attempting the same route. Langsdorff went on to become a member of the Russian Academy of Sciences and Russian consul-general at Rio de Janeiro.

The expedition probably encountered these sea lions in California (Plate 6-1). Langsdorff was impressed by the sheer numbers of animals there, and particularly by the quantity of sea otters, the quarry of Rezanov's Russian-American Company: "There were also seals of various sorts, and above all things, the valuable sea-otter was swimming in numbers about the bay nearly unheeded." Interestingly, this portrait of sea lions lounging on the seashore seems rather more whimsical than precise.

PLATE 6-1. Georg Heinrich von Langsdorff, Untitled, 1803–07; drawing on paper; 8⁵⁄₁₆ x 10¾ in

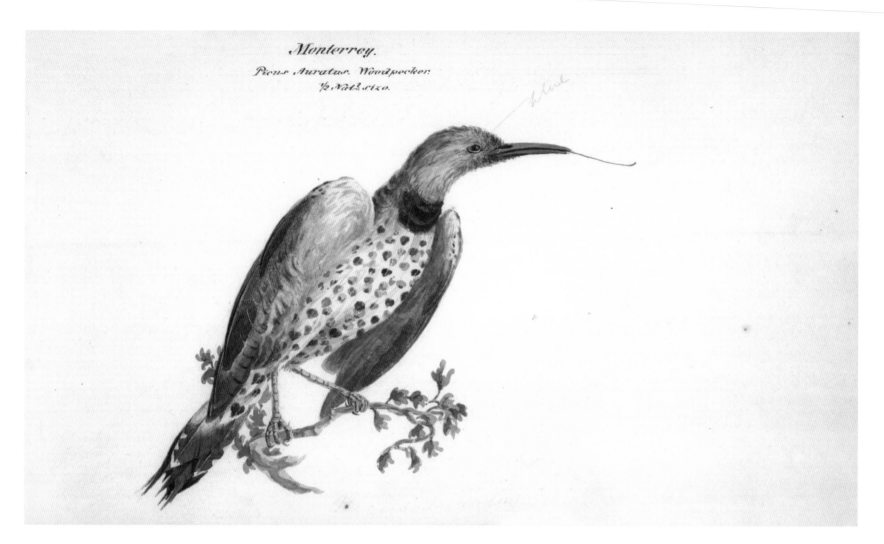

Monterrey.
Picus Auratus. Woodpecker.
½ Nat.ʳ size.

PLATE 6-2. William Smyth,
Monterrey [sic], *Picus Auratus,
Woodpecker,* 1825–27;
drawing on paper: watercolor;
5⅜ x 9 in

THE OBJECTIVE OF CAPTAIN Frederick William Beechey's "Voyage to the Pacific and Beering's [sic] Strait to co-operate with the Polar Expeditions: performed in His Majesty's Ship Blossom" was the discovery of a northwest passage. But the large sloop's crew of one hundred included a team of scientists and two promising artists who attended to other aims. Natural history was a rising star in the eyes of the English public, who delighted in accounts of new species in uncharted lands. The voyage crisscrossed the western ocean and landed in ports in the South Pacific and in Northern California, affording ample opportunities for expedition naturalists to collect and document specimens.

William Smyth—artist, midshipman, and mate—contributed to the visual record of the expedition with

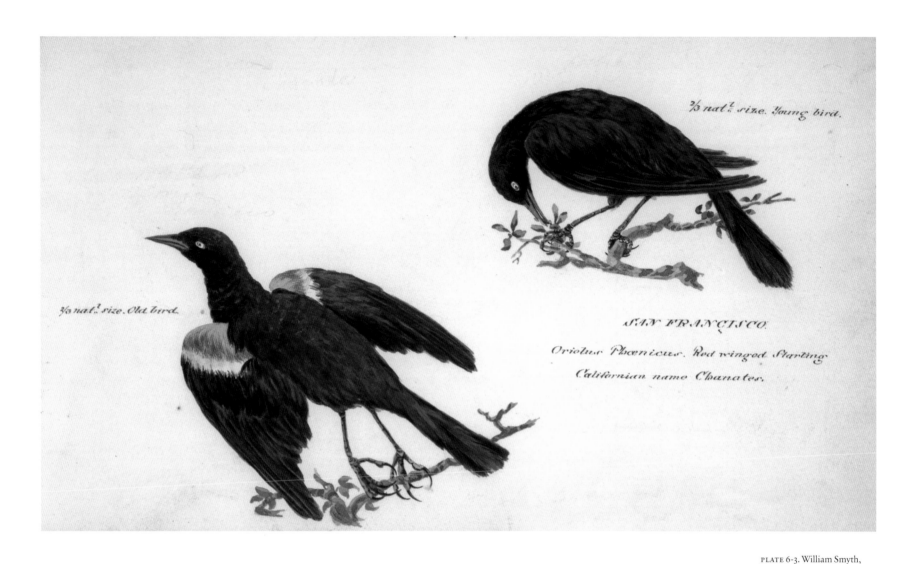

Inside image (as part of the artwork):
⅔ nat.ᵗ size. Young bird.

SAN FRANCISCO.

Oriolus Phœnicus. Red winged Starling
Californian name Chanates.

⅔ nat.ᵗ size. Old bird.

PLATE 6-3. William Smyth,
San Francisco, Oriolus Phoenicus,
Red Winged Starling, Californian
Name Chanates, 1825–27;
drawing on paper: watercolor;
5³/₈ x 9 in

images such as these of two California
birds (Plates 6-2 and 6-3). Appearing
in a small sketchbook of twenty-one
watercolor drawings, they speak to the
importance of natural findings to even
the nonscientific members of the crew.
Smyth later rose to the rank of admiral
in the Royal Navy, but he continued
his artwork. His paintings are in the
collection of the National Maritime
Museum in London.

As early as 1831, the great naturalist John James Audubon began writing of his desire to go west, but it was not until 1843 that he actually embarked on the journey. The *Boston Atlas* of that year announced with great enthusiasm that Audubon had begun his *Viviparous Quadrupeds of North America*. Moreover, it claimed that Audubon had already "set out on his journey across the Rocky Mountains, to explore the entire regions west of them for the purpose of completing his researches." In reality, Audubon's westernmost excursion was a voyage up the Missouri River. Thus the California species shown here (Plate 6-4) may have been drawn from those "stuffed-museums moth eaten remains" that he deplored in a letter to Charles Bonaparte before his trip.

Remarkably, Audubon began the career that would lead to his becoming the nation's premier artist of birds and animal life after having been jailed for bankruptcy in 1819. Besides the tremendous skill with which he seems to bring his subjects to life, his hand-colored lithographs are remarkable for their precision and beauty.

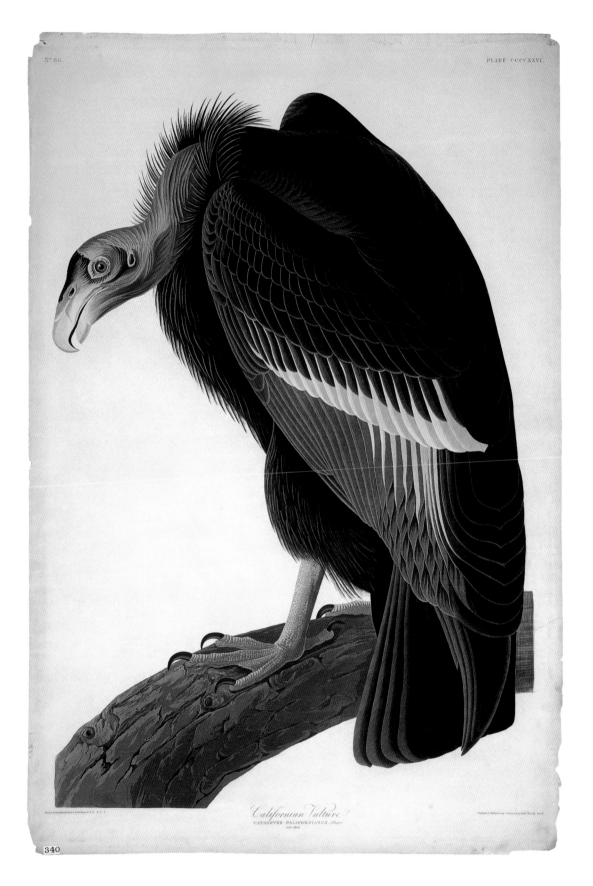

N° 86. PLATE CCCCXXVI.

Californian Vulture
CATHARTES CALIFORNIANUS, Illiger.
Adt. Male.

PLATE 6-4. John James Audubon, artist; printed by Robert Havell Jr., engraver, *Californian Vulture: Cathartes Californianus, Illiger*, 1838; print on paper mounted on board: engraving, hand colored; 39 x 26 in

Louis Jules Rupalley left behind a wife and two-year-old child when he embarked on the treacherous journey across the Atlantic and around Cape Horn to pursue the dream of gold in California. According to scholar Claudine Chalmers, he had a stint as a painter and decorator at the Fremont House in San Francisco before setting off for Benicia and Vallejo, the Greenwood Valley in the Sierra foothills, and eventually the southern parts of the gold country (an area that he called "southern California"). We do not know how he fared as a miner, but he returned to France in 1857 with a wealth of drawings of the flora and fauna he had observed on his travels. Although his brother planted some of the bulbs the artist had brought home from California, and one of the resulting flowers even drew the attention of a professor at the University of Caen, Rupalley did not pursue a career in botany.

Rupalley's admiration of the species he discovered in California shows on every page of his work. He treats each subject with delicacy, detail, and vividness. This album of over one hundred watercolors is the only known collection of its kind by this artist.

PLATE 6-5. Louis Jules Rupalley, *Californie 22*, c. 1850s; drawing on tinted paper: watercolor; 9 x 7 in

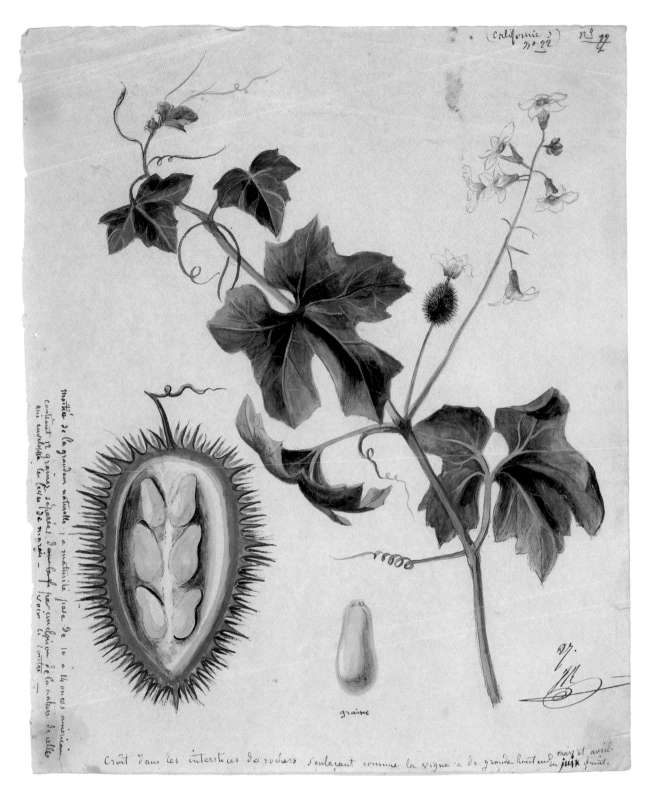

graine

Croît dans les interstices des rochers s'enlaçant comme la vigne à de grande hauteur mars et avril. en juin fruit.

PLATE 6-6. Louis Jules Rupalley, Untitled (Californie 1855), c. 1850s; drawing on paper: watercolor; 3 x 4⅝ in

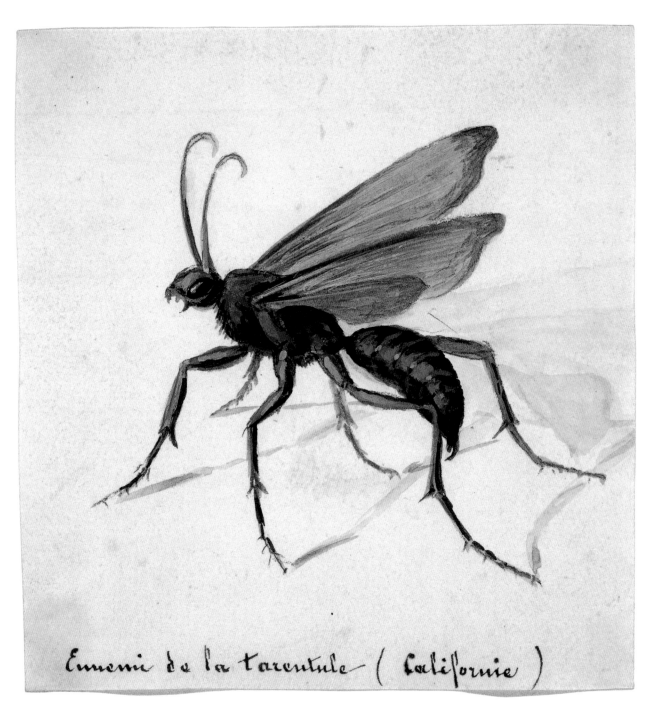

Ennemi de la tarentule (Californie)

PLATE 6-7. Louis Jules Rupalley,
Ennemi de la tarentule (Californie)
(Enemy of the Tarantula),
c. 1850s; drawing on paper:
watercolor; 7 ½ x 7 ³/₁₆ in

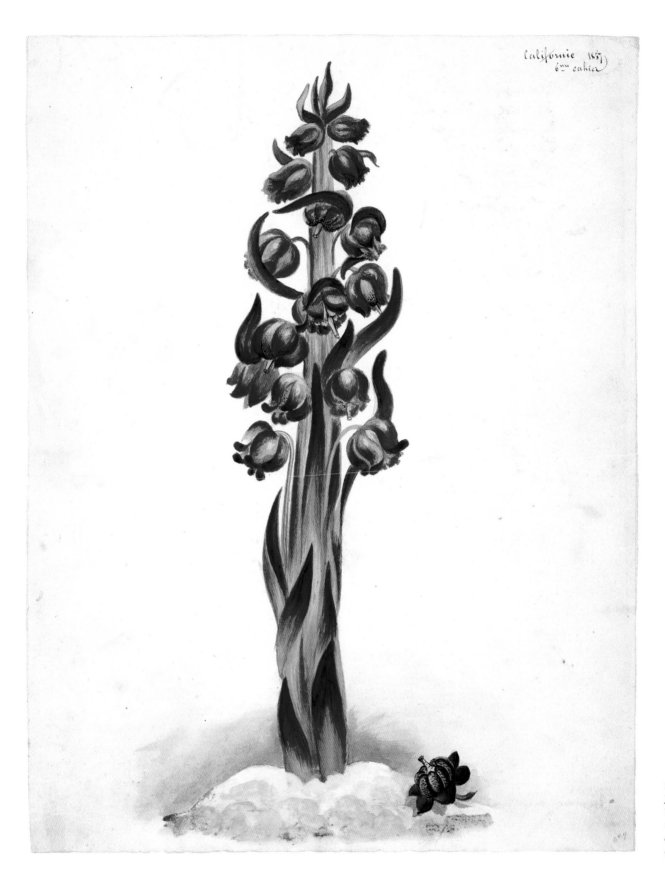

Californie 1857
6me cahier

PLATE 6-8. Louis
Jules Rupalley,
Untitled (Californie
1857), 1857; drawing
on paper: watercolor;
9⅞ x 7 in

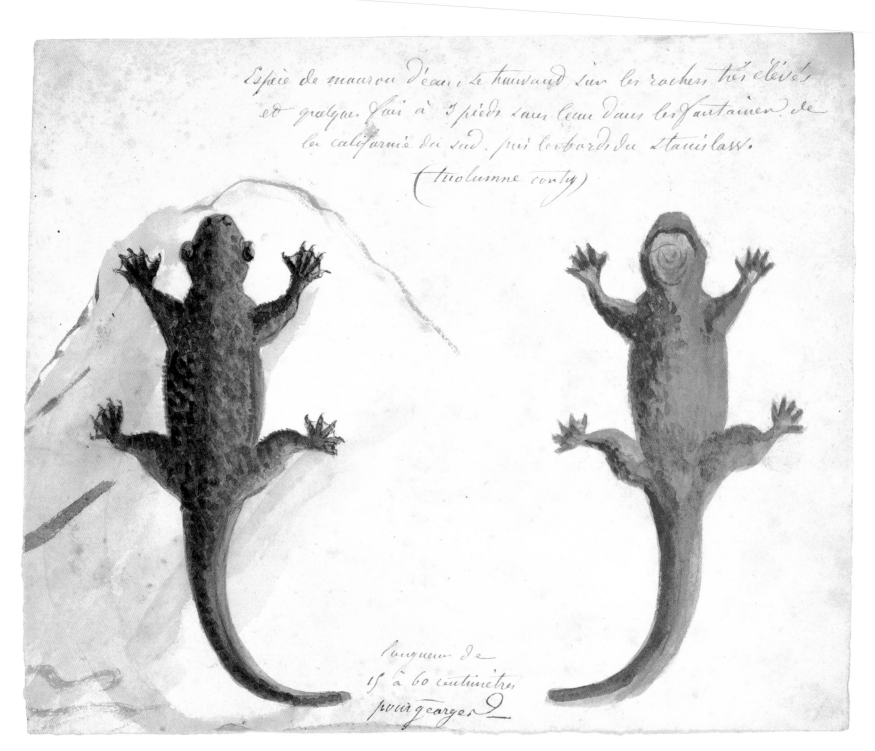

PLATE 6-9. Louis Jules
Rupalley, *Especè de mouron . . .
près les bords du Stanislass* [sic],
Tuolumne Conty [sic] (A type
of salamander . . . near
Stanislaus, Tuolumne
County), c. 1850s; drawing
on paper: watercolor; 5 x 6 in

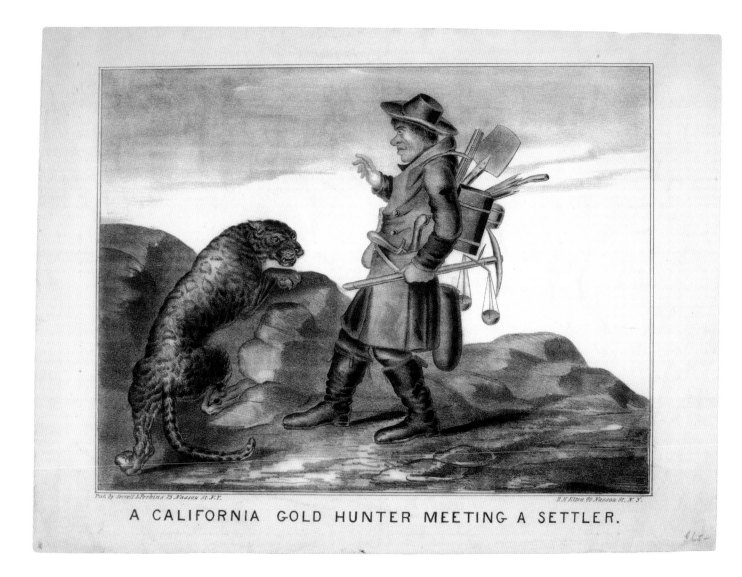

A CALIFORNIA GOLD HUNTER MEETING A SETTLER.

ONE OF MANY HUMOROUS portrayals of the perils of seeking gold, this image presents an argonaut encountering a leopard—indeed a wild sight even for the American West (Plate 6-10). The startled miner, in spite of all his equipment and accoutrements, appears unprepared to confront this savage "settler" of the gold country. With this print, New York publishers were able to demonstrate to their audiences in the eastern United States the unsuitability of many among the hordes who left in search of an easy fortune. The artist concurrently references the exotic wildlife of the West and the uncivilized reputation of Barbary Coast settlers.

Robert H. Elton was an engraver and printer in New York who, with John McLoughlin, founded the firm Elton & Co. Active between 1840 and 1851, the firm specialized in toy books, comic almanacs, and valentines.

From his *Pictorial of California*, meant to be a visual record of the state as commerce and industry transformed it, these two works by Edward Vischer show his keen eye and talent for drawing. In the text accompanying *Mother of the Forest* (Plate 6-11), Vischer, who stripped it of most of its bark, describes the tragic end of the tree at the hands of unscrupulous opportunists, concluding:

> *The tree, once the proudest ornament of the grove, now stands a colossal skeleton, holding up its withering arms as in silent accusation against the vandalism of its executioners.*

Born in Ratisbon, Bavaria, Vischer went to Mexico at the age of nineteen and delved into businesses on the Pacific Coast. His later travels took him to the East Coast and Europe via China. He returned to Mexico in 1847 and finally relocated to San Francisco the year gold was discovered in California.

The Mammoth Grove Hotel, Grounds, and General View of the Forest (Plate 6-12) not only shows the increasing presence of commerce among the big trees, it documents a peculiar chapter in U.S. military history. The animals to the lower right of the frame are not horses but camels. The U.S. Army was struggling to maintain control in the great expanses of the American West, and camels, which eat anything and drink brackish water, were touted to Congress as a more cost-effective solution for desert travel than other animals.

VISCHER'S VIEWS OF CALIFORNIA.

THE MAMMOTH GROVE. PLATE IV.

7. MOTHER OF THE FOREST, (1855 and 1861,) AND OTHER GROUPS.

With an allocation of $30,000, forty-one camels were imported to America in 1857, but the experiment ended in mismanagement and neglect in 1863.

These animals captivated Edward Vischer, who encountered them over the Big Tree Route: "We could not but observe with interest the peculiar habits of these sagacious and much-enduring animals." Vischer paired the idea of civilization with the exoticism of the animals and contrasted both

PLATE 6-11. Edward Vischer, artist; C. C. Kuchel, lithographer; printed by Louis Nagel, *Mother of the Forest (1855 and 1861), and Other Groups*, c. 1862; print on paper mounted on board: lithograph, color; 13 x 107⁄8 in

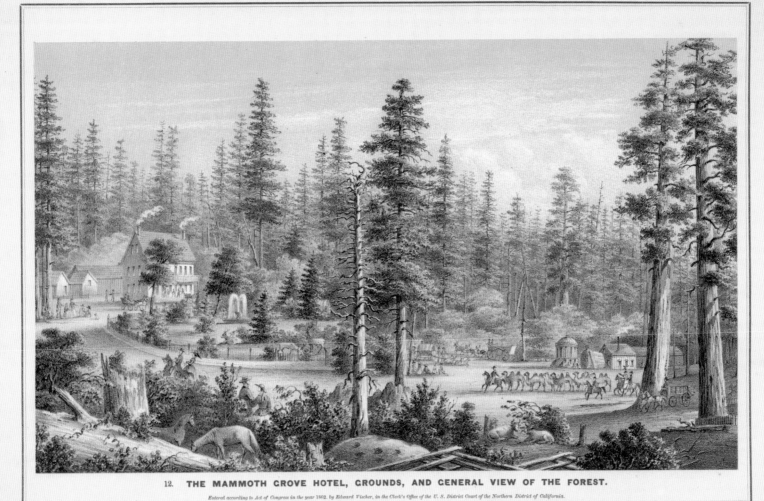

12. THE MAMMOTH GROVE HOTEL, GROUNDS, AND GENERAL VIEW OF THE FOREST.

Entered according to Act of Congress in the year 1862, by Edward Vischer, in the Clerk's Office of the U. S. District Court of the Northern District of California.

with the culture of the disappearing Indian in the description of this view:

> The remnants of felled trees in the foreground, *a chaotic wilderness, show this settlement as an oasis in the apparently boundless forest. As an evidence of there having once existed Indian wigwams in this neighborhood, we notice the holes in the granite boulder close by the fence, which, with the aid of a pestle, formed the usual means of pounding their acorn food. Had their Seers possessed the gift of second-sight, the gaunt, spectre-like forms of the camels, as we saw them passing through the grove, would have harrowed them with fearful visions of intruders from Asia, as well as from the land of the pale faces.*

PLATE 6-12. Published by Edward Vischer, artist; C. C. Kuchel, lithographer; printed by Louis Nagel, *The Mammoth Grove Hotel, Grounds, and General View of the Forest,* c. 1862; print on paper mounted on board: lithograph, color; 10⅞ x 13 in

It took five men twenty-two days to reduce the formerly majestic sequoia in this image to a tourist spectacle (Plate 6-13). From the vantage point of several generations of environmental awareness, the viewer flinches at this scene with revulsion. Yet we can imagine the astonishment of those early tourists on first encountering the Mammoth Tree Grove in Calaveras, the giddy headiness of dancing on a tree so large that it could barely be comprehended. The contrast between the figures politely interacting with each other in their dressy attire and the prostrate remnant of the immense power of nature is telling. Certainly the toppling of this tree satisfied a need to subdue nature, but perhaps it also reflected the desire to measure these giants against human height in order to convey the truth of those first awe-inspiring encounters.

A year before this lithograph was made, James Hutchings published in his *Scenes of Wonder and Curiosity in California* a wood engraving of Nahl's drawing of the same event. Hutchings denounced the stripping and felling of the trees while at the same time rationalizing the results—these "sacrilegious" acts provided proof "that we have great facts in California, that must be believed, sooner or later."

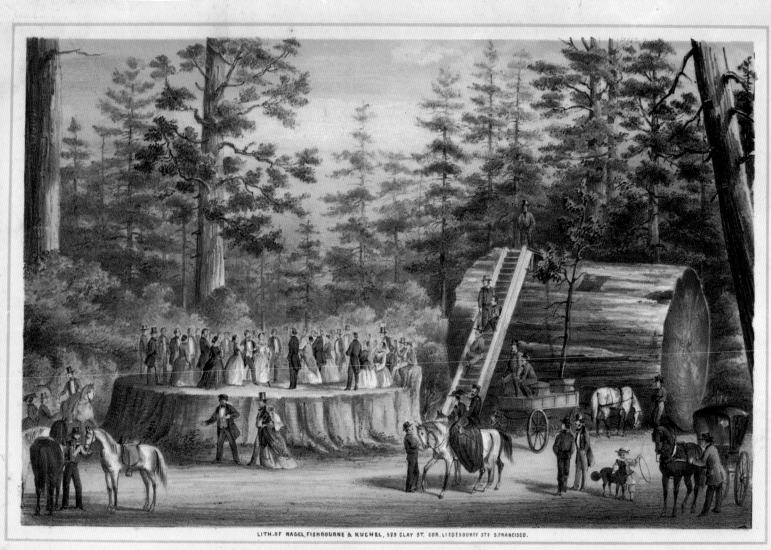

THE STUMP AND TRUNK OF THE MAMMOTH TREE OF CALAVERAS.

Showing a Cotillion Party of Thirty-two Persons Dancing on the Stump at one time.

PUBLISHED BY J.M.HUTCHINGS, S.FRANCISCO.

PLATE 6-13. Nagel, Fishbourne & Kuchel, lithographers; published by James Mason Hutchings, *The Stump and Trunk of the Mammoth Tree of Calaveras,* 1862; print on paper: lithograph, hand colored; 10⅛ x 14¼ in

BEYOND GARGANTUAN TREES, California had other delights for the public. The production of outsized fruits and vegetables induced *Hutchings' California Magazine* in 1859 to boast that the "prolific production of our soil is such as almost to challenge the world." Reports of vegetable magnitude suffered from exaggeration, of course, but a state agricultural report listed "a beet weighing seventy-three pounds; a carrot, weighing ten pounds . . . a tomato, seventeen inches in circumference," and so on. The sensationalistic Currier & Ives would not have missed the story of California's legendary abundance, although full-scale specialty crop farming was only in its infancy in 1869 when this print (Plate 6-14) was made. In later years lithographs such as this would become part of an organized promotional campaign to attract potential immigrants. And who wouldn't be tempted? These luscious Edenic fruits need no serpent to lure the curious traveler to the version of California represented here: a civilized paradise forever preserved in printers' ink.

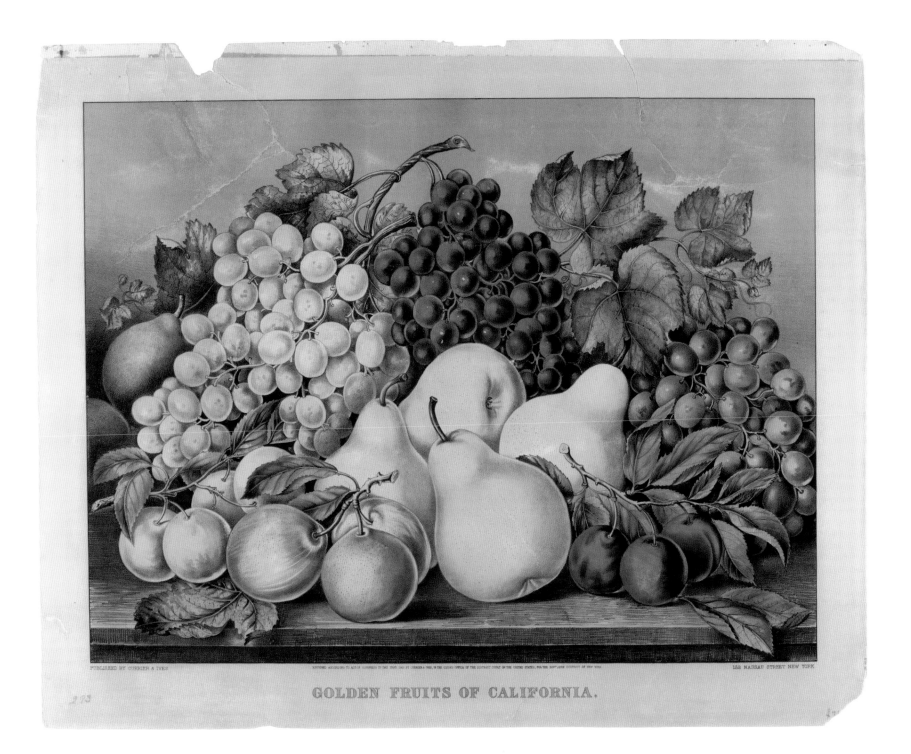

GOLDEN FRUITS OF CALIFORNIA.

PLATE 6-14. Published by
Currier & Ives, *Golden Fruits
of California*, c. 1869; print on
paper: lithograph, hand
colored; 18 x 23 in

Source Notes

Introduction: xi–xv

In Karl May's compelling stories of the Wild West: On the influence of Karl May on the imagery of the Wild West in Europe, see Jeffrey L. Sammons, *Ideology, Mimesis, Fantasy: Charles Sealsfield, Friedrich Gerstacker, Karl May, and Other German Novelists of America* (Chapel Hill, N.C.: University of North Carolina Press, 1998).

"a noted book collector, former metallurgist, geologist": Edwin Booth, "Class Notes" (1920), in *Lehigh Alumni Bulletin*, December–January 1959–60.

"unusual strength in first editions of a number of authors": James D. Mack, "First 100 Years," in *Lehigh Alumni Bulletin*, April–May 1978, issue 8.

"I don't think that Bob Honeyman": Joel Gardner, interviewer, "Jake Zeitlin: Books and the Imagination—Fifty Years of Rare Books," Oral History Program, University of California, Los Angeles, 1980, vol. 1, 262–63.

A brief obituary notice: *New York Times*, 7 June 1987.

Chapter 1, Inhabitants and Travelers: 3–35

"With regard to the people you may visit . . .": Catherine the Great, "Admonitions to Naturalists," quoted in Barbara Sweetland Smith, *Science under Sail: Russia's Great Voyages to America 1728–1867* (Anchorage, Ala.: Anchorage Museum of History and Art, 2000), 14 (unpaginated).

"The missionaries characterize": Edward Mornin, *Through Alien Eyes: The Visit of the Russian Ship* Rurik *to San Francisco in 1816 and the Men behind the Visit* (Oxford and New York: P. Lang, 2002), 47–48. Mornin compares the journals of Otto von Kotzebue, Adelbert von Chamisso, and Louis Choris. His translation of the excerpt from Choris's journal is based on Choris's *Voyage pittoresque autour du monde: avec des portraits desauvage d'Amérique, d'Asie, d'Afrique, et des iles du Grand Océan . . .* (Paris: Firmin Didot, 1820–22) part 3, 1–10.

Wimar, born and trained in Germany: Rick Stewart, Joseph D. Ketner II, and Angela L. Miller, *Carl Wimar: Chronicler of the Missouri River Frontier* (Fort Worth, Tex.: Amon Carter Museum; New York: distributed by Harry N. Abrams, 1991), 33.

The motif of abduction—primarily of women by Indians: For a discussion of the captivity narration as a genre, see Joseph D. Ketner II, "The Indian Painter in Düsseldorf," in Stewart, Ketner, and Miller, *Carl Wimar*, 45.

a Klamath Indian by the name of Kaw-tapish: A. J. Bledsoe, *Indian Wars of the Northwest: A California Sketch* (San Francisco: Bacon & Company, 1885), 161.

This charmingly rendered fantasy assumes a certain poignancy: Walt Reed, *The Illustrator in America, 1880–1980: A Century of Illustration* (New York: published for Society of Illustrators by Madison Square Press; distributed by Robert Silver Associates, 1984), 34.

Particularly after the Plains Indian population: Alfred Miller with Michael Bell, *Braves and Buffalo: Plains Indian Life in 1837* (Toronto: University of Toronto Press, 1973), 8.

A native of Baltimore, Maryland, Alfred Jacob Miller: Ibid.

Whether Darley actually painted: In his *Catalogue of Original Paintings, Drawings and Watercolors in the Robert B. Honeyman Jr. Collection* (Berkeley, Calif.: The Friends of the Bancroft Library, University of California, Berkeley, 1968),189, Joseph Armstrong Baird writes: "Dr. Stenzel traces its provenance from McCaughan and Burr, St. Louis, to Zeitlin, Los Angeles, and thence to Honeyman. Mr. Burr thought it was by Darley."

There is hardly another figure in California history: Josiah Royce (1855–1916) in his 1886 book, *California: A Study of American Character* (Berkeley, Calif.: Heyday Books, 2002) was perhaps the most prominent historian to write critically of Frémont's actions in California.

The result of a collaboration between José Baturone and Augusto Ferrán: Baturone and Ferrán published *Album Californiano* in Havana. See the California State Library website: *The Gold Rush Exhibition: V. Gold Mania Satirized* (http://www.library.ca.gov/goldrush/images/sec05.html): 22 February 2004.

Narjot, like many artists: For a concise biography, see Albert Dressler, *California's Pioneer Artist, Ernest Narjot: A Brief Resume of the Career of a Versatile Genius* (San Francisco: A. Dressler, 1936), 14.

"Sex to be sure, was not for them": Russell Crouse, *Mr. Currier and Mr. Ives: A Note on Their Lives and Times* (Garden City, N.Y.: Doubleday, Doran, 1930), 7.

Chapter 2, The Land Beheld: 36–73

"The true owners": Alexis de Tocqueville, *Journey to America*, trans. George Lawrence, ed. J. P. Mayer (Garden City, N.Y.: Doubleday Anchor, 1971), 354, quoted in Barbara Novak, *Nature and Culture: American Landscape and*

Painting 1825–1875, rev. ed. (New York: Oxford University Press, 1995), 145.

"In short, the only objects": Joshua Paddison, ed., *A World Transformed: Firsthand Accounts of California Before the Gold Rush* (Berkeley, Calif.: Heyday Books, 1999), 173–74.

"in gazing on": Thomas Cole, "Essay on American Scenery," 1835, in John W. McCourbrey, ed., *American Art 1700–1960* (Englewood Cliffs, N.J.: Prentice-Hall, Inc., 1965), 100.

"sublime" transmuted into a more serene, divine state: Barbara Novak offers an intriguing discussion of the sublime and of the relationship among artist, nature, and religion in the nineteenth century in *Nature and Culture.*

"sublime melting into the beautiful": Cole, "American Scenery," 103.

"verbatim ad literature": Asher B. Durand, undated ms., Durand Papers, New York Public Library, quoted in Novak, *Nature and Culture*, 9.

"mere copyist of nature": Unidentified critic for the *Saturday Review*, London, 15 June 1867, quoted in Nancy K. Anderson, "'Curious Historical Artistic Data': Art History and Western American Art," in Jules David Prown et al., *Discovered Lands, Invented Pasts: Transforming Visions of the American West* (New Haven, Conn.: Yale University Press, 1992), 11.

"or even sought to retain": Unidentified critic for *Watson's Weekly Art Journal*, 3 March 1866, 307, quoted in Nancy K. Anderson and Linda S. Ferber, *Albert Bierstadt: Art and Enterprise* (New York: Brooklyn Museum in association with Hudson Hills, 1991), 89.

"love of scenery": Cole, "American Scenery," 101.

Hill suffered at the hands: Harold and Peggy Samuels, *Techniques of the Artists of the American West* (Secaucus, N.J.: Wellfleet Press, 1990), 105.

"The former wild prairie": Quoted in William H. Truettner, ed., *The West As America: Reinterpreting Images of the Frontier, 1820–1920* (Washington, D.C.: published for the National Museum of American Art by the Smithsonian Institution Press, 1991), 27.

"I cannot but express my sorrow": Cole, "American Scenery," 109.

"It is this consciousness of destruction": Tocqueville, *Journey to America*, 399, quoted in Novak, *Nature and Culture*, 147.

McMurtrie was originally: Biographical information on McMurtrie from Katherine Church Holland, "Biographies of the Artists," in Janice T. Driesbach, Harvey L. Jones, and Katherine Holland, *Art of the Gold Rush* (Oakland, Calif.:

Oakland Museum of California; Sacramento, Calif.: Crocker Art Museum; Berkeley: University of California Press, 1998), 124.

Ayres was born in New Jersey: Biographical information on Ayres from Holland, "Biographies of the Artists," 117.

Friend's watercolor sketch of Yosemite: Peggy and Harold Samuels, *The Illustrated Biographical Encyclopedia of Artists of the American West* (Garden City, N.Y.: Doubleday, 1976), 179.

Although Keith achieved greater prominence: See Alfred C. Harrison's excellent book *William Keith: The Saint Mary's College Collection* (Moraga, Calif.: Hearst Art Gallery, Saint Mary's College of California, 1994), 9–26. Also, see Brother Cornelius, *Keith, Old Master of California*, 2 vols. (New York: Putnam, 1942–57).

Over the span of his career: *Catalogue of the Paintings and Sketches of the Late Thomas Hill, the Great American Artist* (San Francisco: printed by the Stanley-Taylor Company, 1910). Compiled by Robert R. Hill, the artist's son and administrator of the estate, this catalog contains a biographical sketch as well as a listing and description of the contents of the Thomas Hill Estate Collection.

A storm was in fact brewing: Quotes and information on Bierstadt's *Storm in the Rocky Mountains* are from Anderson and Ferber, *Albert Bierstadt*, 89.

This modest painting speaks: Harvey L. Jones, "Souvenirs of the Mother Lode: Ernest Narjot and George Henry Burgess," in Driesbach, Jones, and Holland, *Art of the Gold Rush*, 67–8.

From his perch, the artist: Janice T. Driesbach, *Direct from Nature: The Oil Sketches of Thomas Hill* (Yosemite National Park, Calif.: Yosemite Association; Sacramento, Calif.: in association with the Crocker Art Museum, 1997), 18.

Perhaps no other painter: *Herman Herzog, 1831–1932* (New York: Chapellier Galleries, 1973). This exhibition catalog is one of the few items in print on the artist.

worked the California goldfields: Biographical information on Harvey Young from Patricia Trenton, *Harvey Otis Young: The Lost Genius 1840–1901* (Denver: Denver Art Museum, 1975).

greatest allocation of federal monies: Information about federal spending on the arts, government publications, and dissemination of images in this period is from Martha A. Sandweiss's enlightening essay "The Public Life of Western Art," in Prown et al., *Discovered Lands, Invented Pasts*, 120.

Butman had the distinction: John S. Hittell, "Art in San Francisco," *Pacific Monthly* 10 (July 1863), 105, quoted in Driesbach, Jones, and Holland, *Art of the Gold Rush*, 91.

Chapter 3, By Land, By Sea: 74–103

"Eastward I go by force": Henry David Thoreau, "Walking" in *Walden and Other Writings* (New York: Random House, 1950), 607.

In his seminal work: Leo Marx, *The Machine in the Garden: Technology and the Pastoral Ideal in America* (London, Oxford, and New York: Oxford University Press, 1964).

"all means and no end": James Fenimore Cooper, *Home As Found: A Novel of Social Criticism and Observation* (1838; reprint 1961), 24, quoted in Sarah H. Gordon, *Passage to Union: How the Railroads Transformed American Life, 1829–1929* (Chicago: Ivan R. Dee, 1997), 72.

"I see continual trains": Walt Whitman, *Leaves of Grass*, in James E. Miller Jr., ed., *Complete Poetry and Selected Prose* (Boston, 1959), 289, quoted in Gordon, *Passage to Union*, 70.

"The sunburned immigrant": Hubert Howe Bancroft, *History of California*, vol. 7 (San Rafael: Bancroft Press, 1990), 542.

$700 to $1,500 per family: The Editors of Time-Life Books with text by Huston Horn, *The Pioneers* (New York: Time-Life Books, 1974), 6.

Six percent of emigrants: Carlos Arnaldo Schwantes, *Long Day's Journey: The Steamboat and Stagecoach Era in the Northern West* (Seattle: University of Washington Press, 1999), 60.

"The wagons are covered with white cloth": Albert Bierstadt quoted by William S. Talbot (http://www.butlerart.com/pc_book/pages/albert_bierstadt_1830.htm): 14 March 2004.

"To see the heavy mail wagon": Waterman Lilly Ormsby, *The Butterfield Overland Mail: Only Through Passenger on the First Westbound Stage* (San Marino, Calif.: Huntington Library, 1942), 32.

"Don't smoke a strong pipe": George A. Thompson, *Throw Down the Box!: Treasure Tales from Gilmer & Salisbury the Western Stagecoach King* (Salt Lake City: Dream Garden Press), 64.

"finest specimen of naval architecture of the Pacific": *San Francisco Herald*, 20 November 1851, quoted by John Haskell Kemble, "Pacific Mail Service between Panama and San Francisco, 1849–51," *The Pacific Historical Review* (December 1933), 408.

"The passengers of the steerage": Kemble, "Pacific Mail Service," 416.

Hailing from Norfolk, England: Biographical information on Marryat from Robert W. Winks, introduction to *Mountains and Molehills or Recollections of a Burnt Journal*, by Frank Marryat (1855; reprint, Philadelphia and New York: J. B. Lippincott Company, 1962).

"The town of Chagres deserves notice": Frank Marryat, *Mountains and Molehills*, 1–2.

"Much trouble there was": Ibid., 219.

'The Wings of the Morning': quoted in A. B. C. Whipple and the Editors of Time-Life Books, *The Clipper Ships* (Alexandria, Va.: Time-Life Books, 1980), 20.

a staggering three hundred thousand miles: Gordon, *Passage to Union*, 7.

Chapter 4, Incident and Accident: 104–131

"Not simply as a matter of rhetoric": Fred Somkin, *Unquiet Eagle: Memory and Desire in the Idea of American Freedom, 1815–60* (Ithaca, N.Y.: Cornell University Press, 1967), 40.

On a bone-chilling day in December 1835: The events of this paragraph are relayed in Crouse, *Mr. Currier and Mr. Ives*, 9.

"wildest winds of heaven": Herman Melville, *Moby-Dick*, Harrison Hayford and Hershel Parker, eds. (New York: W. W. Norton & Co., 1967), 97.

"But these things must not be dwelt upon": Mark Twain, *The Gilded Age, The Complete Works of Mark Twain* (http://www.mtwain.com, 2003): 20 February 2004.

The period between 1853 and 1904: Michael Barton, "Journalistic Gore: Disaster Reporting and Emotional Discourse in the *New York Times*, 1852–1956," in Peter N. Stearns and Jan Lewis, eds., *An Emotional History of the United States* (New York and London: New York University Press, 1998), 156–57.

"the land of disasters": Ellery Sedgwick, "The Land of Disasters, 1853–1904," *Leslie's Monthly Magazine*, January 1905, 350–51, quoted in Barton, "Journalistic Gore," 156.

"Remember this life is not long": Lewis O. Saum, "Death in the Popular Mind of Pre-Civil War America," in Charles O. Jackson, ed., *Passing: The Vision of Death in America* (Westport, Conn.: Greenwood Press, 1977), 68.

Out of the ashes of burned settlements: For a full discussion of this phenomenon, see Kevin Rozario, "What Comes Down Must Go Up: Why Disasters Have Been Good for American Capitalism," in Steven Biel, ed., *American Disasters* (New York and London: New York University Press, 2001), 72–84.

"Everybody seems in good humour": Marryat, *Mountains and Molehills*, 12.

"Burnt out?": Ibid., 13.

Shipwrecks were common: *New-York Daily Times*, 17 January 1854, quoted in Barton, "Journalistic Gore," 157.

In reality, every able-bodied man: The full story of the disaster of the *Central America*, as well as the project to recover its gold, is told in Gary Kinder, *Ship of Gold in the Deep Blue Sea* (New York: The Atlantic Monthly Press, 1998).

plaintive cry of a little girl: Mary Kay Duggan, *Disasters in California Sheet Music* (http://www.sims.berkeley.edu/~mkduggan/disasters.html, 2001): 8 October 2003.

Signs of high floodwaters: The history of reports of flooding in the Sacramento Valley and efforts to control floods is detailed by Robert Kelley in *Battling the Inland Sea: American Political Culture, Public Policy, and the Sacramento Valley 1850–1986* (Berkeley: University of California Press, 1989).

Many people actually drowned: Dr. John F. Morse as reported by Carlos Alcala, "River Trade Gave Birth to City, then Floods Came," *Sacramento Bee*, 2 March 1998, from the *Sacramento Bee's* "Gold Rush, The Series" (http://www.calgoldrush.com/extra/floods.html): 8 March 2003.

"It is said that": Marryat, *Mountains and Molehills*, 83.

Until the very moment of his death: "James P. Casey and Charles Cora," *Virtual Museum of the City of San Francisco* (http://www.sfmuseum.net/hist6/hang.html, 1995–2003): 6 August 2003.

According to his confession: "Confession of José Forner y Brugada," Ibid.

Nahl frequented a village: Moreland L. Stevens, *Charles Christian Nahl: Artist of the Gold Rush, 1818–1878* (Sacramento: E. B. Crocker Art Gallery, 1976), 38.

"He dressed like an Indian in blankets": Bernard DeVoto, *The Year of Decision: 1846* (Boston: Houghton Mifflin, 1942), 65, quoted in Mary Ellen Jones, *Daily Life on the 19th-Century American Frontier* (Westport, Conn. and London: Greenwood Press, 1998), 39.

"So long as railroads are used accidents will occasionally occur": *Oakland Daily News*, 15 November 1869, quoted in William Deverell, *Railroad Crossing: Californians and the Railroad, 1850–1910* (Berkeley: University of California Press, 1994), 127.

Accidents were popular spectacles: The Editors of Time-Life Books, with text by Keith Wheeler, *The Railroaders* (Alexandria, Va.: Time-Life Books, 1973), 194.

"No conception can be formed of the grandeur": Marryat, *Mountains and Molehills*, 97.

"merely cracked a few weak walls": Hubert Howe Bancroft, *History of California*, vol. 7, 684, quoted in Perry, *Pacific Arcadia*, 189.

He created a satirical "Earthquake Almanac": Quoted in Perry, *Pacific Arcadia*, 189.

Chapter 5, Enterprise: 132–165

"Providence, casting her eye into the far future": Alexandre Dumas, *A Gil Blas in California*, trans. Marguerite Eyer Wilbur (London: Hammond, Hammond & Co. Ltd., 1947), 194.

"I was twenty-four years old and out of work": Ibid., 35.

gold production shot up: Robert Glass Cleland, *March of Industry* (Los Angeles: Powell Pub. Co., 1929), 57.

"All the workers found gold": Dumas, *Gil Blas*, 105.

the ten or so sawmills: The Editors of Time-Life Books, with text by Richard L. Williams, *The Loggers* (Alexandria, Va.: Time-Life Books, 1976), 52.

The first professional loggers: Ibid., 39.

eastern white pines: Ibid., 24–27.

The Spanish padres: Members of the Faculty of the College of Agriculture of the University of California, *California Agriculture* (Berkeley and Los Angeles: University of California Press, 1946), 10–11.

farmers shared information: William A. Bullough and Richard J. Orsi, *The Elusive Eden: A New History of California* (New York: Knopf, 1988), 282.

symbolized progress in nineteenth-century American art: Nicolai Cikovsky Jr., "The Ravages of the Axe: The Meaning of the Tree Stump in Nineteenth-Century American Art," *The Art Bulletin*, vol. 61, no. 4 (December 1979), 611–26.

"a sore sight at any time, unless I'm privileged to work my will on them": James Fenimore Cooper, *The Pioneers: or the Sources of the Susquehanna, a Descriptive Tale* (1825) from The Literature Network (http://www.online-literature.com/view.php/pioneers/20?term=sore, 2000–04): 22 February 2004.

"the coming of Chinese laborers": *Chinese Exclusion Act of 1882*, from The Avalon Project at Yale Law School (http://www.yale.

edu/lawweb/avalon/statutes/chinese_exclusion_act.htm, 1996–2003): 22 February 2004.

the Chinese were the only: Stewart Edward White, *Old California* (New York: Garden City Publishing Co., Inc., 1939), 93.

"At ten feet from the nozzle": Elizabeth Johns, "Settlement and Development: Claiming the West," in Truettner et al., *The West As America*, 225.

also the richest: John S. Baggerly, "Los Gatos Was Once Best Gateway to New Almaden," *Los Gatos Weekly-Times* archives (http://www.losgatos.com/history/newalmaden.shtml): 22 February 2004.

The two brothers are shown: Driesbach, Jones, and Holland, *Art of the Gold Rush*, 96.

the earnest and highly optimistic widow Eliza Farnham: JoAnn Levy, *They Saw the Elephant: Women in the California Gold Rush* (Hamdon, Conn.: Archon Books, 1990), 173–74.

The 1896 publication: *Santa Cruz County: A Faithful Reproduction in Print and Photography of Its Climate, Capabilities, and Beauties* (1896), 26 and 27, quoted in "The California Powder Works (1896)" (http://www.santacruzpl.org/history/work/capowder.shtml): 28 September 2003.

the Roberts and Doan Traction Engine: Don Baumgart, "Steam Power Helped Build California," *Nevada County Gold Magazine*, (http://www.ncgold.com/History/BecomingCA_Archive33.html, 2003): 22 February 2004.

New breeding and feed techniques: Cleland, *March of Industry*, 63.

French immigrants Jean Brun and Jean Chaix: William F. Heintz, *Wine Country: A History of Napa Valley, The Early Years: 1838–1920* (Santa Barbara: Capra Press, 1990), 217.

beekeeping industry: Barbara Newton, "E. W. Morse and the San Diego County Beekeeping Industry, 1875–1884," *The Journal of San Diego History*, Summer 1981, vol. 27, no. 3, San Diego Historical Society (http://www.sandiegohistory.org/journal/81summer/morse.htm): 28 September 2003.

Chapter 6, Wonder and Curiosity: 166–187

"In America, therefore, animated Nature is weaker": Georges-Louis Leclerc, Comte de Buffon, *Histoire Naturelle, 1749–1804* (http://faculty.njcu.edu/fmoran/vol5new.htm#page 112): 1 November 2003.

weaker, "degenerate" versions: Ibid.

"I wish these spoils": Jefferson to Georges-Louis Leclerc, Comte de Buffon, Paris, 1 October 1787, *The Letters of Thomas Jefferson: 1743–1826*, quoted in *From Revolution to Reconstruction* (http://odur.let.rug.nl/~usa/P/tj3/writings/brf/jefl63.htm, 1994–2003): 3 November 2003.

This volume trounced: Thomas Jefferson, *Notes on the State of Virginia* (Boston: printed by David Carlisle for Thomas & Andrews [etc.], 1801).

The journals and letters of early explorers: Paddison, *A World Transformed*.

a belief system began to emerge: This paragraph is indebted to Lynn Barber's "Beliefs about Nature," chapter five of her instructive and highly readable *The Heyday of Natural History 1820–1870* (London: Jonathan Cape, 1980), 71–82.

Even after the debates: Ibid., 286.

a kind of celebrity: Ibid., 13–26.

"beauty in truth": Wilfrid Blunt, *The Art of Botanical Illustration* (London: Collins, 1950), 3.

a practical joke: Barber, *Heyday of Natural History*, 62.

"We do naturally look": Ibid., 194.

"It is much to be questioned": James Madison Hutchings, *Scenes of Wonder and Curiosity in California* (San Francisco: Hutchings & Rosenfield, 1860), 9.

English and French naturalists quibbled: Simon Schama, *Landscape and Memory* (London: Harper Collins, 1995), 187.

Luminaries such as Thomas Starr King: Ibid., 189–90.

"Holy of Holies": Ibid., 190

"noblest of God's trees": John Muir, *The Yosemite* (New York: The Century Co., 1912), excerpted in Peter Johnstone, ed., *Giants in the Earth: The California Redwoods* (Berkeley, Calif.: Heyday Books, 2001), 269.

Desperate to make the voyage: Paddison, *A World Transformed*, 97.

"Though at Kamschatka large promises were made me": Ibid., 98.

"There were also seals of various sorts": Richard A. Pierce, *Rezanov Reconnoiters California, 1806: A New Translation of Rezanov's Letter, Parts of Lieutenant Khvostov's Log of the Ship Juno, and Dr. Georg von Langsdorff Observations* (San Francisco: Book Club of California, 1972), 66.

"set out on his journey across the Rocky Mountains": *Atlas*, 12 April 1843, quoted in John Francis McDermott, comp., ed., *Audubon in the West* (Norman, Okla.: University of Oklahoma Press, 1965), 4.

"stuffed-museums moth eaten": Ibid., 11.

According to scholar: Claudine Chalmers, *Splendide Californie!: Impressions of the Golden State by French Artists: 1786–1900* (San Francisco: Book Club of California, 2004), 40–43.

"The tree, once the proudest": Edward Vischer, *Vischer's Pictorial of California: Landscape, Trees and Forest Scenes: Grand Features of California Scenery, Life, Traffic and Customs* (San Francisco: J. Winterburn & Company, 1870), 97.

The U.S. Army: A. A. Gray, "Camels in California," *California Historical Society Quarterly*, 1930, vol. 9, no. 4, 299–317.

"We could not but observe": Vischer, *Pictorial of California*, 66–67.

"The remnants of felled trees in the foreground": Ibid.

"sacrilegious" acts: Hutchings, *Scenes of Wonder and Curiosity*, 44.

"prolific production of our soil": "A Large Pear," *Hutchings California Magazine* 3, (March 1859), quoted in Claire Perry, *Pacific Arcadia: Images of California, 1600–1915* (New York and Oxford: Oxford University Press, 1999), 72.

"a beet weighing seventy-three pounds": Ibid., 74.

Index to Artists and Plates

The following information is supplied by the Bancroft Library, based in part on the *Catalogue of Original Paintings, Drawings and Watercolors in the Robert B. Honeyman Jr. Collection*, compiled by Joseph Armstrong Baird Jr. and published by the Friends of The Bancroft Library in 1968. Artist dates were derived from a variety of published sources, including Edan Hughes, *Artists in California 1786–1940* (1989); and Peggy and Harold Samuels, *The Illustrated Biographical Encyclopedia of Artists of the American West* (1976). Translations of titles, when they occur, are by members of Bancroft staff, various published sources, and the authors of this book. "Inventory Sheets" refers to the inventory compiled by Warren Howell of John Howell-Books with the assistance of Dr. Gunter Troche for the purchase and transfer of the Honeyman Collection to The Bancroft Library.

Abbreviations
Ins.: inscription
BANC PIC . . .: The Bancroft Library's call and accession number

Untitled (Mokelumne Hill, Calaveras County, California), 1857; painting on canvas, mounted on board: oil; 34 x 49⅛ in; supplied title (based on information from Inventory Sheets); BANC PIC 1963.002:1388–FR. Plate 2-18, page 69.

Brown, Grafton T. (1841–1918), artist; Kuchel, C. C., lithographer. *Virginia City, N. T. 1864*, c. 1864; print on paper: lithograph, color; 29 x 39⅞ in; printed title; BANC PIC 1963.002:0843–F. Plate 5-12, page 151.

Burgess, George Henry (1831–1905). Untitled, 1800s; painting on paper mounted on board: watercolor; 6 x 4 in; BANC PIC 1963.002:1338–A. Plate 2-12, page 59.

Butman, Frederick A. (1820–71). Untitled, 1858; painting on canvas: oil; 12 x 18¼ in; BANC PIC 1963.002:1371–FR. Plate 2-19, page 71.

Butterworth, James Edward (1817–94), and E. Brown Jr. (active c. 1852), artists; Currier, Nathaniel, lithographer. *Clipper Ship "Flying Cloud,"* c. 1852; print on paper: lithograph, hand colored; 19 x 25 in; printed title; other text: "Dimensions / Length of Keel: 208 Feet / Length on Deck: 225 Feet / Length Overall (from Knight Heads to Taffrail.): 235 Feet / Extreme Breadth of Beam: 41 Feet / Depth of Hold: 21 1/2 Feet / Tonnage per Register: 1750 / Built by Donald McKay at East Boston, Mass. 1851."; ins.: "To Messrs Grinnell, Minturn & Co. this Print of their Splendid . . . is Respectfully dedicated by the Publisher"; BANC PIC 1963.002:0333–D. Plate 3-10, page 91.

Cardero, José (1768–after 1800). *Copia de un dibujo que deja el Pintor del Conde dela Perouse a los Padres de la Mision del Carmelo en Monterey* (Reception of Jean-François de La Pérouse at Mission Carmel in 1786, [after Gaspard Duché de Vancy]), c. 1791–92; drawing on paper: ink, wash, and pencil; 8⅜ x 10⅛ in; handwritten title on original mount; BANC PIC 1963.002:1311–FR. Plate 1-1, page 7.

Casilear, George William (active c. 1860), and Henry Bainbridge (active c. 1850), artists; Ormsby, W. L., engraver. *View of Sacramento City as It Appeared during the Great Inundation in January 1850*, c. 1850; print on paper: lithograph, hand colored; 22 x 35 in; printed title; other text: "The city is situated on a Plain, on the east Bank of the Sacramento River about 143 miles from San Francisco. The rise of the River during the flood occasioned by heavy rains and the melting of Snow / from the Mountains was about 20 feet. The small Island covered with tents at the head of J. St. on the left is called by the Indians, Sa'cum a

Knoll of ground made by the Indians and the only dry spot visible for miles / during the flood. In the distance at the head of J. St. will be seen Sutters Fort about 2½ miles from the Levee. In the extreme distance will be seen the Sierra Nevada Mountains or the Gold Region whose tops are / mostly covered with Snow the year round and present a most striking and beautiful appearance when viewed from the City. The City Hotel, the large frame building facing on the Levee or River on the left of J. St. / was [word missing due to loss] during the summer of 1849 at a cost of $78,000. The Sutter Hotel, the large frame building facing on the Levee on the extreme right was built during the fall of 1849, Cost $50,000"; ins.: "We cheerfully concur in recommending the above picture as being a true and accurate Drawing of the City of Sacramento as it appeared during the Flood of January 1850. [signed] Capt. J. A. Sutter; J. S. Thomas, Alcade of Sacramento City; E. H. Gibs, Editor of the 'Placer Times' Sacramento City; Hubert J. Priest, Firm of Priest Lee, & Co., Sacramento City"; BANC PIC 1963.002:1537–E. Plate 4-5, page 115.

Cham (Henri, Amédée Charles de Noe) (1819–79), artist; P. S. and Diolot, engravers. *Croquis Californiens, par Cham: M. Williaume exportant en Californie un article qui est excessivement demandé* (California Sketches by Cham: Mr. Williaume Exports Goods which Are in Great Demand in California), c. 1850s; print on paper: engraving; 14 x 10 in; Illustration from *Le Charivari* magazine; BANC PIC 1963.002:0458–B. Plate 5-10, page 148.

Childs, J. (active after 1857). *Wreck of the Steamship Central America*, c. 1857; print on paper: lithograph, hand colored; 13 x 17 in; printed title; other text: "Appalling Disaster / On Saturday, September 12th, 1857, Capt. Herndon, bound to New York, from California, with the Pacific Mails / Passengers and Crew, to the number of 592 persons, and treasure to the amount of over / $2,000,000, foundered in a hurricane, off Cape Hatteras / Whole number on board, 592. Number saved, 166. Number on board whose names are known, 134. Names unknown, 292."; BANC PIC 1963.002:0331–B. Plate 4-3, page 112.

Choris, Louis (1795–1828). *Danse des Californiens* (Dance of the Californians), c. 1816; painting on paper: watercolor and pencil; 7 x 11 in; handwritten title (on mount); BANC PIC 1963.002:1312–FR. Plate 1-2, page 9.

Colman, Samuel (1832–1920). *Emigrant Train

Attacked by Indians, Ute Canyon, Utah, c. 1870s; painting on tinted paper: watercolor and gouache; 9 x 12⅞ in; handwritten title on mat (on recto); BANC PIC 1963.002:1508–FR. Plate 4-13, page 126.

Crépin, Louis Philippe (1772–1851) artist; Prot & Dissart Sculpserum, engravers, *Naufrage de M.M. de Laborde sur les canots de la Peyrouse au Port des François dans la Californie Dédié a Monsieur Alexandre de Laborde . . .* (Shipwreck of Messers de Laborde in the boats of La Pérouse in Port des François, California, dedicated to Monsieur Alexandre de Laborde . . .) printed title; print on paper: engraving, hand colored; 20⅞ x 28⅛ in; BANC PIC 1963.002:0337–E. Plate 4-1, page 109.

Currier & Ives (active 1857–1907), publishers. *The California Beauty*, 1800s; print on paper: lithograph, hand colored; 14 x 10 in; printed title; BANC PIC 1963.002:0815–B. Plate 1-22, page 35.

———. *Golden Fruits of California*, c. 1869; print on paper: lithograph, hand colored; 18 x 23 in; printed title; BANC PIC 1963.002:0737–C. Plate 6-14, page 187.

———. *The Great West*, c. 1870; print on paper: lithograph, hand colored; 9 x 14 in; printed title; BANC PIC 1963.002:1423–A. Plate 3-18, page 99.

———. *The Route to California: Truckee River, Sierra Nev.*, c. 1871; print on paper: lithograph, hand colored; 10⅞ x 14 in; printed title; BANC PIC 1963.002:1425–B. Plate 3-19, page 100.

Currier, Nathaniel (1813–88). *Burning of the Clipper Ship "Golden Light,"* c. 1853; print on paper: lithograph, hand colored; 10 x 14 in; "The 'GOLDEN LIGHT' sailed from Boston for San Francisco February 12th-1853, at nine o'clock P.M. on the 22nd during a thunder storm, / she was struck by lightning, and set on fire and at 6 P.M. of the 23d all hands were driven to the boats, leaving the ship entirely in flames"; BANC PIC 1963.002:0332–B. Plate 4-2, page 111.

Darley, Felix Octavius Carr (1822–88) (attributed to). Untitled (Indian Captive), c. 1880; painting on canvas: oil; visible image: 29 x 24 in; supplied title; note from Inventory Sheets: Dr. Stenzel traces its provenance from McCaughan and Burr, St. Louis, to Zeitlin, Los Angeles, and thence to Honeyman. Mr. Burr thought it was by Darley. (Also see engraving in *Godey's Magazine* of 1845.): BANC PIC 1963.002:1359–FR. Plate 1-14, page 25.

Dembour et Gangel, *Découverte des riches mines d'or de Sacramento en Californie* (Discovery of

Rich Gold Mines in Sacramento, California), c. 1848; print on paper: woodcut, hand colored; 7 x 11 in; printed title; text and lyrics about gold rush (on verso); BANC PIC 1963.002:0265–A. Plate 5-2, page 138.

Drouaillet, lithographer; Vance, Robert H., photographer; E. L. Ripley & Co., publisher. *California Flood Mazurka*, c. 1862; print on paper: lithograph; 13 x 10 in; printed title; BANC PIC 1963.002:1733–AX. Plate 4-6, page 116.

Duhem, V. (active c. 1890). *Nouveau Medoc Vineyard and Wine Cellars*, c. 1890; print on paper mounted on board: lithograph, color; 20 x 25 in; printed title; BANC PIC 1963.002:0362–FR. Plate 5-18, page 161.

Edouart, Alexander (1818–92). Untitled (Blessing of the Enrequita Mine), 1860; painting on canvas: oil; 30 x 48 in; supplied title; BANC PIC 1963.002:1360–FR. Plate 5-8, page 145.

Elton, Robert H. (active c. 1848–50), engraver; Serrell & Perkins, publisher. *A California Gold Hunter Meeting a Settler*, c. 1850; print on paper: lithograph; 10⅜ x 13⅞ in; printed title; BANC PIC 1963.002:0442–B. Plate 6-10, page 181.

Farny, Henry (1847–1916). Untitled, 1901; painting on tinted paper: gouache; 7 x 10⅝ in; BANC PIC 1963.002:1323–FR. Plate 1-13, page 24.

Ferrán, Augusto (1813–79). *Vaqueros Lassoing a Steer*, c. 1849; painting on canvas mounted on board: oil; 15⅜ x 18⅜ in; title based on label (on verso), date based on Ferrán's travels to California; BANC PIC 1963.002:1350–FR. Plate 1-6, page 15.

——. *Vista de San Francisco 1850* (View of San Francisco 1850), 1850; painting on canvas: oil; 11⅞ x 23⁷⁄₁₆ in; handwritten title; BANC PIC 1963.002:1357–FR. Plate 2-20, page 72.

——. *Vista de San Francisco 1850* (View of San Francisco 1850), 1850; painting on canvas: oil; 11⅞ x 23⁷⁄₁₆ in; handwritten title; BANC PIC 1963.002:1356–FR. Plate 2-21, page 73.

Friend, Washington F. (1820–86). Untitled (Yosemite Falls, Autumn), c. 1855; painting on paper: watercolor; 15 x 11 in; supplied title; BANC PIC 1963.002:0398–B. Plate 2-7, page 52.

Graham, Charles (1852–1911). *A Steam Wagon Hauling Lumber in the Sierras*, 1800s; painting on paper: gouache; 12 x 18 in; handwritten title; note from Inventory Sheets: probably done for reproduction in a periodical, *Picturesque California* or *Century*; BANC PIC 1963.002:1392–FR. Plate 5-14, page 154.

Harper's Weekly, publisher. *A California Bee Ranch*, 1881; print on paper: engraving, hand colored; 14⅞ x 10⅝ in; printed title; other text: "Hunting Wild Bees" (subtitle); captions (clockwise from left): "Following a Bee to the Hive / Sawing off the Limb / Smoking the Bees Out / Intrepid Handling / Gathering the Honey"; "Bee Culture" (subtitle); captions (clockwise from left) "Attacked / Straining the Honey/ Transplanting the Swarm / Examining the Young Brood / Making Boxes for Shipment / A California Apiary, Santa Rosa"; BANC PIC 1963.002:0663–B. Plate 5-19, page 163.

Herzog, Herman (1832–1932). Untitled (Valley near Los Angeles, California), c. 1870s; painting on board: oil; 7⅜ x 11⅞ in; supplied title; BANC PIC 1963.002:1373–FR. Plate 2-15, page 63.

——. Untitled (Valley near Los Angeles, California), c. 1870s; painting on board: oil; 7⅜ x 12 in; supplied title; BANC PIC 1963.002:1376–FR. Plate 2-16, page 65.

Hill, Thomas (1829–1908). Untitled (El Capitan, Yosemite, California), 1894; painting on canvas: oil; 18 x 22 in; supplied title; BANC PIC 1963.002:1365–FR. Plate 2-9, page 55.

——. Untitled (Irrigating at Strawberry Farm), 1888; painting on board: oil; 12 x 18 in; note from inventory sheet: "made for *Picturesque California*, 292. Known to be Northern California; is area near Santa Clara?"; BANC PIC 1963.002:1364–FR. Plate 5-16, page 157.

——. *Byrnes Ferry on the Stanislaus River, Calaveras County, California*, c. 1860; painting on canvas: oil; 12 x 16⅛ in; title based on attached label (on verso); BANC PIC 1963.002:1366–FR. Plate 2-13, page 61.

Hittell, Charles (Carlos) Joseph. (1861–1938). *Lumber Chute at Fisk's Mill*, 1883; drawing on paper: pencil; 9 x 11⅝ in; handwritten title; BANC PIC 1963.002:1193–A. Plate 5-13, page 153.

Hittell, Charles (Carlos) Joseph (attributed to). *Flood, Feb 17th '81 Sacramento*, 1881; drawing on paper: pencil; 4¼ x 10 in; handwritten title; note: attribution based on comparison to 1963.002:1095–A; BANC PIC 1963.002: 1167–A. Plate 4-7, page 117.

Hollier (active 1850s), lithographer and publisher. *Les Mines d'Or de la Californie* (Gold Mines of California), c. 1850s; print on paper: lithograph, hand colored; 10 x 13 in; printed title; BANC PIC 1963.002:0250–B. Plate 1-19, page 32.

Jump, Edward (1832–83). *Earth Quakey Times*,

San Francisco, Oct. 8, 1865, c. 1865; print on paper: lithograph, color; 25 x 37⅜ in; printed title; BANC PIC 1963.002:0449–C. Plate 4-16, page 129.

Justh & Co. (active c. 1851), lithographers. *Fire in San Francisco in the Night from the 3rd–4th May, 1851*, 1851; print on tinted paper: lithograph; 9 x 11⅜ in; printed title; other text: "Loss $20,000,000"; handwriting lower left: "✕ F.S.M. store about whre the fire commenced"; BANC PIC 1963.002:0037–A. Plate 4-15, page 128.

Justh, Quirot & Co. (active c. 1851–52), lithographers; Noisy Carrier's Book and Stationery Co. (Ch. P. Kimball), printer. *Execution of José Forner, Dec. 10, 1852. On Russian Hill San-Francisco, for the Murder of José Rodrigues*, 1852; print on paper: lithograph; 8 x 10 in; printed title; note: attribution to Justh, Quirot & Co. based on Harry Twyford Peter, *California on Stone*, 133; BANC PIC 1963.002:0033 (variant)–A. Plate 4-10, page 122.

Keller, George Frederick (active c. 1872), lithographer; Thistleton, Colonel George, publisher. Untitled, c. 1872; print on paper mounted on board: lithograph, color; 22 x 18⅞ in; BANC PIC 1963.002:0873–B. Plate 3-21, page 102.

Keith, William (1839–1911). *Sentinel Rock, Yosemite*, 1872; painting on canvas: oil; 18 x 14 in; printed title (attached to frame); BANC PIC 1963.002:1351–FR. Plate 2-8, page 53.

Key, John Ross (1832–1920). *Carmel River Scene*, c. 1870s; painting on canvas: oil; 16 x 23⅞ in; handwritten title; BANC PIC 1963.002:1504–FR. Plate 2-14, page 62.

Langsdorff, Georg Heinrich von (1773–1850). *Ansicht des Spanischen Etablissements von St. Francisco in Neu-Californien* (View of the Spanish Establishment of St. Francisco in New California), c. 1806; drawing on paper: ink and wash; 8 x 10¹³⁄₁₆ in; handwritten title; BANC PIC 1963.002:1021–FR. Plate 2-1, page 43.

——. *Ein Tanz der Indianer in der Mission in St. Jose in Neu-Californien* (Indians Dancing in Mission San Jose, New California), c. 1806; drawing on paper: ink wash highlighted with gouache; 8⅜ x 11 in; handwritten title; BANC PIC 1963.002:1023–FR. Plate 1-3, page 10.

——. Untitled, 1803–07; drawing on paper; 8⁵⁄₁₆ x 10¾ in; BANC PIC 1963.002:1035–ffALB. Plate 6-1, page 171.

Lee, Joseph (1828–80). Untitled (Oakland Estuary near Lake Merritt Inlet from 7th Street, California), 1800s; painting on canvas:

oil; 23 x 42 in; supplied title; BANC PIC 1963.002:1363–FR. Plate 3-22, page 103.

Major, R., engraver, *U.S. Steamer Golden Gate*, c. 1800s; print on paper: engraving, hand colored; 10 x 12⅞ in; printed title; ins.: "Engraved for 'Stuarts' Naval and Mail Steamers of U.S."; BANC PIC 1963.002:0325–B. Plate 3-5, page 84.

Marryat, Francis Samuel (1826–55), artist; Brandard, J., lithographer; M. & N. Hanhart, printer. *Crossing the Isthmus*, 1855; print on paper mounted on board: lithograph, color; 5 x 7⅛ in; printed title; BANC PIC 1963.002:1440:8–A. Plate 3-7, page 87.

——. *The Winter of 1849*, 1855; print on paper mounted on board: lithograph, color; 5 x 7 in; printed title BANC PIC 1963.002:1440:4–A. Plate 4-8, page 119.

McMurtrie, William Birch (1816–72). Untitled (Angel Island), c. 1850s; painting on paper: watercolor; 9 x 13 in; supplied title; BANC PIC 1963.002:1277–A. Plate 2-4, page 47.

Miller, Alfred Jacob (1810–74). *Sho-shoni Indians*, c. 1860s; painting on board: oil 6⅜ x 8⅜ in; title based on plate attached to frame; BANC PIC 1963.002:1385–FR. Plate 1-12, page 23.

Musical Bouquet Office, publisher. *Pull Away Cheerily! The Gold Digger's Song*, 1800s; print on paper: engraving; 14 x 10 in; printed title; other text: "Written and Sung by Harry Lee Carter, in His Entertainment of / 'The Two Lands of Gold.' / Also Sung by / George Henry Russell, / in Mr. Payne's Popular Entertainment, / 'A Night in the Lands of Gold' / Music Composed by / Henry Russell"; BANC PIC 1963.002:1785 (variant)–AX. Plate 5-3, page 139.

Nagel, Fishbourne & Kuchel (active c. 1862), lithographers; Hutchings, James Mason, publisher. *The Stump and Trunk of the Mammoth Tree of Calaveras*, 1862; print on paper: lithograph, hand colored; 10⅛ x 14¼ in; printed title; other text: "Showing a Cotillion Party of Thirty-two Persons Dancing on the Stump at one time"; BANC PIC 1963.002:0381–B. Plate 6-13, page 185.

Nahl, Charles Christian (1818–78), and Frederick August Wenderoth (1819–84), artists; Butler, B. F., lithographer; Shelton, C. A., publisher. *Miner Prospecting*, c. 1852; print on paper: lithograph, hand colored; 17⅞ x 12⅜ in; printed title; BANC PIC 1963.002:0972–B. Plate 1-17, page 29.

Nahl, Charles Christian. Untitled (Incident on the Chagres River, Panama), 1867; painting on canvas: oil; 26⅝ x 36⅞ in; supplied title;

BANC PIC 1963.002:1361–FR. Plate 3-8, page 88.

——. Untitled (Indian Ambush), c. 1860s; painting on board: oil; 12 x 9⅝ in; supplied title; BANC PIC 1963.002:1519–FR; Plate 4-11, page 123.

——. Untitled (The Elopement), c. 1875; painting on board: oil; 9⅝ x 12⅝ in; supplied title; BANC PIC 1963.002:1380–FR. Plate 1-8, page 17.

Narjot, Ernest (1826–98). Untitled (Days of Gold), 1884; painting on canvas: oil; 39⅝ x 26 in; supplied title; BANC PIC 1963.002:1377–FR. Plate 1-20, page 33.

——. Untitled (Placer Mining at Foster's Bar), 1851; painting on millboard: oil; 11 x 13⅞ in; supplied title; BANC PIC 1963.002:1353–FR. Plate 5-5, page 141.

Nesbitt, G. F., & Co., printer. *Franklin*, 1800s; print on paper: letterpress; 6 x 4 in; printed title; BANC PIC 1963.002:1556:032–A. Plate 3-16, page 95.

——. *Galatea*, 1800s; print on paper: engraving, color, and letterpress; 6 x 4 in; BANC PIC 1963.002:1556:033–A. Plate 3-11, page 92.

——. *Invincible*, 1800s; print on paper: letterpress; 4 x 7 in; printed title; BANC PIC 1963.002:1556:052–A. Plate 3-13, page 94.

——. *Silas Fish*, 1800s; print on paper: engraving, color, and letterpress; 4 x 6 in; printed title; BANC PIC 1963.002:1556:093–A. Plate 3-12, page 93.

——. *Tycoon*, 1800s; print on paper: engraving; 4 x 6 in; printed title; BANC PIC 1963.002:1556:102–A. Plate 3-14, page 94.

——. *Zouave*, 1800s; print on paper: engraving, color, and letterpress; 6 x 4 in; printed title; BANC PIC 1963.002:1556:115–A. Plate 3-15, page 95.

O'Grady, William H. (active c. 1854–57) (attributed to). *Corlappich, Klamath River Indian Chief, 1851*, 1851; drawing on tinted paper: ink and wash; 6 x 4⅞ in; handwritten title (on verso); note: from a group of related drawings; BANC PIC 1963.002:0296–B. Plate 1-4, page 11.

Palmer, Francis (Fanny) Flora Bond (1812–76) artist; Currier & Ives, publisher. *The Pioneer's Home*, c. 1867; print on paper: lithograph, hand colored; 20 x 27⅞ in; printed title; other text: "On the Western Frontier"; BANC PIC 1963.002:0766–FR. Plate 1-10, page 20.

Ranney, William Tylee (1813–57). *The Trapper's Last Shot*, c. 1850; painting on canvas: oil; 18⅝ x 24⅜ in; BANC PIC 1963.002:1511–FR. Plate 1-9, page 19.

Robbins, Charles F. (active c. 1862), publisher

and printer. *I Do Not Want To Be Drowned*, c. 1862; print on paper: lithograph, hand colored; 13 x 10 in; printed title; other text and ins.: "A Song Respectfully Dedicated to the Survivors of the Wreck of the Golden-Gate / Poetry by Soule Frank Esqr., Music by P. R. Nicholls"; handwriting at upper right: "Sister Mary Aloysius"; BANC PIC 1963.002:1762–AX. Plate 4-4, page 113.

Rupalley, Louis Jules. *Californie 22*, c. 1850s; drawing on tinted paper: watercolor; 9 x 7 in; handwritten notes along lower edge: "Croit dans les interstices des rochers s'enlacent comme la vigne a de grand hauteur mars et avril en juin fruit" (Grows in the interstices of rocks intertwining itself like a tall vine March and April, fruit in June"; notes along side and on verso (includes description of plant's medicinal use); BANC PIC 1963.002:1305:073–ALB; Plate 6-5, page 176.

——. *Ennemi de la tarentule (Californie)* (Enemy of the Tarantula), c. 1850s; drawing on paper: watercolor; 7½ x 7 3/16 in; BANC PIC 1963.002:1305:011–ALB. Plate 6-7, page 178.

——. *Especè de mouron d'eau se trouvant sur les rochers tres élevés et quelques fois à 3 pieds sous l'eau dans les foutenaine de la Californie du sud, près les bords du Stanislass* [sic], *Tuolumne Conty* [sic] *Longueur de 15 à 60 centimetres* (A type of salamander living on very high rocks and sometimes at 3 feet under water in the springs of southern California near Stanislaus, Tuolumne County), c. 1850s; drawing on paper: watercolor; 5 x 6 in; handwritten title; ins.: "Pour George" (for George); BANC PIC 1963.002:1305:008–ALB. Plate 6-9, page 180.

——. Untitled (Californie 1857), 1857; drawing on paper: watercolor; 9⅞ x 7 in; handwritten notes on verso: "Se trouve dans les environs des camps de San Iago et Martinez" (found in the areas of San Iago and Martinez camps); BANC PIC 1963.002:1305:094–ALB. Plate 6-8, page 179.

——. Untitled (Californie 1855), c. 1850s; drawing on paper: watercolor; 3 x 4 5/8 in; handwritten list describing each specimen on verso; BANC PIC 1963.002:1305:007–ALB. Plate 6-6, page 177.

Saalburg, Charles W. (active c. 1890), lithographer. *Riverside House & Cottages, Santa Cruz*, 1800s; print on paper: lithograph, color; 13 x 22 in; printed title; other text in addition to text in advertisements: "Open the year round by day of the month. / Free Carriages to the House from all Trains and / Steamers. First-class in every particular. Terms mod / erate.

Send for Circular and Particulars"; BANC PIC 1963.002:0818–C. Plate 5-20, page 164.

"San Francisco Newsletter," publisher. *The Late Collision between the Trains of the Western Pacific and S. F. & Alameda R. R. Cos. near Simpsons Station, Sunday Nov. 14th, 1869*, 1869; print on paper: lithograph; 7 x 17 in; printed title; other text: "From a scetch [sic] made on the spot one hour after the collision"; BANC PIC 1963.002:0188–B. Plate 4-14, page 127.

Schile, H. *Across the Continent*, c. 1870s; print on paper: lithograph, hand colored; 21⅞ x 27⅝ in; printed title; BANC PIC 1963.002:1538–D. Plate 3-20, page 101.

Schuyler, Herman. *The First Train*, c. 1880; painting on canvas mounted on board: oil; 27⅝ x 47 in; supplied title; BANC PIC 1963.002:1378. Plate 3-17, page 97.

Seamon, Victor (active c. 1853). *Oh Boys I've Struck It Heavy*, 1853; drawing on paper: watercolor, pen, and pencil; 6 x 7 in; handwritten title and date; handwritten poem (on verso) in French entitled "Priere d'un Naufrage (Prayer of a Shipwreck)"; BANC PIC 1963.002:0224–A. Plate 5-1, page 137.

Sherwin, artist (active c. 1856); Rosenthal, L. N., lithographer; Marsh, John, publisher. *Fremont Polka, Fremont March, Fremont Schottish*, c. 1856; print on paper: lithograph, color; 12 x 9⅞ in; printed title; ins.: "Composed & Respectfully dedicated to John C. Fremont, by Alex. De Buena"; BANC PIC 1963.002:1752–AX. Plate 1-15, page 27.

Smith, J. B., & Son, artist; Parsons, Charles R., lithographer; Currier, Nathaniel, publisher. *Clipper Ship "Red Jacket,"* c. 1855; print on paper: lithograph, hand colored; 22⅜ x 29 in; printed title; other text: "In the Ice off Cape Horn on her Passage from Australia to Liverpool, August 1854/ Bilt by Geo. Thomas Esq. At Rockland, Me. 1853 for Messrs. Seacomb & Taylor, Boston, Mass."; BANC PIC 1963.002: 0960–D. Plate 3-9, page 89.

Smyth, William (1800–77). *Monterrey* [sic], *Picus Auratus, Woodpecker*, 1825–27; drawing on paper: watercolor; 5⅜ x 9 in; handwritten title; other text: "1/2 natl size"; BANC PIC 1963.002:1303:17–ALB. Plate 6-2, page 172.

——. *San Francisco, Oriolus Phoenicus, Red Winged Starling, Californian Name Chanates*, 1825–27; drawing on paper: watercolor; 5⅜ x 9 in; handwritten title; other text: "⅔ natl size old bird, ⅔ natl size young bird"; BANC PIC 1963.002:1303:13–ALB. Plate 6-3, page 173.

Star & Herald (active c. 1860). *P. M. S. S. Co's Steamship "Constitution" Dinner Bill of Fare*, c. 1860s; print on paper: letterpress; 12¼ x 5½ in printed title; BANC PIC 1963.002:1814–A. Plate 3-6, page 85.

Sykes, John (1773–1858). *View of Monterrey* [sic], c. 1791–95; drawing on paper: watercolor; 5⁵/₁₆ x 14 in; handwritten title; BANC PIC 1963.002:1116–FR. Plate 2-2, page 44.

Tait, Arthur Fitzwilliam (1819–1905), artist; Currier & Ives, lithographers. *American Frontier Life: "The Hunter's Stratagem,"* c. 1862; print on paper: lithograph, hand colored; 22 x 29⅝ in; printed title; BANC PIC 1963.002:0845–D. Plate 4-12, page 125.

Tavernier, Jules. Untitled (The Blocks' Farmyard on Dry Creek near Healdsburg, Sonoma County, California), 1883; painting on paper: watercolor and pencil; 10 x 16 in; supplied title; note from Inventory Sheets: Tavernier had been a Thanksgiving dinner guest. Chef Block was of the original Old Poodle Dog [restaurant]; BANC PIC 1963.002:1317–FR. Plate 5-15, page 155.

Thompson & West, publisher. *A Birds-eye View on the Cattle Ranch of Daniel McCarty . . . East of Sacramento, Cal.*, c. 1878; print on paper: lithograph; 11 x 13⅞ in; printed title; other text: "352 Acres, purchased in 1878, along the / American River, 1½ mile east of Sacramento, Cal."; BANC PIC 1963.002:0483:02–B. Plate 5-17, page 159.

——. Untitled, c. 1879; print on paper: lithograph; 10⅜ x 13 in; BANC PIC 1963.002: 0483:01–B. Plate 1-16, page 28.

Unknown artist. *Chinese, Gold Mining in California*, c. 1850s; print on paper: engraving; 4 x 4 in; printed title; BANC PIC 1963.002: 0499–A. Plate 5-4, page 140.

Unknown artist. *Cowan Catalina Brand Japan Tea*, c. early 1900s; print on tissue paper: engraving, color; 12⅝ x 10⅝ in; title based on printed text within image; other text: "No. / pure uncolored / basket fired / Japan tea / imported by / Earl Cowen Co. / Los Angeles, Cal."; BANC PIC 1963.002:0945–B. Plate 5-21, page 165.

Unknown artist. *Habitans de la Californie* (Natives of California), 1800s; print on paper: engraving, hand colored; 6½ x 3⅞ in; printed title; BANC PIC 1963.002:0363–A. Plate 1-5, page 13.

Unknown artist. *La Grange Mining Co., Weaverville, Trinity County, California*, c. 1870; painting

on canvas: oil; 23 x 31 in; handwritten title; BANC PIC 1963.002:1379–FR. Plate 5-7, page 144.

Unknown artist. *The Last Race: A Stage Coach Race between Oakland and San Jose, Cal*, 1800s; handwritten title; painting on paper: watercolor; 15 x 27 in; BANC PIC 1963.002:0685 (enclosure)–D. Plate 3-4, page 83.

Unknown artist. *The Old Reliable Schuttler Wagon*, 1800s; print on paper: lithograph, color; 18 x 25 in; printed title (within image); BANC PIC 1963.002:1418–FR. Plate 3-2, page 80.

Utagawa, Yoshikazu (c. 1850–70). *Amerikakoku jokisha orai* (Steamship in an American Port), 1861; print on hosho paper: woodcut; composed of 3 sheets; 14 x 28⅞ in; printed title; BANC PIC 1963.002:0916–D. Plate 1-21, page 34.

Vischer, Edward (1808–79), artist; Kuchel, C. C., lithographer; Nagel, Louis, printer. *Mother of the Forest (1855 and 1861), and Other Groups*, c. 1862; print on paper mounted on board: lithograph, color; 13 x 10⅞ in; printed titled; BANC PIC 1963.002:0385.04–ALB. Plate 6-11, page 182.

——. *The Mammoth Grove Hotel, Grounds, and General View of the Forest*, c. 1862; print on paper mounted on board: lithograph, color; 10⅞ x 13 in; printed title; BANC PIC 1963.002:0385.09–ALB. Plate 6-12, page 183.

Walker, James. Untitled (Patrón [Boss]), c. 1849; painting on canvas: oil; visible image: 11⅞ x 9⅝ in; BANC PIC 1971.007–FR. Plate 1-7, page 16.

Wikersheim, Fritz (active c. 1847–51). *Californie— Établissement (asiento) du mining de mercurie de la nueva almaden* (Factory [seat] of the Mercury Mine at New Almaden, California), 1845–51; drawing on paper: pencil; 5 x 8⅜ in handwritten title; BANC PIC 1963.002:1304:31–ALB. Plate 5-9, page 147.

Wimar, Carl (1828–62). *Fleeing a Prairie Fire*, c. 1860; painting on board: oil; 6 x 8 in; title attached to frame; BANC PIC 1963.002: 1515–FR. Plate 1-11, page 21.

Young, Harvey O. (1840–1901). Untitled (Mountain with Prairie Landscape), 1871; painting on canvas mounted on board: oil; 30 x 50⅛ in; supplied title; BANC PIC 1963.002:1382–FR. Plate 2-17, page 67.